ASHMOLEAN

BRITAIN'S FIRST MUSEUM

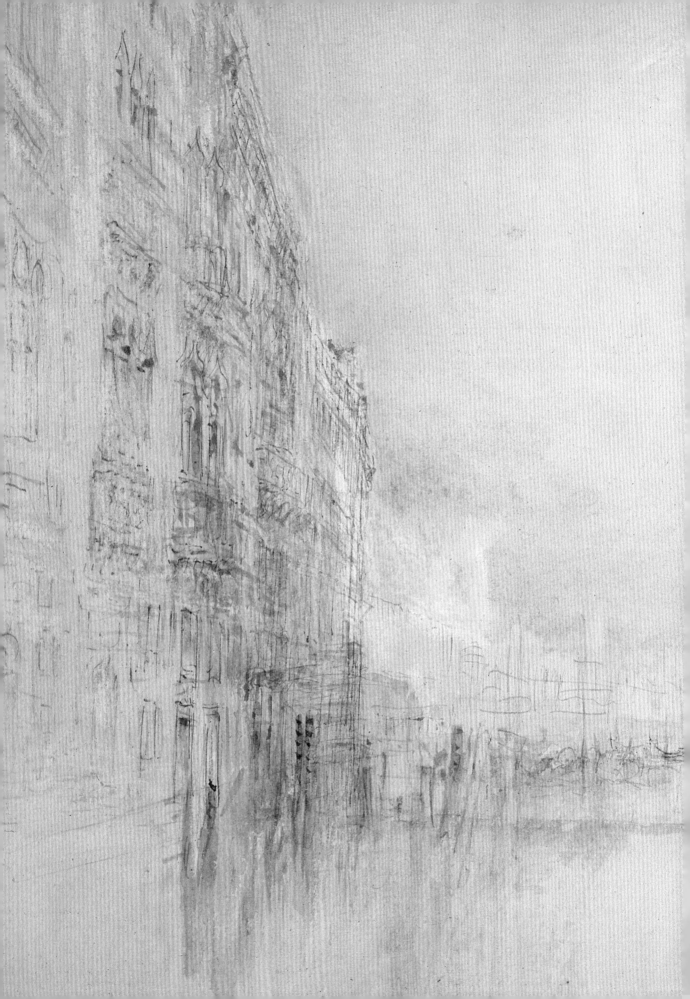

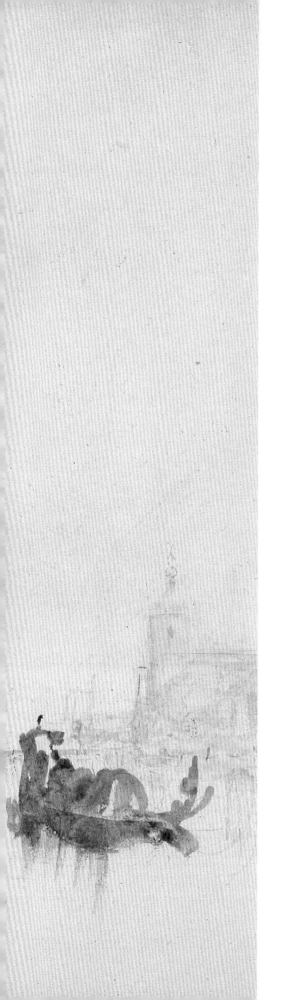

ASHMOLEAN

BRITAIN'S FIRST MUSEUM

Joseph Mallord William
Turner (1775-1851)
**Venice: The Grand
Canal** ᴄ
*(detail) Watercolour over
pencil with pen and red
and blue inks and white
body colour, English,
about 1840, 21.5 x 31.5 cm*
(WA1861.8)

**The Elias Ashmole Group and Tradescant Patrons are proud supporters
of this publication.**

Copyright © Ashmolean Museum, University of Oxford 2009

First published in the United Kingdom by the Ashmolean Museum, Publications
Department, Beaumont Street, Oxford OX1 2PH

ISBN 978-1-85444-243-7

British Library Cataloguing in Publication Data

A catalogue record for this book is available from the British Library

Catalogue designed by Baseline Arts Ltd, Oxford

Typeset in Requiem and Foundry Sans

Printed and bound in UK by EPC Direct Ltd

Photographic acknowledgments:
pp.xi, 2,3, 21 and 30 © Rick Mather Architects/Andy Matthews
p.154 © Succession Picasso/DACS 2006
p.156 © ADAGP, Paris and DACS, London 2009
p.157 © Estate of Walter R. Sickert/DACS 2006
p.158 © The Artist's Estate
p.159 © Estate of Stanley Spencer/DACS 2006
p.160 © The Coper Estate
p.161 © The Artist's Estate
p.162 © George Baselitz
p.163 © The Artist's Estate

ASHMOLEAN

For further details about the Ashmolean Museum's publications please visit:
www.ashmolean.org/shop

Contents

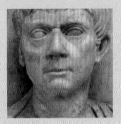

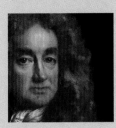

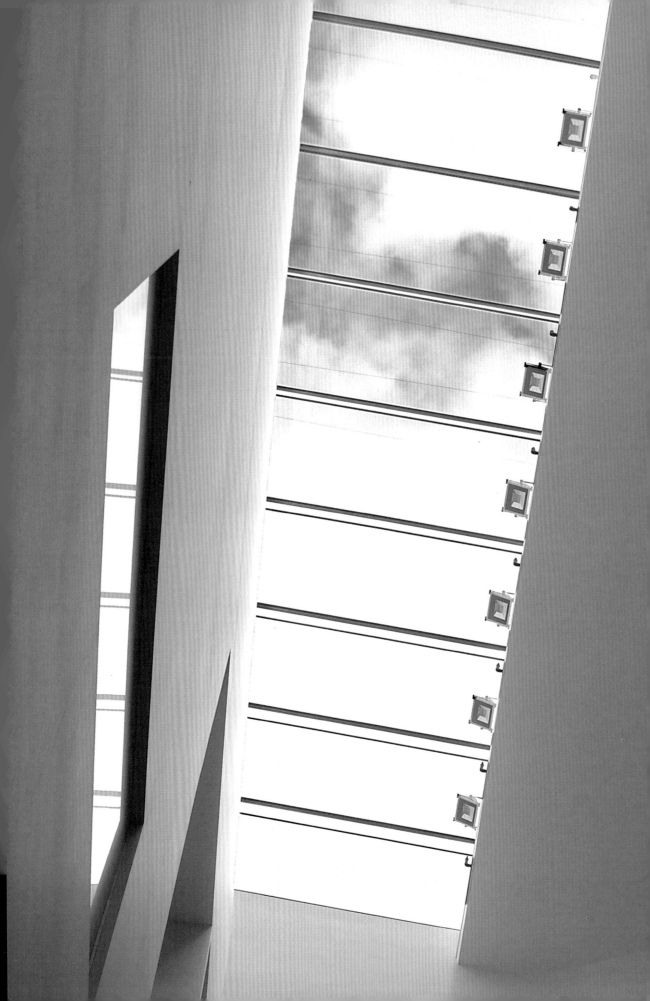

Introduction

⊙ Asian Crossroads gallery located on the first floor of the new building.

THE ASHMOLEAN'S COLLECTIONS ARE EXTRAORDINARY. THEY REFLECT FOUR CENTURIES OF EVOLVING KNOWLEDGE ABOUT MANY OF THE WORLD'S GREAT CIVILISATIONS. SOME COLLECTIONS, SUCH AS THE CHINESE GREENWARE AND ARTEFACTS FROM PRE-DYNASTIC EGYPT, ARE THE FINEST TO BE FOUND OUTSIDE THEIR COUNTRIES OF ORIGIN. THE OBJECTS WE DISPLAY FROM ARTHUR EVANS'S EXCAVATIONS ON CRETE DEFINED THE ACCEPTED VIEW OF MINOAN CIVILISATION FOR A HUNDRED YEARS. OTHER COLLECTIONS OF RENAISSANCE ART, TEXTILES AND GREEK AND ANGLO-SAXON COINS REFLECT THE PASSION AND DEDICATION OF THE COLLECTORS WHO CREATED THEM. THESE TREASURES, BROUGHT TOGETHER IN A 'COLLECTION OF COLLECTIONS', DESERVE A MUSEUM THAT MAKES THEM ACCESSIBLE TO THE WIDEST POSSIBLE AUDIENCE IN AN ENGAGING AND INSTRUCTIVE MANNER. IT IS THIS VISION THAT IS AT THE HEART OF THE NEW ASHMOLEAN.

The new building, designed by the celebrated architect Rick Mather, is the museum's most significant architectural development since the construction of Charles Cockerell's great neoclassical building on Beaumont Street in 1845. It provides visitors with a seamless transition from the old building to five floors of galleries linked by bridges with clear vistas. This is a single, integrated museum where the relationships between galleries are often as important as the galleries themselves. Under the theme *Crossing Cultures, Crossing Time*, the new Ashmolean focuses on the influences and links between cultures rather than the differences. It is a significant departure from the rigid geographical and chronological divisions of older museum presentation, and has opened up the opportunity to look in new ways at our collections and how we display them. This is appropriate for a museum that is a key part of a university where research is constantly producing new ideas and new questions.

⊙ Natural light is channeled throughout the building by creative use of glass walls and balustrades which boldly contributes to an increased sense of open space.

In many respects this approach represents a return to the original intentions of the creators of the Ashmolean. When the Museum's founding collection was shown by the Tradescant family in their house in London in the early seventeenth century, visitors noted that viewing the collection was like going around the world in a day. Similarly, Arthur Evans's vision, in a publication of 1891, was to ensure that students of classics and history in the University had a real understanding of art and archaeology and that it was the job of the Museum, as part of the University, to provide that understanding. In both respects, the new Ashmolean responds to those historic intentions.

Creating the new Ashmolean has taken the effort of hundreds of people and organisations over the course of a decade. I would like to put on record my profound gratitude to my colleagues for their dedication to the Museum and their hard work. The University has been supportive from the outset, recognising that the Ashmolean plays a central role in its life and understanding the importance of the collections for research and the teaching of material culture in many of its faculties. The Heritage Lottery Fund gave us an immensely generous grant in 2004 and has supported us throughout with valuable advice based on long experience. The donor boards in the Museum record our great debts of gratitude to the many private individuals and foundations throughout the world who have shared our vision for the new Ashmolean.

One man in particular deserves my special thanks: without the commitment and financial support of Lord Sainsbury of Preston Candover, the new Ashmolean would simply not have happened. He has been both wise advisor and generous benefactor, and for these reasons, and also as a mark of our personal friendship, I have dedicated this book to him.

DR CHRISTOPHER BROWN, Director, 2009

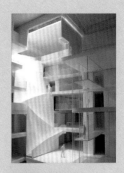

The skilful interlinking of internal spaces and the dynamic use of natural light are hallmarks of the new building, which is classically modern with clean lines and bold vistas.

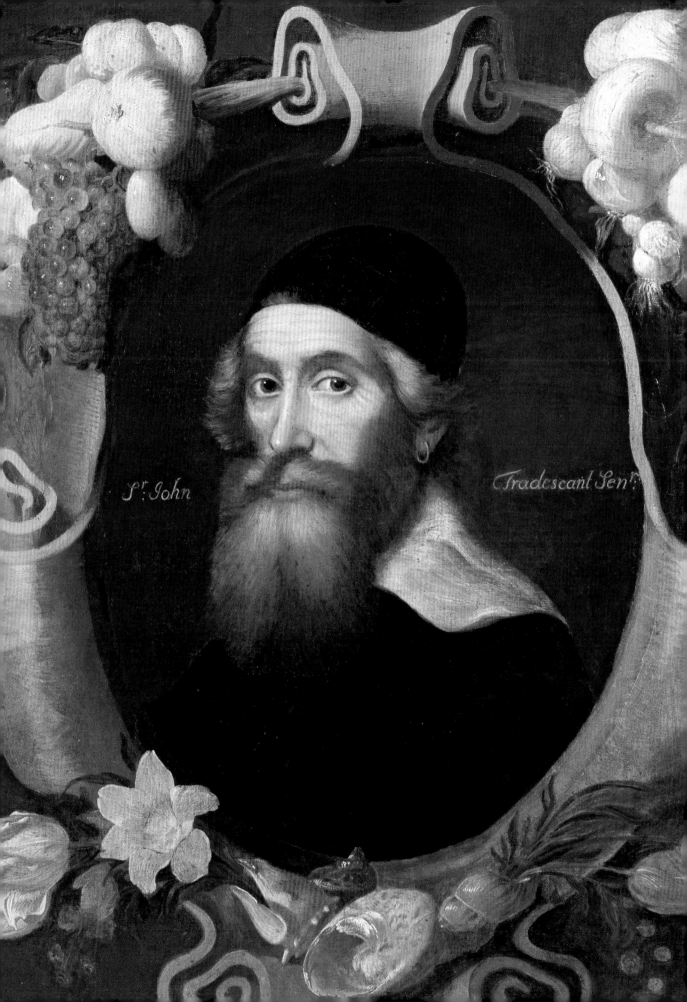

Sr. John Tradescant Senr.

From the Oldest University Museum to the New Ashmolean

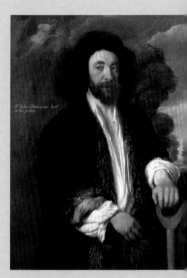

'THOSE RARITIES AND CURIOSITIES ...'

The origins of the Ashmolean's collections lie with a father and son, both called John Tradescant, who lived in London in the early seventeenth century. By profession they were gardeners, and the portrait of John the younger (1608-1662, *above right*) shows him proudly holding a spade. John the elder (born about 1570, died 1638) was gardener successively to the Earl of Salisbury at Hatfield House, to Lord Wotton at St Augustine's Palace, Canterbury, and to the all-powerful favourite of James I and Charles I, George Villiers, 1st Duke of Buckingham (1592-1628). In the early 1600s, John the elder began to assemble a collection of 'curiosities' that included botanical, geological and zoological items as well as man-made objects. He had travelled widely in Europe and Russia and had also used Buckingham's influence to persuade sea captains to bring back exotic specimens. After his death in 1638 his son carried on with, in his own words, 'continued diligence' to add to and preserve 'those rarities and Curiosities which my Father had sedulously collected'. Most importantly, he added significantly to the collections during three visits he made to Virginia between 1637 and 1654, acquiring works of native American art, most notably, 'Powhatan's Mantle' *(pp. 6 & 115)*.

The Tradescant collection was kept in London, in a house near Lambeth Palace on the south bank of the Thames. It was open to the public and soon became known as 'The Ark' because of its comprehensive character. In 1634 a well-travelled visitor on home leave from the East India Company wrote that he had 'spent that whole day in peruseinge, and that superficially, such as hee [Tradescant] had gathered together ... soe that I am almost perswaded a Man might in one daye behold and collece into one place more Curiosities than hee s[h]ould see if hee spent all his life in Travell'.

Lithograph of Powhatan's Mantle ⟳ from an article published by Edward Burnett Tylor (1832-1917), the University's first Reader in Anthropology, in 1888.

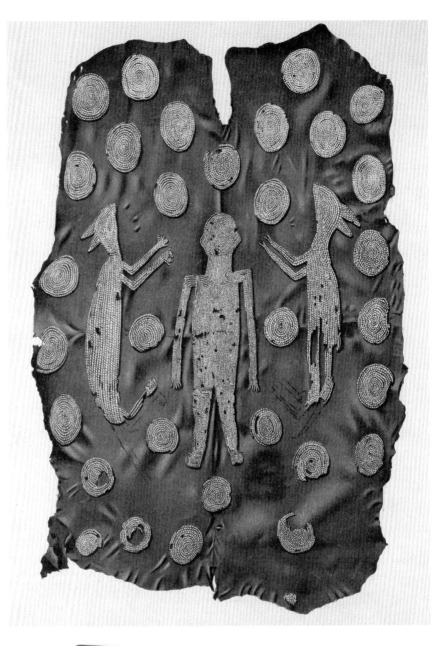

North American ball-headed clubs and skin pouch ⟳
Before 1656

The clubs are made of wood inlayed with metal and shell. The pouch is leather with shell bead decoration. Possibly collected by John Tradescant the Younger during his travels to Virginia.
(AN1685 B.133 and 135)
(AN1685 B.370)

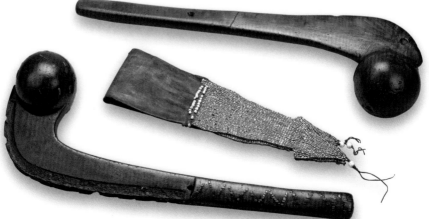

In 1650 the younger Tradescant received the first of many visits from Elias Ashmole, a lawyer who was also an antiquary and genealogist. With Ashmole's encouragement, assistance and financial backing, a catalogue was published in 1656 with the title *Musaeum Tradescantianum*. In gratitude, Tradescant made over the collection by deed of gift to Ashmole, who in turn promised it to the University of Oxford in 1677.

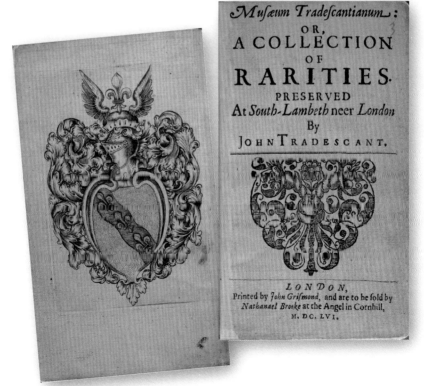

Musæum Tradescantianum:
OR,
A COLLECTION
OF
RARITIES.
PRESERVED
At *South-Lambeth* neer *London*
By
JOHN TRADESCANT.

LONDON,
Printed by *John Grismond*, and are to be sold by
Nathanael Brooke at the Angel in Cornhill,
M. DC. LVI.

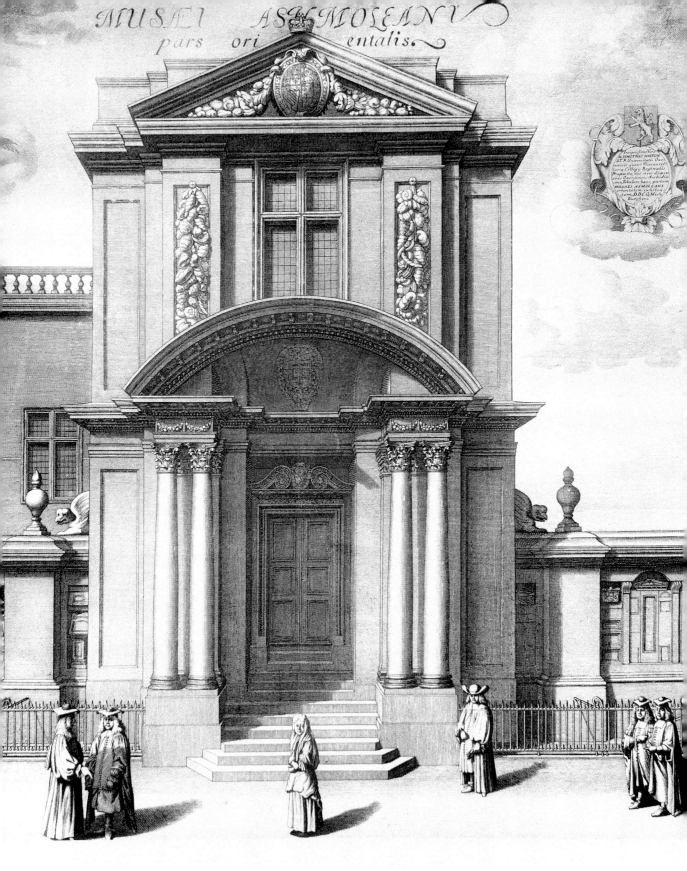

Michael Burghers (1647/8-1727)
**East front of the original Ashmolean building
in Broad Street** ○
From a 1685 engraving

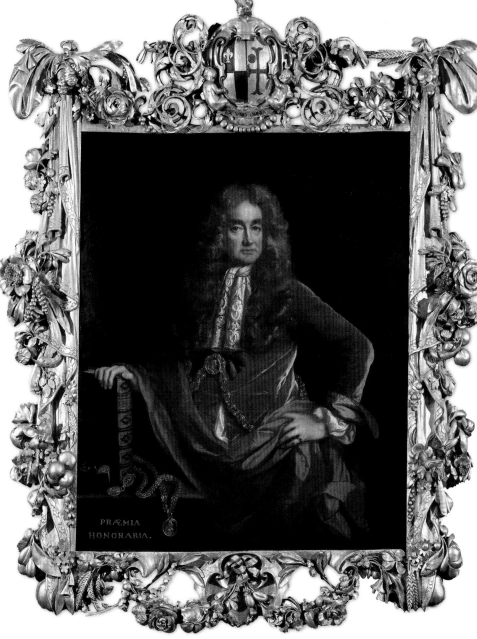

John Riley (1646-1691)
Elias Ashmole G
(1617-1692)
Oil on canvas,
124 x 101 cm

Elias Ashmole, whose gift to the University of Oxford in 1683 formed the basis of the Ashmolean Museum in Broad Street (now the Museum of the History of Science), is portrayed with objects reflecting his scholarly interests as an antiquary and herald. The book, *Ashmole of the Garter*, represents his Institution, Laws and Ceremonies of the Most Noble Order of the Garter (1672). The medals (Praemia honoraria), carefully depicted, no doubt at Ashmole's request, are a filigree chain and portrait medallion of Frederick William, Elector of Brandenburg (worn by the sitter); a portrait medal of Karl Ludwig of Bavaria; the George of the Order of the Garter which had belonged to Thomas Howard, 2nd Earl of Arundel, and which was given to Ashmole by the Earl Marshal; and another chain and medal, given by the King of Denmark. It is likely that the portrait was painted in 1681-1682 for presentation to the new Museum in Oxford. The spectacular frame was carved by Grinling Gibbons (1648-1720), for whom Ashmole cast a horoscope in 1682. It is surmounted by Ashmole's arms and his motto, EX UNO OMNIA ('All things come from one').

Presented by the sitter, 1683.
(WA1898.36, F730)

'THE INSPECTION OF PARTICULARS, ESPECIALLY THOSE AS ARE EXTRAORDINARY ...'

The Ashmolean Museum was opened for the first time on 21 May 1683 by the Duke of York, the future King James II, in the building in Broad Street, Oxford, that today houses the Museum of the History of Science. The building had been erected by the University to the designs supplied by the master mason Thomas Wood in order to house the collections donated by Ashmole. Ashmole himself drew up a series of statutes to govern his new foundation, recognising its scientific importance: 'Because the knowledge of Nature is very necessarie to humaine life, health, & the conveniences thereof, & because that knowledge cannot be soe well & usefully attain'd, except the history of Nature be knowne & considered; and to this end, is requisite the inspection

Statutes Order & Rules for the Ashmolean Museum, in the University of Oxford.

[handwritten original statutes text]

The original statutes of the Ashmolean Museum ↻
drafted by Elias Ashmole in 1686.

of Particulars, especially those as are extraordinary in their Fabrick, or usefull in Medicine or applyed to Manufacture or Trade ... I have amass'd together great variety of naturall Concretes & Bodies, & bestowed them on the University of Oxford.' The Ashmolean's first Keeper was Robert Plot, also the University's first Professor of Chemistry, who installed the collection on the first floor of the building, the other floors being devoted to a chemical laboratory and the 'School of Natural History'.

From the outset the Ashmolean was a public museum, and a vivid account of the early years is given in the diary of a young aristocratic German traveller, Zacharias Conrad von Uffenbach (1683-1734). He visited in 1710 and was appalled by what he saw. 'The specimens in the museum ... might be better arranged and preserved,' he noted, 'but it is surprising that things are preserved even as well as they are, since the people impetuously handle every thing in the usual English fashion and ... even the women are allowed up here for sixpence; they run here and there, grabbing at everything and taking no rebuff from the sub-custos.' Clearly little attention was being paid to Ashmole's statues: 'That the Rarities shall be shewed but to one Company at a tyme, & that upon their being entred into the Musaeum, the dore shall be shut.' Records from the period make it clear that, in addition to scholars, the Museum was popular with ordinary visitors, including servants, country people coming to market in Oxford and bargees passing along the Thames.

Charlotte Augusta, Duchess of Marlborough (d.1850)
Study of a Dodo and a Guinea-pig ↻
1847, watercolour *[WA1961.12].*
One of the most important specimens in the Tradescant collection was a dodo, the remains of which were transferred to the University Museum (now the Oxford University Museum of Natural History) in the early 1860s.

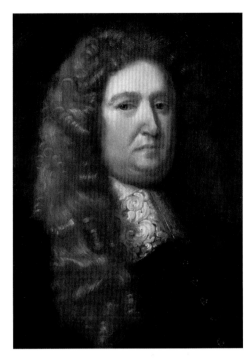

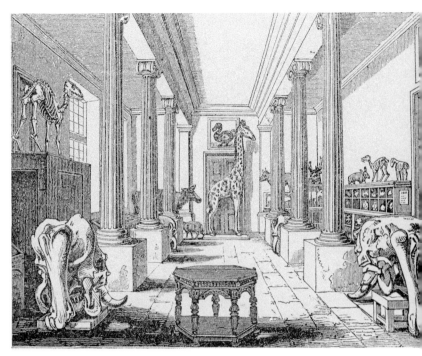

William Reader *(active 1672-1680),*
Robert Plot
oil on canvas.
Robert Plot served as the first Keeper of the Ashmolean
Museum from 1683 to 1691.
(WA1898.31)

Orlando Jewitt *(1799-1869)*
The interior of the Ashmolean
Engraving
From the title page of 'A Catalogue of the Ashmolean
Museum', published in 1836.

A 'TEMPLE OF THE ARTS'

The Ashmolean collections were displayed, added to and conserved with varying
degrees of diligence during the eighteenth century, but early in the nineteenth
a number of important developments profoundly affected the Museum. For
many years the University's works of art – largely painted and sculpted
portraits, coins and antiquities (notably the Arundel collection of classical
sculpture given by the Countess of Pomfret in 1755) – had been housed in
the Bodleian Picture Gallery *(see p. 12)* and elsewhere. In 1845 they moved to
the new University Galleries opened in Beaumont Street in a masterpiece of
Greek revival architecture designed by Charles Robert Cockerell (1788–1863)
(see pp. 14 & 15). It was the fulfilment of an idea for a 'temple of the arts', which
had been proposed in the *Oxford Almanack* as early as the 1750s. There was no
money for such a building at that time, but in 1797 the University received a
bequest of £1,000 from Dr Francis Randolph, principal of St Alban Hall, towards
the cost of building new galleries for the Arundel Marbles *(see pp. 16 & 17)* and other
works of art. This was still not enough, and it was only in 1839 that the
present building was planned, thanks to an ingenious scheme devised by
the University Registrar, Dr Philip Bliss, to combine the proposed art
gallery with the Taylor Institution for the teaching of modern languages.

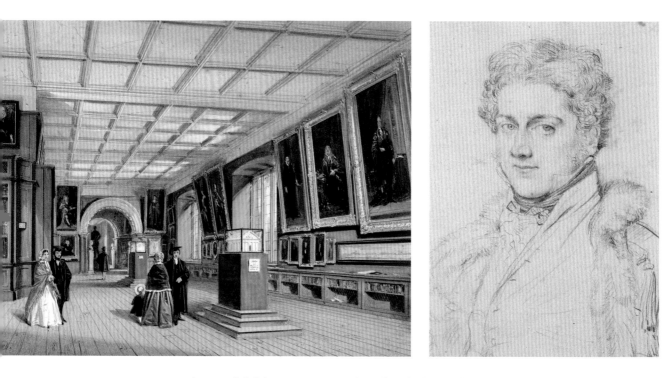

Watercolour by Joseph Nash ☊
(1809-1878)
The interior of the Bodleian Picture Gallery, 1830s. Reproduced by kind permission of the Bodleian Library, University of Oxford.

Jean-Auguste-Dominique Ingres (1780-1867)
Portrait of Charles Robert Cockerell ☊
(detail) graphite on paper (WA1998.179)

The Randolph bequest was combined with the much larger one from the architect Sir Robert Taylor (1714-1788), who left the bulk of his fortune of £180,000 'for establishing a foundation for the teaching and improving the European languages'. A competition was held to choose an architect to design a 'Grecian building' that would combine these two proposals. The commission was given to the most distinguished of the 28 competing architects, Charles Cockerell, who devised a scheme with two large projecting wings and a recessed centre facing Beaumont Street, the Taylorian in the east wing and the galleries in the north and west wings. Despite its superb elevation with the giant Ionic portico facing an open courtyard, the University Galleries were relatively small, the main range being very shallow and just one room deep, displaying sculpture on the ground floor and paintings and drawings on the first floor. The sculpture galleries and parts of the picture galleries survive as designed by Cockerell, along with the great staircase adorned with plaster casts of part of the frieze from the Temple of Apollo at Bassae, discovered by an Anglo-German team that included Cockerell himself.

As intended, the new University Galleries attracted significant gifts. Among the most noteworthy was the outstanding group of drawings by Raphael and Michelangelo *(see pp. 18 & 19)* purchased during the dispersal of the collection of the portrait painter Sir Thomas Lawrence (1769-1830) and presented in 1846 by a consortium of supporters of the University led by Henry Wellesley, nephew of the Duke of Wellington. As a consequence the Ashmolean has the largest and most important collection of drawings by Raphael in the world and one of the greatest collections of drawings by Michelangelo.

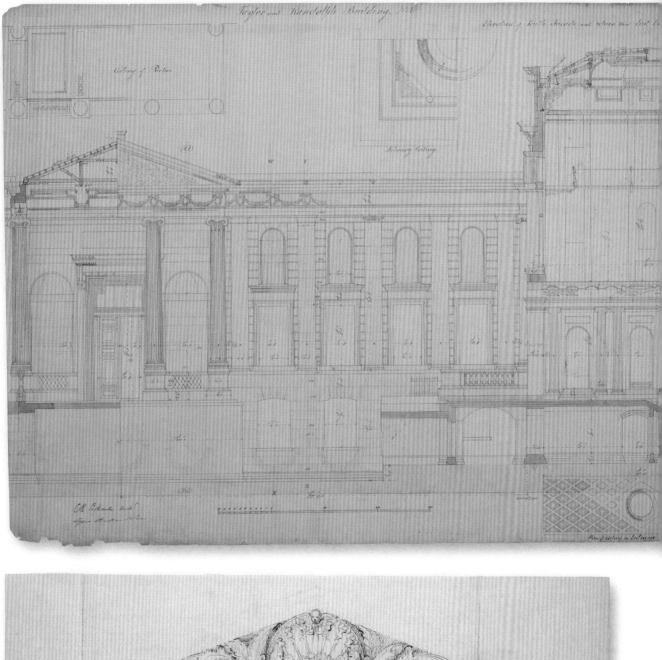

**Designs for the pediment and south front of
the University Galleries** ⌒
*Produced by Charles Robert Cockerell (1788-1863),
early 1840s.*
(LI1055.14 and 27)

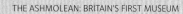

Frederick Mackenzie (1787-1854)
South East View of the Taylor Building and University Galleries
1848, Watercolour produced for the Oxford Almanack.

The University Galleries were opened in 1845 and combined with the Ashmolean Museum in 1908.
[WA1850.96]

'A CONSTANT REFERENCE TO ARCHAEOLOGY AND ART ...'

The next phase of the Ashmolean's development was led by Arthur Evans (1851-1941) *(opposite)*, well known as the excavator of Knossos, who was Keeper of the Museum from 1884 until 1908. It was Evans's inspiration, along with that of Charles Fortnum (1820-1899) *(see p. 19)*, to combine art and archaeology in the same building, and both campaigned for a museum where the arts of different cultures could be seen and compared within the same space. In 1891 Evans wrote in *The Scheme for a New Museum of Art and Archaeology*: 'It is coming more and more home to students that classical and historical learning can no longer be effectively pursued without a constant reference to Archaeology and Art. The establishment of the proposed Museum on a broad and enduring basis concerns in the most intimate way the central studies of the place.'

Antique sculpture ↻
from the Arundel and Pomfret collections in the Randolph Sculpture Gallery.

The collections continued to increase at an impressive rate through Evans's own archaeological work in the Balkans, as well as through the energetic acquisition of Near Eastern and Egyptian material by Greville Chester (1830-1892) and the loan and subsequent bequest of the remarkable collection of Renaissance decorative art assembled by Charles Fortnum. In order to accommodate these collections, Evans, using funding from Fortnum, built a series of five interlinked pitched-roof structures to the designs of H.W. Moore at the back of Cockerell's building.

In 1894 the archaeological collections began to be transferred from Broad Street into the new extension, and in 1908 the University Galleries and the Ashmolean Museum were formally merged to form the Ashmolean Museum of Art and Archaeology, the official title of the Museum today.

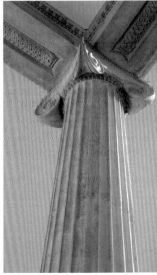

Sir William Blake Richmond (1842-1921)
Sir Arthur Evans ↺ among the Ruins of the Palace of Knossos
Oil on canvas
(WA1907.2)

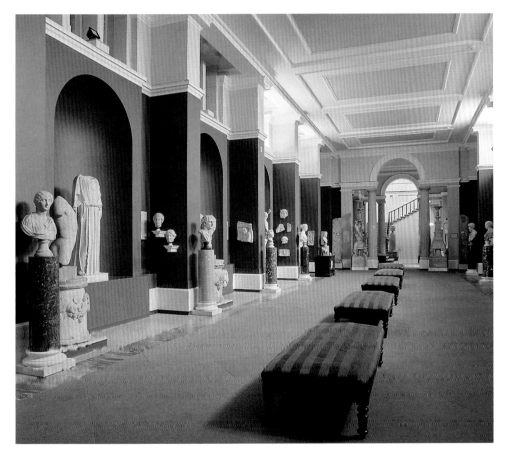

The Randolph Sculpture Gallery looking east towards the grand staircase ↺

One of the pillars supporting the Museum's impressive neo-classical portico ⇨

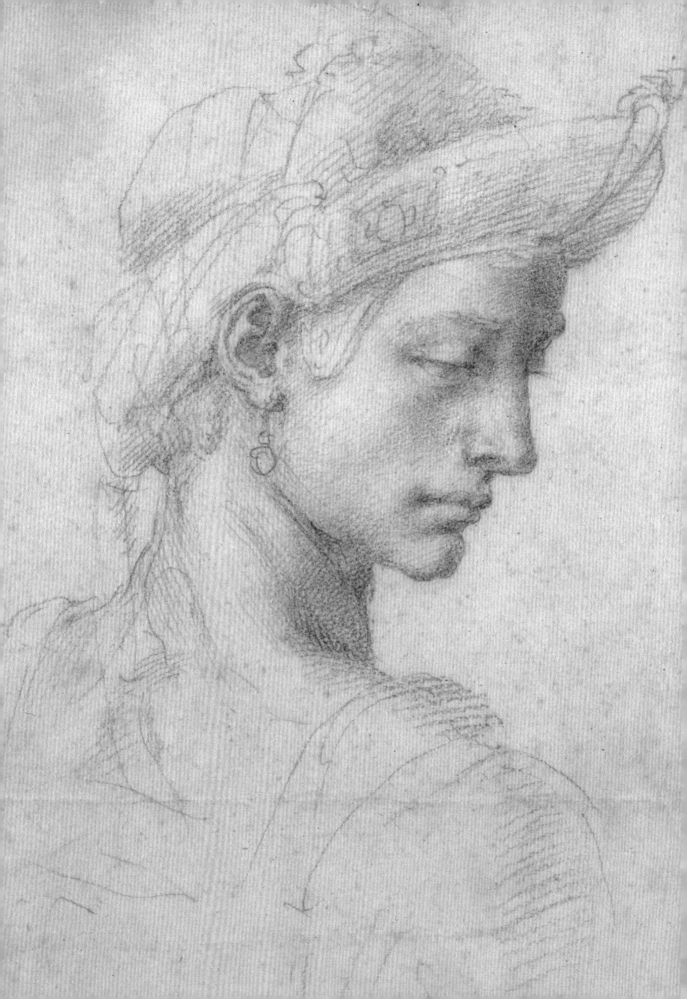

Coins and medals came to the Ashmolean from the Bodleian Library in 1921, and in 1961 the University's Eastern art collections moved to Beaumont Street from the Indian Institute.

Throughout the twentieth century new extensions were added to the existing buildings, and internal courtyards were filled to create space for the ever-increasing collections. In the 1990s a visionary scheme by the architects Stanton Williams to create new facilities – including a lecture theatre, café, workshops and Education Department offices – was carried out beneath the forecourt with the support of the Headley Trust, but behind the Cockerell building was a maze of storerooms, offices and galleries that demanded heroic efforts by visitors and staff to use and navigate. It was time to create a master plan for the Museum and its collections as a whole.

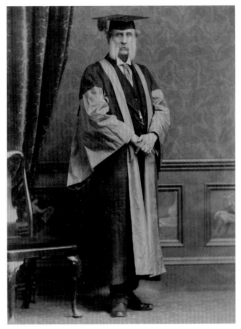

Photograph of **C.D.E. Fortnum** (1820-1899) ☊ wearing doctoral robes, 1889.

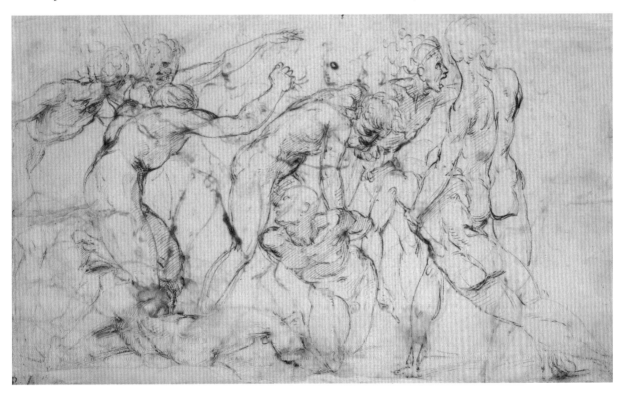

Michelangelo Buonarroti (1475-1564)
Ideal Head ☋
Red chalk on off-white paper
(WA1846.61)

Raphael (1483-1520)
Battle Scene with Prisoners being pinioned ☊
Pen and brown ink in black chalk on blue-grey paper
(WA1846.179a)

Orientation galleries on each floor will introduce the key themes and provide story-trails to be followed, enabling visitors to plan their own routes through different cultures and eras, and to make those illuminating connections and comparisons that bring the past to life.

'THE GREATEST UNIVERSITY MUSEUM IN THE WORLD ...'

In 2001, following an international competition, Rick Mather Architects was commissioned to create the new Ashmolean. The practice has worked on a number of important historic buildings – including the Dulwich Picture Gallery, the Wallace Collection and the National Maritime Museum in London – sympathetically adapting and extending them to meet the demands of modern museums.

The skilful interlinking of internal spaces and the dynamic use of natural light are hallmarks of the new building, which is classically modern with clean lines and bold vistas. At the heart of the building is the main staircase, which rises over six storeys. Lit from a clear glass skylight, it floods the building with natural light during the day, while at night it is illuminated by hidden cold-cathode lighting within the staircase. The sense of open space is increased by the use of glass walls and balustrades. Bridges span the larger galleries, connecting those on adjoining floors.

The building subtly complements Cockerell's neoclassical structure. There are eight doors through which visitors can move from the old to the new building,

providing access on all levels. Where new galleries meet the old, they are the same height, creating a smooth transition from one space to the next. The integration of the two buildings is also evident in the choice of materials. The stone floors of the old building are joined to Portland stone floors in the new; old and new oak flooring complement each other on the upper levels. Each detail serves to present a single, unified museum.

Where the buildings diverge is in the treatment of detail. The Cockerell building will continue to be enjoyed for the rich fabrics that cover the walls, the herringbone flooring, the intricate ironwork and the details of its mouldings and cornices. The new building is classically modern, with plain, crisp finishes on the walls, ceilings and staircases. It is a profoundly sympathetic response to an important historic building.

There is no flamboyant rhetoric about the new Ashmolean. The external elevations are at the back of the building and hardly visible to the visitor. What makes it a great building is the careful use of restricted space – it is surrounded on all sides by other University buildings – and the ways in which it meets the hugely varied demands of a twenty-first-century museum.

Staircase lightwells are naturally lit with large windows and roof lights. Some wall cases are entirely constructed of glass, allowing vistas across double-height galleries and views of related displays and objects.

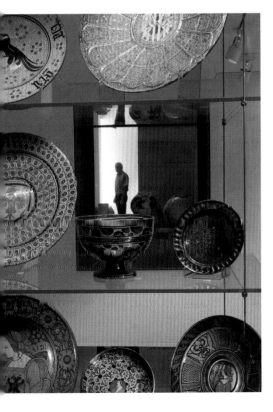

New ways of seeing our past: At its opening in 1683, the Ashmolean was the world's first ever public museum, a beacon of learning for a newly scientific age. Over the centuries, as an integral part of the University of Oxford, it has remained at the forefront of modern thinking on how museums can best foster learning, while giving enjoyment and inspiration to the widest possible audience. With a breathtaking new building, and a completely fresh approach to how our collections are displayed, the Ashmolean will be equipped to lead the way in meeting the challenges of the next 300 years.

In the new building there is environmental control in every gallery. Organic material, especially the superb textile collections, can be made accessible to the public for the first time. For the archaeology galleries in particular, the ability to show objects made from bone, wood and leather has transformed the displays. There is 100 per cent more display space on the same footprint. Fitting five floors into the new museum required the floor structure itself to be very shallow, and all the services to run through the walls, a complex feat of engineering. The new Ashmolean also serves the needs of a modern, working organisation: a new loading bay, conservation studios, storage facilities, libraries, education suites, meeting rooms and offices are all crucial to the 'backstage' work of a world-class museum.

Sustainability, both commercial and green, is a key responsibility for a twenty-first-century museum. The new Ashmolean's green credentials are impeccable, with low-energy lighting, locally sourced brick and stone and naturally lit and ventilated spaces wherever possible. Even the uncompromising demands of environmental control in the galleries are met with low-energy displacement ventilation that introduces cool, low-speed air at floor level and extracts it from above. Commercial sustainability can be a thorny topic for museums, often involving choices that go to the heart of what it believes it is there to do. There can be no debate, however, about the importance of the new Ashmolean café, situated on the roof of the new building and commanding unrivalled views. It provides a wonderful experience of Oxford both for visitors during the day and diners in the evening.

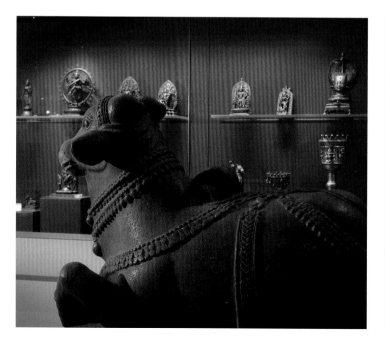

Crossing Cultures, Crossing Time

As a university museum, the Ashmolean's collections are used for study, teaching and research as well as being on public display. This combination of cutting-edge scholarship and service to the public gives the Museum its special character. We aim to challenge as well as to inform, presenting new ideas and searching questions about the peoples and cultures whose art and artefacts are on display.

As the architectural form began to take shape, the Museum began to debate internally how the new building could change the ways in which the collections would be displayed. We needed an approach that would work both with the aesthetic needs of Western and Eastern art galleries and with the necessarily more didactic demands of archaeological displays. We also needed to feature current and future research on material culture by the Museum and within the wider University.

The outcome of that debate was *Crossing Cultures, Crossing Time*, a thematic approach that underpins the layout of the galleries in the new building over its five floors. It is based on the simple idea that cultures interact with and influence one another.

Mummy portrait of a young man from Roman Egypt, AD 200, and **Self-Portrait** by Samuel Palmer (1805-1881) ⮑

Beauty across continents (left) Kitagawa Utamaro **Japanese woodblock print**, dated about 1795- 96 and (right) Giambattista Tiepolo (1696-1770) **Young Woman with a Macaw** ⮑⮑
These two images represent versions of ideal beauty. The former is a portrait of the Courtesan Kisegawa of the Matsuba-ya House, which celebrates traditions associated with early autumn. The latter belongs to a distinctively Venetian genre of fantasy portraits and was one of series painted for the Empress of Russia, Elizabeth Petrovna.

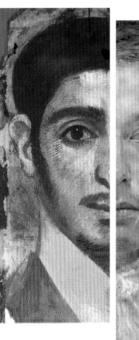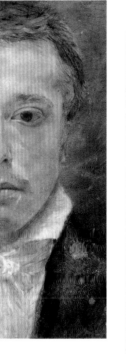

Such interaction comes in many forms, whether through the adoption and adaptation of religions, the transfer of ideas and technologies, the creation of new trading routes or the migrations of people.

As the *Crossing Cultures, Crossing Time* approach evolved, one particular object was a constant in our discussions. It is an image of the Buddha, produced in Gandhara, now western Pakistan, in the second or third century AD. The depiction of the haloed Buddha is distinctly Indian, but the style of dress and pose are reminiscent of a figure from the eastern provinces of the Roman Empire. It displays the continuing influence of classical civilisation that had begun nearly five hundred years earlier as Greek culture followed the military expeditions of Alexander the Great.

Rare coats, common threads ⌓
These two beautiful garments from the 1900s – an imperial robe from Beijing, China and a man's coat from Kashgar, Central Asia. These were made thousands of miles apart, and each is a fine example of its specific culture. Yet, at the same time, they have a great deal in common, most notably the elaborate embroidered roundels, which are typically Chinese.

Traditional museum thinking would place this statue firmly in the 'Oriental' section, near objects from China and Japan, which would fail to convey the strong cultural connections between the West and the Indian subcontinent during antiquity. Could the *Crossing Cultures, Crossing Time* approach deliver a means of displaying the sculpture to reveal its classical heritage as well as its relation to contemporary and later Indian art? It can and does, with a sequence of linked galleries exhibiting Greek, Roman, Gandharan as Indian figures of gods and humans.

The interlinking of gallery spaces and the carefully constructed views and vistas on and between floors are a powerful physical manifestation of the *Crossing Cultures, Crossing Time* theme. The whole building is conceived around strong visual axes with key objects, often visible at a distance, across several galleries. For example, the visitor can look through a window case of ceramics in the China gallery down to

East meets West ↻
East meets West ↻
Hellenistic and Roman
objects such as this
terracotta figurine (left)
made their way to India
from the time of
Alexander onwards.
And Graeco-Roman
stylistic influences are
evident in the classically
draped and posed
Gandharan Buddha
(right). The two
sculptures are a
continent and two
hundred years apart.

Model Boat ↻
*Egyptian, 9th-11th
Dynasty (about 2125-
1975 BC)
(AN1896-1908 E.2302)*

glazed tiles from the Islamic world and across to the
Ceramics gallery, where lustre-ware and majolica show
a different use of the same tin-glaze technology.

The thinking behind *Crossing Cultures, Crossing Time* —
stressing cultural connections and influences
rather than pointing out cultural differences —
has been in the mainstream of academic
discussion for the past quarter of a century.
What makes it unique at the Ashmolean is its
application to an entire museum. It has
governed the arrangement of the galleries on
each floor and joined together the Museum's
five departments. Through *Crossing Cultures,
Crossing Time*, visitors can experience our
collections, not simply in terms of great
civilisations that are independent and separate,
but as cultures that share a connected history that
stretches from Europe in the West, through the Near
East and Asia to the Far East, from ancient times until
the present day.

25

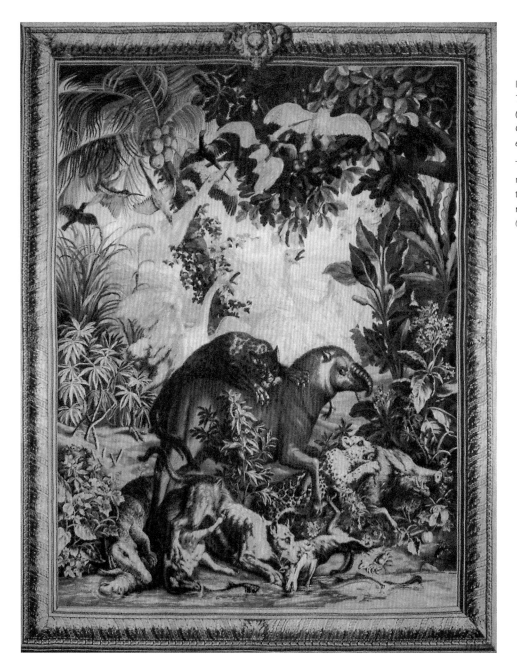

Figure of a camel ↻
*Tang Dynasty
(AD 618-906)
Ceramic, unglazed
earthenware*

This camel illustrates a
major method of
transport along the Silk
route.
(EA1956.988)

Combat des Animaux (Battle of the Animals) ↻
Gobelins, Paris, woven by Jean II Jans, about 1723

The tapestry comes from a set of eight, representing
the natural history of Brazil. These were based on
designs by Albert Eckhout (about 1610-1666), one of
several artists and scientists who accompanied Johan
Maurits, Count of Nassau, to Brazil in 1637. The border,
a simulated gilded frame, includes the arms of Louis
XIV. Eckhout's designs were woven at the Gobelins
factory in Paris into large tapestries from 1687 onwards.

This tapestry comes from a set of smaller designs, first
woven from 1723, and is signed by Jean II Jans (Jean Jans
the Younger), one of three weavers responsible for the
smaller sets. At one time it bore an inventory ticket of the
Emperor Chien Lung, dated 1771, and may have
belonged to a set which was apparently sold to the
Emperor of China in 1769. In 1861, it was looted from the
Emperor's summer palace and brought back to Europe.

*Presented by the residuary legatees of Lieutenant-General H.H.
Crealock, CB, CMG, in 1901. (WA1901.1)*

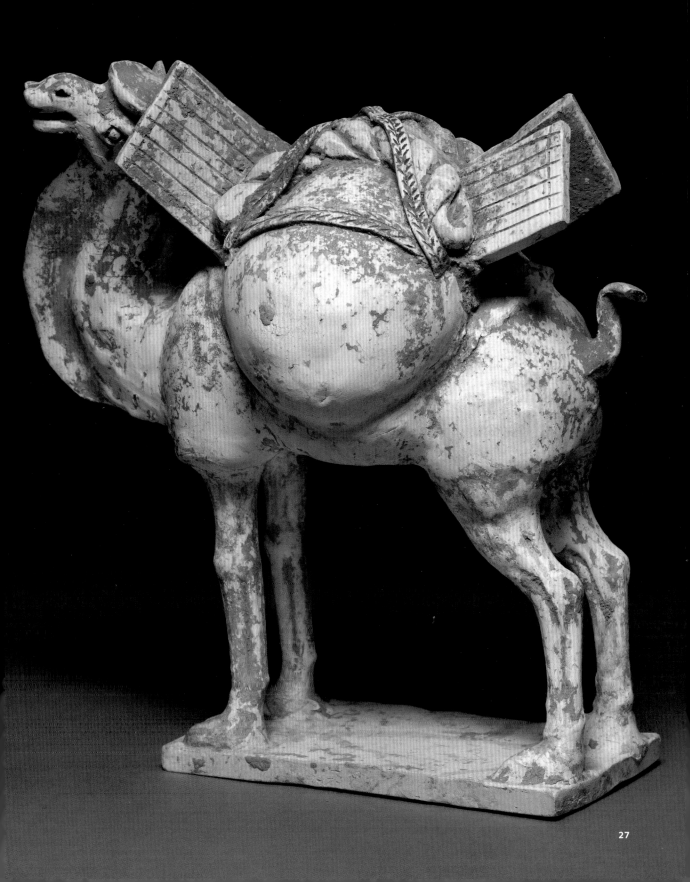

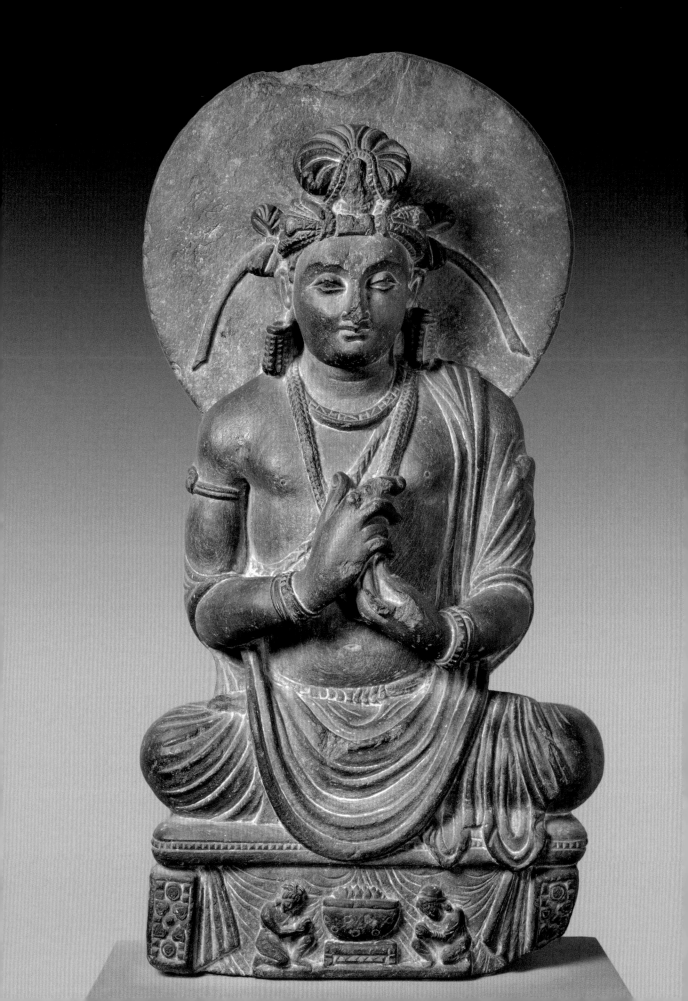

GALLERIES AND HIGHLIGHTS

Visitors come to the Ashmolean with widely different interests and levels of knowledge. A single theme, even one as broad in reach as *Crossing Cultures, Crossing Time*, should not mean a single approach. The collections themselves, from Worcester porcelain to Bronze Age horse decoration, demand different methods of display and interpretation. We have adopted a pragmatic approach, arranging the floors in broadly chronological order as the visitor ascends through the building, and creating galleries that suit the different character of the collections. For example, one entirely new development has been the creation within the early Japan gallery of a Tea House, built by Japanese craftsmen with the advice and support of a distinguished Tea Master, which will enable the visitor to understand the vital importance of tea utensils in Japanese culture far more effectively than the display of ceramics in a glass case.

Orientation galleries (*Asian Crossroads, West meets East, Ancient World* and *Exploring the Past*) make the *Crossing Cultures, Crossing Time* theme explicit on each floor. Examples of Eastern and Western art are often displayed side by side. Illustrated maps and timelines pick out the key dates and events. The galleries highlight a number of objects displayed on that floor that show the impact of cultural contacts.

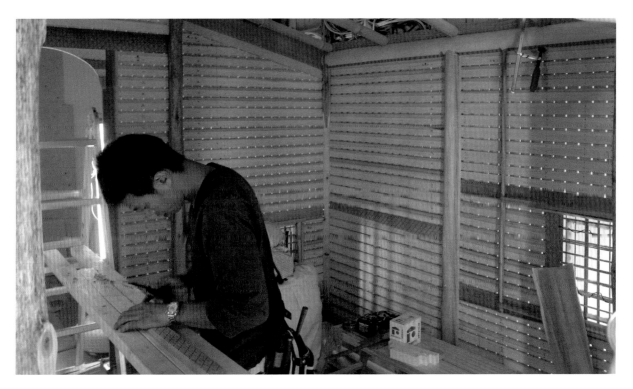

Most of the new Ashmolean galleries are specific to a particular era, region or civilisation, and their names have a familiar ring – *Rome 400BC-AD300, Greece, China 3000 BC to AD 800, Japan, European Prehistory, England 400-1600*. If visitors enter the museum wishing to see, for example, only our outstanding collection of Meiji Japanese art, they will make their way to the gallery of later Japan. However, the layout of the galleries makes it possible for other visitors to pursue a range of rich cultural contacts. Dutch art shares a floor with displays from China and Japan, and we can see evidence of the East-West trade in tea, coffee, tobacco and ceramics in almost every painting of a still life or domestic interior. Meanwhile, in the *Japan* gallery, we find caricatures of Dutch merchants drawn by Japanese artists. In the *Rome* gallery we discover that, across its vast multicultural empire, only a fraction of Roman citizens came from Italy or spoke Latin. A shared display between the *Aegean World* and *Ancient Near East* galleries shows examples of the trade in objects that brought those cultures into contact. While the key collections remain intact (enthusiasts can still find the 1,088 pieces of Worcester porcelain of the Marshall collection in one place) – it is the exploration of the cultural connections that link those collections that makes the new Ashmolean distinctive.

Thematic galleries such as *Money, Human Image, Reading & Writing (right, above)* and *Textiles* offer another way to explore the *Crossing Cultures, Crossing Time* theme by assembling objects from across the collections and covering great spans of time. The *Human Image* gallery looks at depictions of people in sculpture from the Neolithic period to the modern age, revealing fundamental differences as well as fundamental similarities in the approach of different cultures to the human form. The *Money* gallery considers the varied history of money, explaining its evolution from pre-coin money such as ingots and cowries into coins, paper money and the electronic currencies of today, and showing the ways in which coins and banknotes could be used both as symbols of power and as agents of political control.

Two galleries on the lower ground floor look at the practice and ethics of conservation. There are accounts of both scientific investigation and meticulous conservation in the *Conserving the Past* and *Restoring the Past (right, below)* galleries, but visitors are also asked to consider questions of ethics and artistic judgement. How far is it acceptable to take restoration before the fundamental nature of an object is changed? Should a repair carried out 200 years ago be covered up, or left in place as part of an object's history? Should we put the bright paint back on classical marble statues to show them as the Romans intended, or leave them white as the Victorians preferred? These questions, and the expertise to address them, are all part of what makes the new Ashmolean.

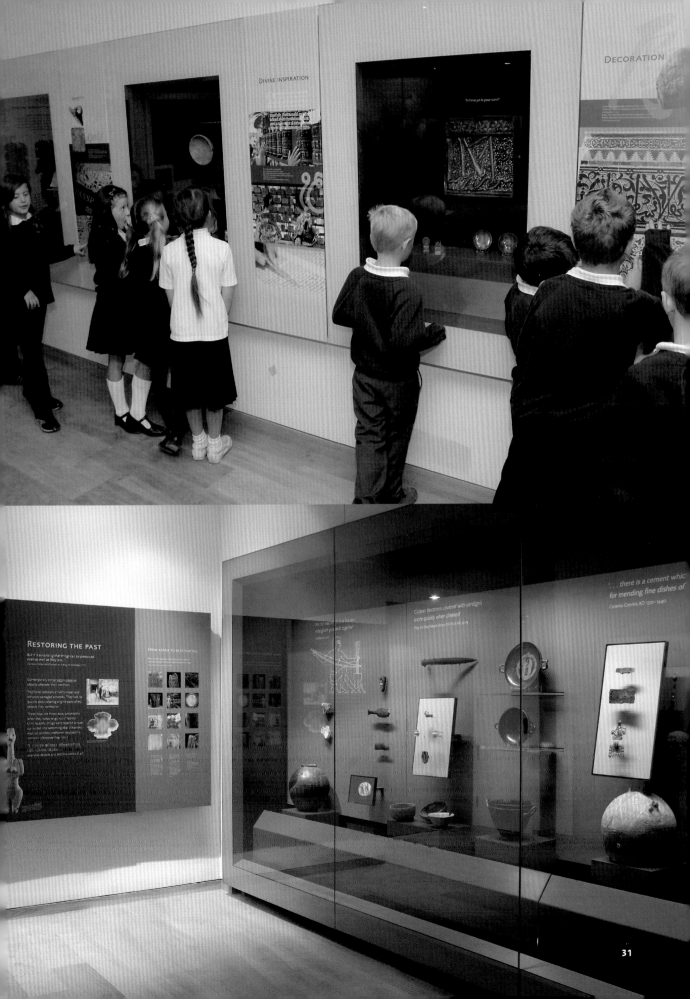

DIVINE INSPIRATION

DECORATION

Believe ye in your Lord?

RESTORING THE PAST

FROM REPAIR TO RESTORATION

'...there is a cement whic[h]
for mending fine dishes of
Cennino Cennini AD 1370 - 1440

'Copper becomes covered with verdigris
more quickly when cleaned'
Pliny the Elder (Natural History XX.XXv.ii) AD 23-79

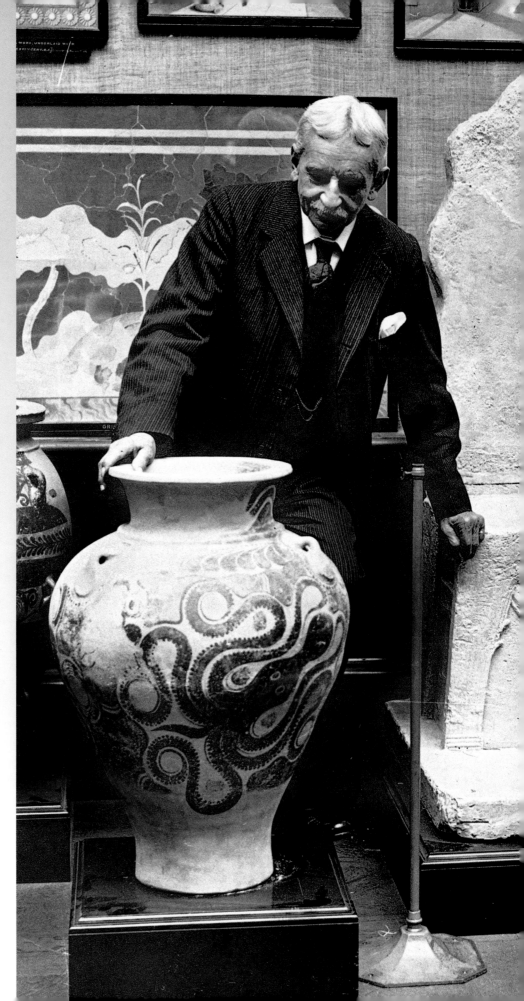

Sir Arthur Evans at the Minoan exhibition ⊃ which he organized at the Royal Academy, London, to celebrate the Golden Jubilee of the British School at Athens in 1936.

For more information on the octopus jar see p. 46.

Connections

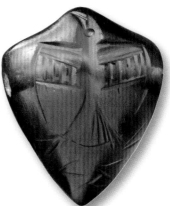

The Ashmolean collections are rich in objects reflecting cultural connections across distance and time. As visitors walk through the museum, they will see that a number of these have been highlighted.

Some of these *Connections* show how skills and technology are communicated. Some illustrate the ways in which contact between cultures creates new tastes and fashions. Others demonstrate the spread of ideas, religious belief and scientific knowledge. While some are well known, others are far less so, having spent years in store or displayed with little information. As part of *Crossing Cultures, Crossing Time*, curators looked again at their collections to select objects for their importance as agents of cultural change.

The Ashmolean has been a leader in Greek Bronze Age archaeology since the time of Arthur Evans, the excavator of Knossos. The Museum's collection of Aegean seals contains one amethyst gem, which was acquired by Evans in 1894. It clearly connects the Minoan world to a powerful neighbour to the south. It shows a bird of prey with outspread wings, but in this context it is not the skilful engraving of the Cretan craftsman that is significant but the material from which the seal is made. Amethyst is a semi-precious stone not found in the Aegean and it almost certainly came from Egypt. The seal, along with other imported materials found on the island, like hippopotamus ivory, agate and possibly cornelian, makes it clear that Minoan Crete had important links to the exchange networks of the Eastern Mediterranean.

Throughout the Museum there are many examples of raw materials travelling long distances to be used by other cultures. In the *European Prehistory* gallery, there are beads found at Hallstatt in Austria that are made of Baltic amber and glass spindle weights from Italy, proof of the dynamic trading connections between Central Europe and both the north and south of the continent in prehistoric times. More recently, trade brought exotic materials from the new world to the old.

A flying bird, amethyst seal ↺
Said to be from Knossos, 1700-1400 BC.
A.J. Evans gift, (AN1938.977)

Amber Spacer Bead ↻
Amber, 6cm x 3cm
Early Bronze Age,
Tumulus de Saint-Fiacre, Brittany, France

The amber is from the Baltic and is part of a grave group that includes other high status objects including a silver cup and a dagger with a hilt decorated with gold pins.
(AN1926.146)

Spindle whorl ↻
Early Iron Age (about 700-450 BC), Hallstatt, Austria
Glass, 2.5cm diameter

Glass was a very rare material in Europe at this time and was probably imported from Italy. Domestic objects are very rarely found made of glass during this period. A wooden spindle was also found at this site.
(Glass: AN1927.950 & spindle: AN1927.983)

Edward Dodd
(1705-1810)
Violin bow ↻
About 1775
Pernambuco wood and
ivory
Presented by Mr A. Phillips
Hill, in accordance with the
wishes of Arthur and Alfred
Hill in 1948.
(WA1948.145)

Oxford Plate ↻
Made in China for
export, about 1755.
Enamelled porcelain,
famille rose and gilt.

Chinese ceramics were
the height of fashion in
England in the 1700s.
People enjoyed East Asian
patterns, but they also
commissioned specific
European designs. This
plate shows the gate to
Oxford's Botanic Garden.
It is based on an
engraving published 1713
in Oxford.
Purchased with the help of
the Hulme Surplus Fund.
EA1985.10

In the *Music and Tapestry* gallery a violin bow made
from pernambuco wood connects Europe to Brazil,
where Portuguese merchants harvested the highly prized
timber and sent it back for use both as a red dye and in the
production of musical instruments.

Manufactured goods tell their own stories of cultural connection and interchange.
In the *West Meets East* gallery is a Chinese plate made in the ceramics centre of
Jingdezhen about 1760. It shows the gates of the Oxford Botanic Garden. A
draughtsman must have made a drawing in Oxford that was later engraved and the
engraving sent to China. There it was copied onto the plate, which was then
exported back to England as part of the large-scale trade in finished goods between
Europe and the Far East.

Our collections help us to understand how goods and raw materials travelled across
vast distances. The movement of people is harder to trace, but there are some
objects that help connect us to the travellers of the ancient world. In the *Reading and
Writing* gallery is a runestone that documents the connection between northern and
southern Europe. Found in Sweden, the stone bears an inscription that reads:
'Þorsteinn had the landmark made in memory of Sveinn, his father, and in
memory of Þórir, his brother. They were abroad in Greece. And in memory of
Ingiþóra, his mother. Œpir carved.' Possibly Sveinn, and Þórir were traders, or
mercenaries in the service of a foreign court. Whatever the reason for
their journey, the inscription is a poignant memorial to
Swedes who had travelled thousands of miles nine
hundred years ago, when such journeys were
difficult and dangerous – but more frequent
that we might at first imagine.

Rune stone ↷
Scandinavian, AD 1050-1100
Red sandstone (with modern colouring)

Formerly built into the wall of the churchyard at
Ed in Uppland, Sweden, and presented to the
Ashmolean by John Robinson, on behalf of
the Swedish King Karl XI, in 1687.

According to its runic inscription, this
monument was made in memory of two
Scandinavian soldiers who traveled to Greece
to serve in the imperial guard that protected the
Byzantine emperor. *(AN1997.2)*

The movement of materials, goods and people can cause ideas and designs to travel from one culture to another. The Ashmolean has the greatest collection of Chinese greenware outside China. One jar is strikingly different from the others. On display in the Early China gallery, it is tall and richly decorated with palmettes and floral devices. The designs are familiar from decorations on classical Mediterranean metalware but very rarely found on Chinese greenware. We must assume that the artist had seen a classical jar or bowl and adapted the decoration. In the same gallery a number of bronze incense burners from the Han period look strikingly similar to contemporary Roman lamps, illustrating the influence of the West, transmitted through trade and travel along the Silk Road. An even earlier bronze belt plaque from around the fifth century BC shows a lioness in a style and pose similar to the decoration on Luristan bronzes from west central Iran, a reminder of the connections between China and the Near East at that time.

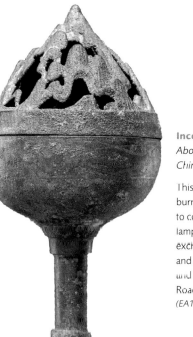

Incense burner ↶
About 200 BC–AD 100
China, Han Dynasty

This Chinese incense burner is strikingly similar to contemporary Roman lamps, illustrating the exchange between West and East through trade and travel along the Silk Road.
(EA1956.900)

Greenware jar ↷
About AD 550
China

Decorated with palmettes and other motifs that are familiar from ornament on classical Mediterranean metalware, but rarely found on Chinese objects of this period.
(EA1956.964)

Statuette of Heracles killing the Erymanthian boar ↻
About AD 50-150
Roman, Luna marble

This small-scale, marble version of a classical Greek bronze shows how the Romans adapted images of Greek gods and heroes like Heracles (Latin: Hercules). *(AN1928.529)*

The Roman Empire presents the prime example of cultural exchange as a result of conquest and settlement. From its origins, Rome was remarkably open to external influence. The Greek hero Heracles entered Roman mythology, as shown by the small marble statue of him in the Rome Gallery. In the same gallery is a tombstone of a doctor and his wife. Although the pair are entirely Roman in dress and pose, the accompanying inscription is in Greek and identifies them as Greek citizens of the vast multicultural empire of Rome. The Greek world was especially esteemed by the Romans for its advances in medicine.

Displayed in the Mediterranean World gallery is a superb collection of late Roman gold glass fragments found in the catacombs of Rome. They date from the decades after Constantine gave Christianity its legal status in AD 312, when different faiths were practised alongside one another in Rome. The glass fragments clearly show how the practice of remembering the dead by setting into the walls of their tombs elaborate gold glassware was shared by different faiths. Images showing the life of Christ are known, along with pagan images of Heracles and the seven-branched candelabrum, the menorah, which for three thousand years has been the symbol of Judaism.

Some objects vividly reveal the transfer of technologies across distance and time. In the Ceramics gallery there is a tin-glaze tile, manufactured around 1800 in Puebla, Mexico. It is an everyday object, chipped and missing one corner, decorated with a cartoonish image of a Chinaman. Yet the tin-glaze technique that created the tile

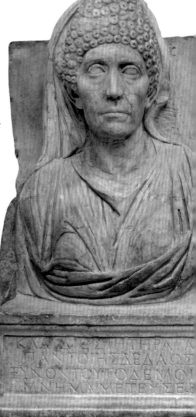

Tombstone of the doctor Claudius Agathemerus and his wife Myrtale ↻
About AD 100
Roman, marble

Although the pair are entirely Roman in dress, the inscription is in Greek and identifies them as Greek citizens of the vast multicultural empire of Rome. *(AN Michaelis 155)*

has its origins a thousand years earlier in eighth-century Iraq and the city of Basra, where blue painted ware was made in imitation of contemporary Chinese white porcelain. From there, the technique spread westwards through Islamic communities in North Africa. It was imported into Europe during the tenth century by Islamic craftsmen in Spain, where it was developed, most notably in the Hispano-Moresque lustre-wares of Andalucia. Once introduced into Europe, it began its journey to become one of the most important ceramic techniques of the modern age when it was transported from Spain to Italy to be used in maiolica in the fourteenth century in the production of French faience and Delftware. Finally our Mexican tile shows the transfer of the tin-glaze technique from the old world to the new through the trading networks established by Spain and her colonies.

Part of the base of a glass bowl decorated in gold leaf with a Jewish menorah ☾ (seven-branched candlestick)
About AD 350, Roman

Gold-glass scenes, made after Christianity was legalised in Rome, reveal pagan, Jewish and Christian imagery, showing that the different faiths were still practiced alongside one another.
(AN2007.6)

CONNECTIONS TODAY

The new Ashmolean has been an inspiration for those working on it and, we hope, for everyone who visits the museum. It has revealed new ways to look at collections and objects and highlighted a cast of traders, pilgrims, soldiers, explorers, administrators, artists and craftsmen whose business or belief, duty, curiosity or genius brought them into contact with other countries and cultures. Above all, the new Ashmolean challenges us all to consider and value the human history represented by our collections. It is a history that still profoundly affects our lives, from the food we eat, to the words we use, and, most importantly, to the ways in which we understand other cultures in our closely interconnected modern world.

Tile with a grotesque Chinaman ☽
About 1800
Mexico (Puebla)
Tin-glazed earthenware

This humble object, chipped and missing one corner, vividly illustrates the transfer of tin glaze technique from the old world to the new through the trading networks established by Spain and its colonies.
Presented by Sir Edmond Ovey, 1956 (WA1956.67.1)

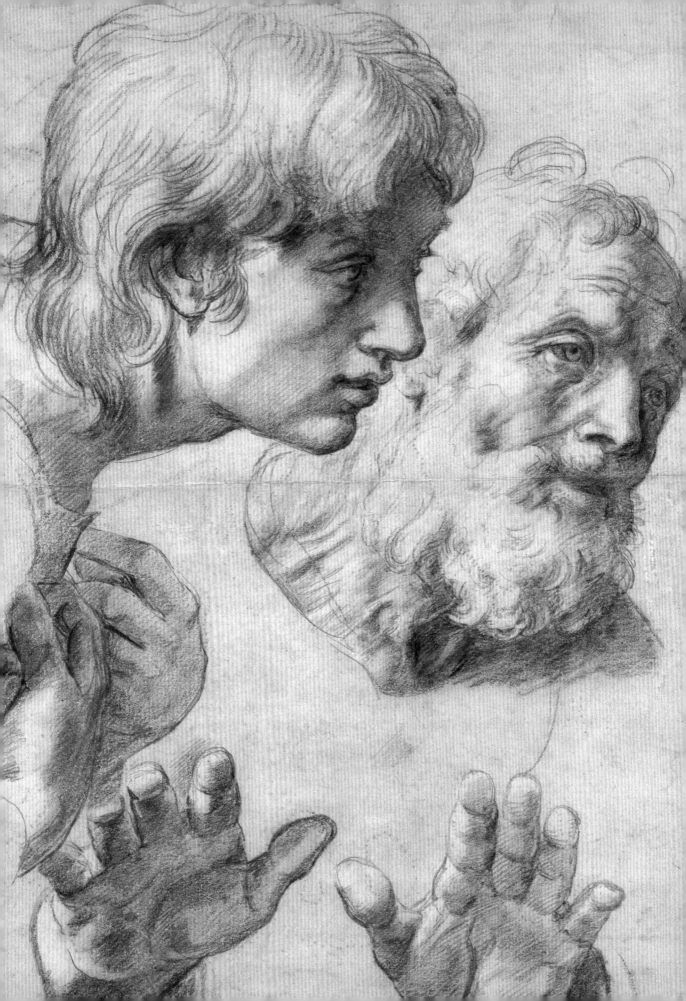

Treasures

The Ashmolean is the oldest museum in this country, with collections of unparalleled importance. It contains the greatest group of Pre-Dynastic Egyptian artefacts outside Cairo; the most outstanding collection of Minoan antiquities outside Heraklion; the world's largest holdings of drawings by Raphael and a major group of works by Michelangelo; as well as treasures from the Ancient Near East, prehistoric Europe, classical Greece and Rome, and Anglo-Saxon England. These are just a few of the enormous number of exhibits, every one of which has its own significance. This selection is a personal one, made from across the range of the Museum's rich and varied collections.

CONNECT

This label highlights objects that link different peoples, cultures and places around the world and through time. Many more of these can be found on display in the galleries.

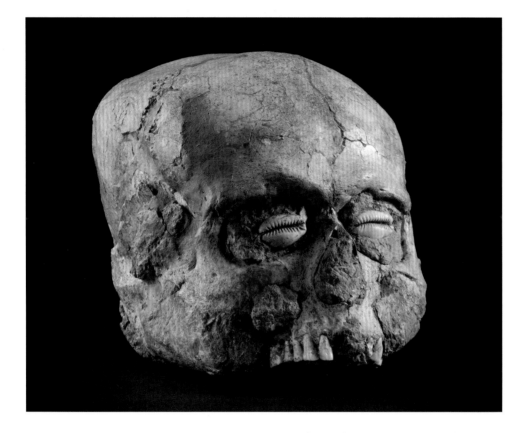

Skull with restored features ☾

Jericho, about 7000 BC
Palestinian National Authority

Originally plastered and painted, one of several human skulls from the site of a Neolithic settlement at Jericho, all with shells inset for the eyes – perhaps one of the earliest human attempts at portraiture. The flesh was built up from the skull in clay, as in modern forensic reconstructions. The skull was recovered from excavations by Dame Kathleen Kenyon (1906-1978).

Presented by Dame Kathleen Kenyon on behalf of the British School of Archaeology in Jerusalem, 1955. (AN1955.565)

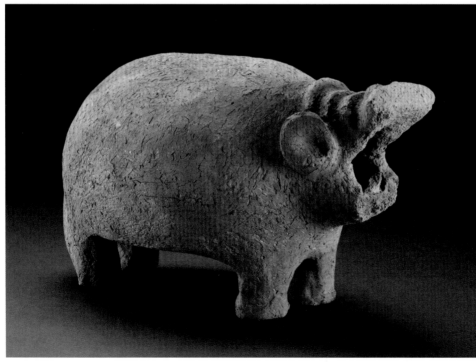

Hippopotamus figurine ☾

Pottery, Egyptian, about 3600-3500 BC, 27.3 cm long

Found in grave R134 at Hu (Upper Egypt), of Predynastic date. Hippopotami abounded in prehistoric Egypt, to judge by the many models that have survived. They were associated by the ancient Egyptians with the deity Taweret, protectress of babies and mothers in childbirth. Today they inhabit the river no further north than Khartoum.

Presented by the Egypt Exploration Fund, 1899. (AN1896-1908 E.3267)

Ceremonial palette ⟳

Siltstone, Egyptian, about 3300-3100 BC, 42.5 x 22 cm

Found in the 'Main Deposit' within the temple enclosure at Hierakonpolis in the Nile Valley, the palette, carved in low relief, is of Predynastic date. It is one of a collection of objects (including the 'Scorpion King' macehead, also in the Ashmolean) linked to legendary accounts of the period of transition from the prehistoric Egypt of local chieftains to the united kingdom under one ruler whose Upper Egyptian base may have been in the area of Hierakonpolis. Around the reservoir for grinding cosmetic paint wind the long necks of two fabulous feline creatures whose tongues lick a stumbling gazelle; hounds wearing collars pursue other gazelles below. Framing the upper half are the elongated bodies of two hyena.

Presented by the Egyptian Research Account, founded by Flinders Petrie in London, 1920 (AN1920-1900 E.3924)

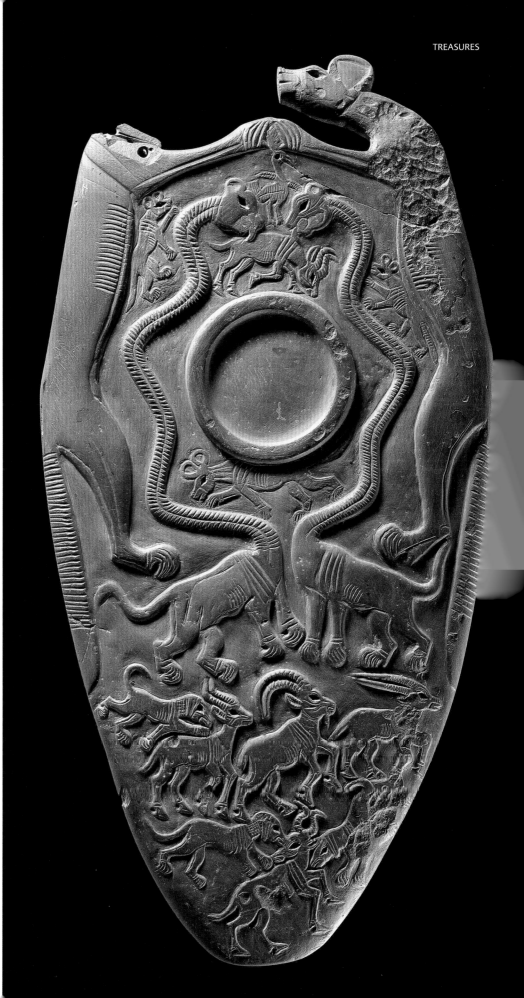

Burial urn ↻
Red earthenware, Chinese, about 3000 BC, 48.3 cm high

The pot was made by building up coils of clay which were pressed with a paddle to create a smooth surface. It was then decorated with red-and-black slip painted decoration. Red earthenwares are found at Neolithic sites in north-central and north-west China, and separate cultures may be identified by the different designs. In east China earthenwares are grey or black in colour, the result of firing them in kilns under oxygen-starved conditions.

Presented by Sir Herbert Ingram. (EA1956.847)

Female figurine with folded arms ↪
Marble, Cycladic, about 2800-2300 BC, 30 cm high

Said to be from a cist grave on Amorgos, Cyclades, Greece; a number of Cycladic figurines have been found in tombs on Amorgos, Naxos, Melos and other Cycladic islands of the Aegean. The extensive looting of Cycladic antiquities restricts a better understanding of the different uses and meanings of these figurines. Various interpretations have been put forward ranging from representations of gods and goddesses to ritual offerings and amulets. Modern appreciation of Cycladic art owes much to the interest shown in primitive art by such twentieth-century artists as Picasso (1881-1973) and Brancusi (1876-1957) who praised the simplicity and white form of Cycladic figurines. We now know that most, if not all, Cycladic figurines bore brightly painted facial characteristics and ornamentation. This particular figurine bears faint traces of facial characteristics such as eyes, eyebrows and hair or headdress.

(AN AE 178)

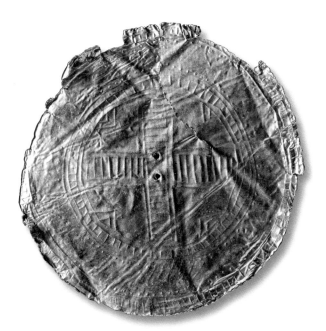

The Ballyshannon 'sun-disc' ☉
Sheet gold, Irish, about 2400-2100 BC, 5.5 cm diameter

'Sun discs', so called, form part of the common range of sheet gold-work typical of the British Early Bronze Age. They are frequently perforated, as here, and may have been sewn to clothing; another suggestion is that they may have formed button covers. Whether used in everyday, ritual or funerary contexts remains unknown. The simple form of ornament exhibited here – a cross motif surrounded by circles and geometric patterns – is typical: it is executed in *repoussé* technique, which it is to say that it is pushed into relief from the back.

The discovery of the disc is one of the earliest on record for a prehistoric artefact from the British Isles. The Ashmolean's 'Book of Benefactors' notes that it had been found by Dr Charles Hopkins in 1669, 'with the help of an ancient dirge chanted by an old Irish harpist, in which he sang of a strong man and his place of burial' at Ballyshannon, Donegal. It was later brought to wider public notice with its publication in Edmund Gibson's revised edition of Camden's *Britannia* (1695).

Presented by Dr Charles Hopkins.
(1696, AN AMS 9, 954 (NC 466))

Engraved sealstones
The use of seals as a means of authentication or identification, or simply decoration, goes back to at least 7000-6000. They constitute an invaluable repository of prehistoric and later imagery. Both stamp seals and cylindrical seals were usually made of metal, bone or stone, the latter often semi-precious gems. The Ashmolean has a formidably rich representation from the Aegean, Egypt, the ancient Near East, Greece and Italy.

Dolphins ☉
Steatite covered with gold foil
Minoan
From Palaikastro, Crete, Greece
1800-1450 BC, 1.75 cm long
(AN 1938.963)

Acrobats ☉
Chalcedony, Minoan
From near Knossos, Crete, Greece
1800-1450 BC, 2.15 x 1.8 cm
Presented by Sir Arthur Evans, 1938
(AN1938.955)

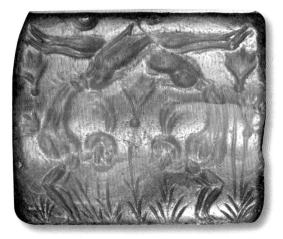

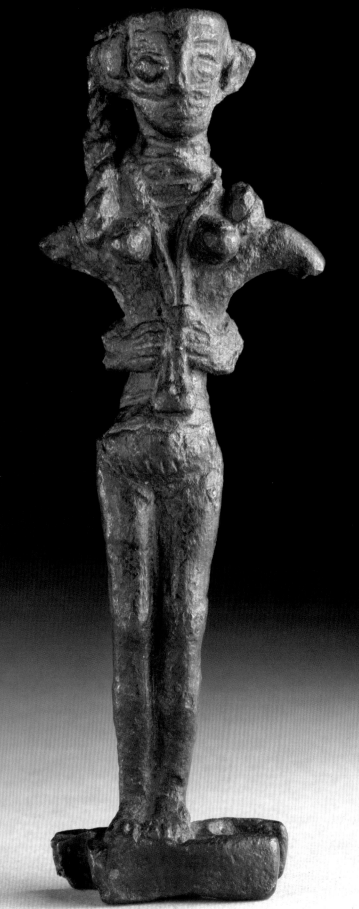

'Astarte' ☾

Bronze, Cypriot, about 1200-1050 BC, 9.9 cm high

With her prominent breasts and jewellery, this statuette of a naked woman standing on an 'oxhide' ingot seems to represent a fertility goddess. Towards the end of the period 2000-1000 BC religious activity increased substantially on the island of Cyprus and an association of the island's copper with the fertility deity becomes evident. Copper was Cyprus's main export at this time, shipped across the Mediterranean in the form of ingots shaped as the hides of the oxen that pulled the carts of ore from the mines. Each ingot represented about 29 kg of copper. Combined in this statuette with the ingot base, the goddess becomes the protector of the metal industry and its productivity. She may be related to the Ancient Near Eastern fertility deity Astarte, and is often referred to as Astarte-on-the-Ingot.

Acquired from the Bomford Collection, 1971. (AN 1971.888)

'Sumerian King List' prism ↺

Clay, Sumerian, from Larsa, Southern Iraq, about 1800 BC, 20 x 9 cm.

Cuneiform script written in the Sumerian language runs in two columns on each of the four sides of this prism. It lists Sumerian and Akkadian rulers of southern Iraq from the 'creation of kingship' in a mythical past to king Sin-magir of Isin (around 1800 BC). A wooden spindle originally went through the centre, perhaps so it could be rotated and read on all four sides. The text evokes the biblical story of the Flood as well as the genealogies in Genesis 5 and 11.

Presented by Herbert Weld-Blundell, 1923. (AN1923.444)

45

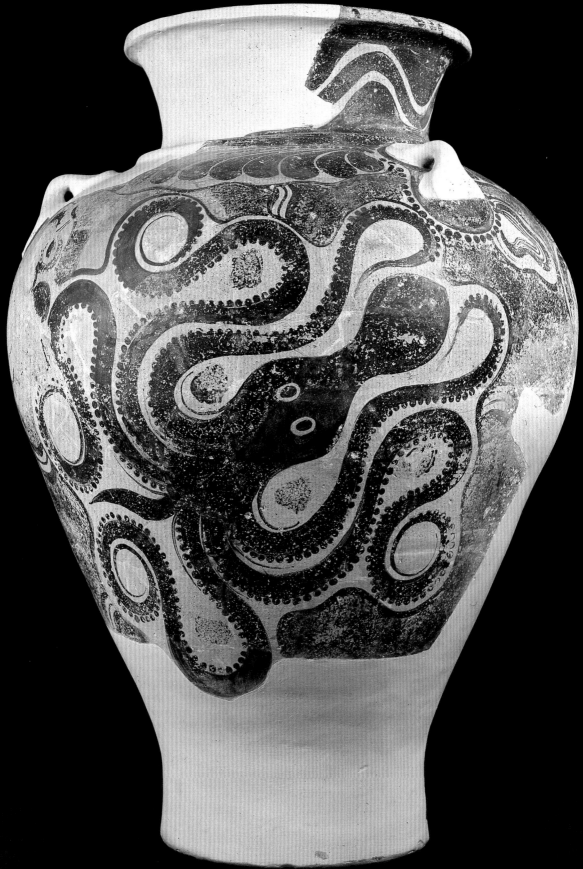

Storage jar (pithos) with octopus design ☾

Clay, Minoan, 1450-1400 BC, 74.5 cm high

The Minoan collection is one of the most important groups of material in the Ashmolean. It was largely formed from the excavations of Sir Arthur Evans in the 'Palace of Minos' at Knossos, Crete, Greece. Evans, Keeper of the Ashmolean Museum from 1884 to 1908, conducted excavations at this site between 1900 and 1931. His work at Knossos, brought to light the largest palace site in the Aegean. The objects were given to him by successive Cretan and Greek governments in recognition of his work. One of the most characteristic decorative motifs employed in Minoan Crete were sea creatures and marine plants. This pithos is decorated with a sinister but stately six-tentacled octopus. A murex shell is visible in the top left part in this view. Murex shells were the source of the purple dye that was highly prized throughout antiquity.

Presented by Sir Arthur Evans. (AN1911.608)

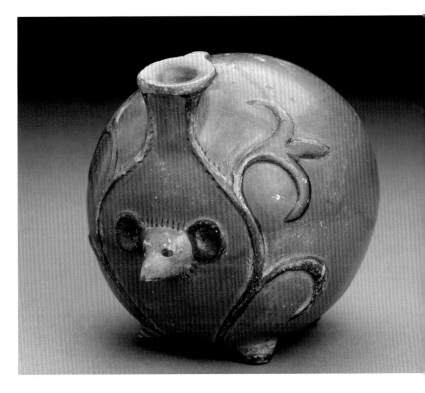

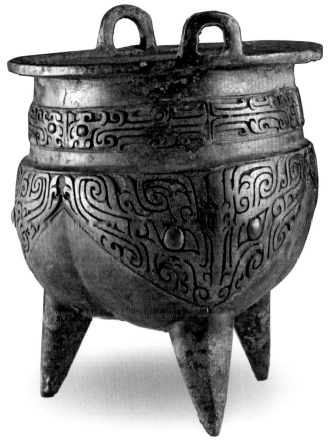

Hedgehog vase ☝

Red pottery, Egyptian, about 1479-1425 BC, 7.4 cm high

A somewhat abstract version of an animal usually treated with great realism in faïence or pottery; a stylised tree in relief forms arabesques over the creature's rump, and behind the spout is a tiny handle. From tomb D11 at Abydos (Upper Egypt), 18th dynasty, reign of Tuthmosis III.

Presented by the Egypt Exploration Fund, 1908. (AN1896-1908 E.2775)

Bronze vessel ☾

Bronze, Chinese, about 1400-1200 BC, 19.7 cm high

This ritual bronze vessel was used for food offerings and probably borrows its form from a cooking utensil. It was an item of tomb furniture from the early Shang dynasty and was made using clay moulds, a casting technique unique to China in the Ancient World and more expensive in labour and materials than beating, for example. The decoration is a version of a monster mask, with prominent eyes and scrolling horns. The motif has been known since the 1100s as a *taotie*. Its significance remains mysterious.

Presented by Sir Herbert Ingram, 1956. (EA1956.855)

Linear B tablet ⊃

Burnt clay, Minoan / Mycenaean, 1375 BC, 10.5 x 10.7 cm

The Ashmolean houses the largest collection of Aegean scripts outside Greece. Arthur Evans went to Crete in search of clues for the existence of pre-alphabetic writing in the Aegean. His travels, research and excavations at Knossos brought to light three different systems of writing: Cretan Hieroglyphic, Linear A and Linear B. This incomplete page-shaped Linear B tablet is from the Palace at Knossos, Crete, Greece. With 14 rows and minute handwriting, it lists women workers. The name is followed by the sign that stands for 'woman' in Linear B, and a number. Sometimes check marks (X) appear before or after the number. Some women's names are followed by kowa (girl[s]) and ko-wo (boy[s]), probably their children. There is evidence from other tablets to suggest that the women mentioned here may have been associated with the textile industry and the processing of wool. Lists of personnel are known from several tablets and provide insights into the centralised palatial administration of the major Aegean centres.

Presented by Sir Arthur Evans. (AN1910.218)

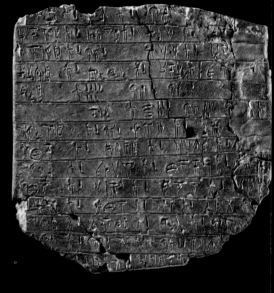

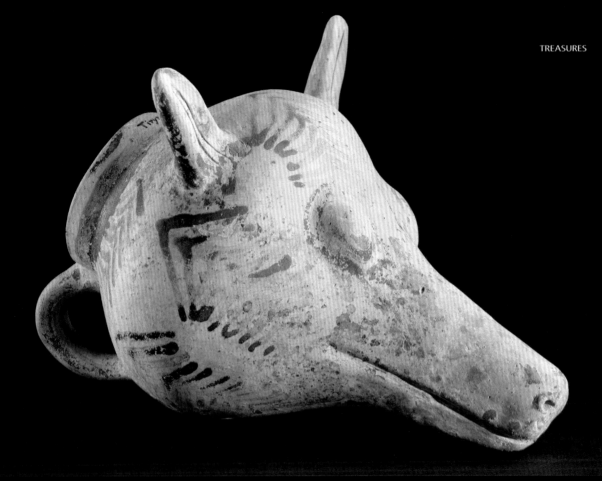

Vessel in the form of a humped-backed bull (zebu) ↻
Baked clay, Iranian, about 1350-1000, 39 cm long

From Gilan in north-west Iran. The potters of ancient Iran (like the local metalworkers, also well represented in the Ashmolean) were particularly fond of animal designs, whether painted on pottery or in free-modelled vessels of this kind, which were placed in graves in considerable numbers in the Early Iron Age. When first discovered in the 1950s they proved so attractive that numerous copies were made by modern potters. This one has been authenticated by thermoluminescence dating.

(AN1964.347)

Fox rhyton ↺
Baked clay, Mycenaean, 1300-1190 BC, 16.8 cm long

Said to be from Tiryns, mainland Greece; a *rhyton* is a libation vessel in domestic or religious use for pouring liquids. Animal-headed *rhyta* (for example bull, lion, pig and ram) form the most elaborate versions. Here the wine, or any other liquid substance, would have come out of the hole in the fox's mouth. *Rhyta* were made of various materials such as silver, alabaster, serpentine and clay. Animal-headed *rhyta* made of precious metals are depicted in Egyptian tombs among the 'diplomatic gifts' offered by the people of 'Keftiu' (possibly the land of Crete) to Egyptian high officials. The muzzle and one ear of this fox *rhyton* are restored.

Presented by Sir Arthur Evans. (ANAE 298)

ThThe daughters of Akhenaten and Nefertiti ↶↷

Painted plaster, Egyptian, about 1345-1335 BC, 40 x 165 cm

This fragmentary scene is the lower part of a painting of the royal family in a domestic setting that once decorated a room in Tell el-'Amarna (ancient Akhetaten), the new capital city of the Pharaoh Akhenaten (late 18th dynasty, about 1353-1335 BC).

Two younger daughters, Neferure and Neferneferuaten, are perched on cushions at the feet of their mother, the red sash of whose dress falls obliquely behind them. Between her feet and those of their father, seated on a stool at the right, are the legs of the three elder daughters; the sixth, baby Setepenre, probably sat on her mother's lap. This is one of the many scenes of the private life of the royal family that are such a distinctive feature of the unorthodox art of the Amarna period. Excavated by Flinders Petrie; other fragments of the scene are in the Petrie Museum, University College London and the Manchester Museum.

Presented by W.M.F. Petrie and H. Martyn Kennard, 1893. (AN1893.1-41 (267))

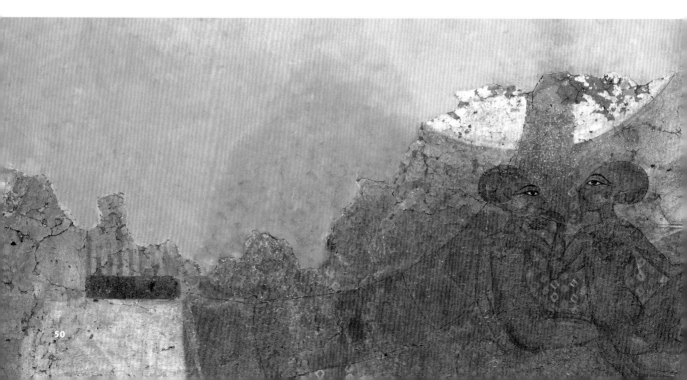

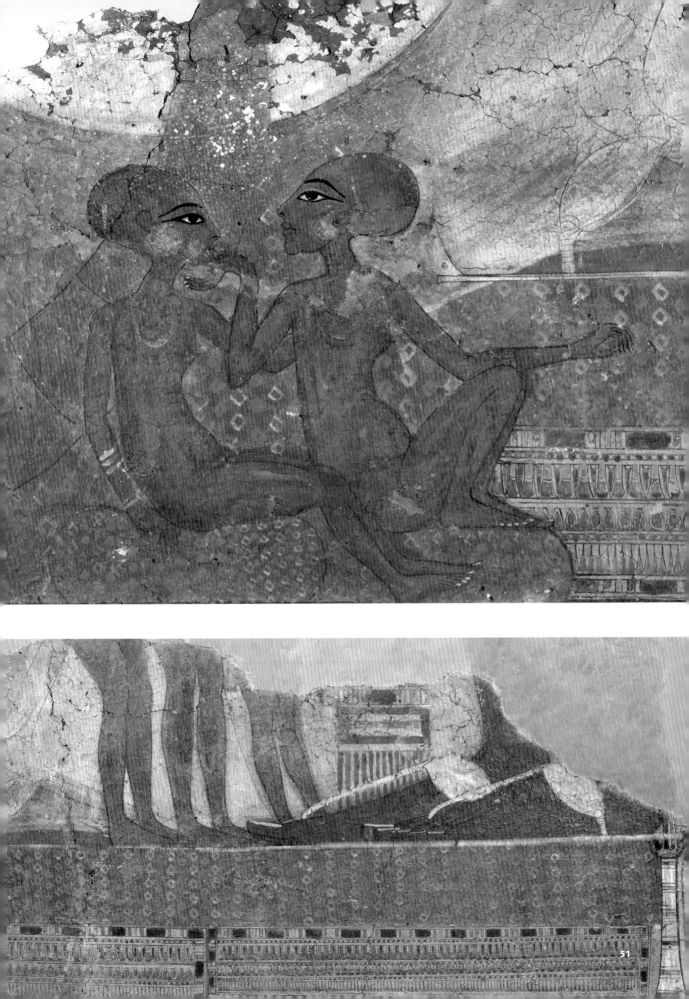

Statue of a scribe and priest of the god Thoth ⊙

Limestone, Egyptian, 1292-1190 BC, 31.5 cm high

The figure wears a priestly leopard skin over his pleated linen tunic and carries on his shoulders a baboon, sacred animal of Thoth, the god of writing, who serves as the gods' own scribe. In his right hand the man holds a softly folded object, perhaps a bag of writing equipment. Three columns of hieroglyphic inscription on the back of the statue invoke a funerary offering of Thoth for the scribe, who served in his temple at Hermopolis (Middle Egypt); his name is unfortunately lost with the lower part of the statue. From Ashmunein (ancient Hermopolis), dating from the New Kingdom, 19th dynasty.

Acquired in 1961, with the aid of The Art Fund. (AN1961.536)

Ritual vessel or gui ⊙

Bronze, Chinese, about 1050-771 BC, 22.7 cm high

In the Western Zhou dynasty bronze vessels were used not only ritually to honour ancestors but also, by means of inscriptions, to commemorate military or political success. A six-character inscription cast into the interior of this vessel associates it with the state of Yong, now part of Henan province in north China. The decoration is restrained and the mounting on a square pedestal base indicates the importance of the piece.

Purchased with aid from The Art Fund, the MLA/V&A Purchase Grant Fund and the Friends of the Ashmolean. (EA1996.15)

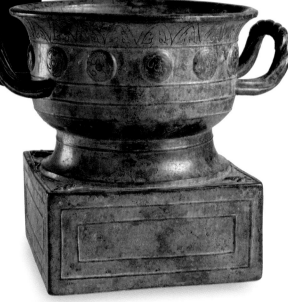

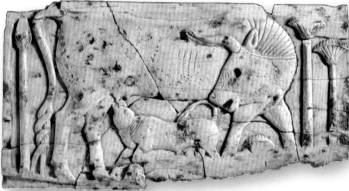

CONNECT

Decorative plaque with relief of a cow and calf among papyrus plants ⊙

Ivory, Levantine, about 850-700 BC, 12.6 x 6.6 cm

The plaque was made as inlay for a piece of wooden furniture, taken as booty or tribute to the Assyrian king in whose storehouse at Nimrud, in northern Iraq, it was found by modern excavators. The subject, symbolising fertility, was a favourite theme of the period.

Presented by the British School of Archaeology in Iraq, (AN1962.602)

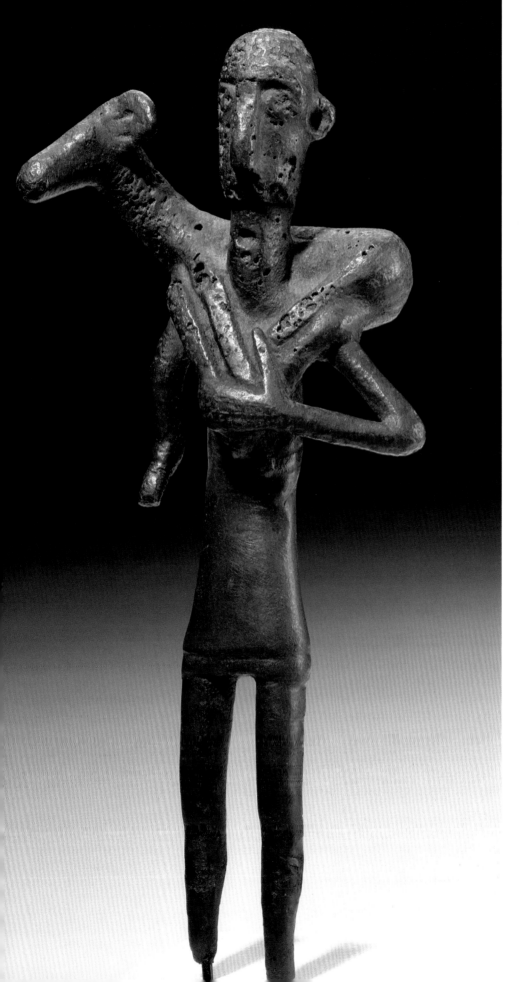

Statuette of a worshipper carrying a ram ☾
Bronze, Sardinian, about 750 BC, 17.5 cm high

The figure is characteristic in style and subject of the Nuraghic culture of Sardinia, which flourished from between about 1600 and 100 BC Unusually, the man is not dressed as a shepherd but wears a warrior's tunic.

Presented by Sir Arthur Evans. (AN1840.24)

Statuette of a warrior ↻

Bronze, Italian, about 450 BC, 28 cm high

Such figures attest to flourishing schools of Etruscan bronze-working in Umbria, central Italy, in the fifth century BC. They illustrate a gradual stylisation by local craft workers of classical Greek forms. This one, in threatening stance, obviously held in his hand a spear (now missing).

Presented by C.D.E. Fortnum, 1888. (Fortnum B.6)

Barrel jug ↺

Clay, Cypriot, about 700-600 BC, 30 cm high

This is an outstanding example of Cypriot craftsmanship in orientalising style. The elaborate combination of intricate geometric pattern with representational figure drawing, presented so boldly on an otherwise largely unworked surface, has come to be known as 'free field' style.

Bought in Larnaca, Cyprus, 1885. (AN1885.366)

The 'Shoemaker pot' ↻
Clay, Greek, about 500-400 BC, 40 cm high

This pottery vessel, from Athens, was found in Rhodes. Most Greek pots show scenes of aristocratic life, but the Ashmolean's collection is peculiarly rich in scenes of men and women at work – potters in their workshop, an armourer, a furniture-carrier, women winding wool or here a shoemaker. Most pieces were acquired when the Arts and Craft movement was at its height. Here we see a shoemaker cutting a piece of leather round the foot of a customer. There is a rack of tools above his head. The customer is bearded, and therefore not a child. The painter has shown him on a smaller scale to make him fit into the picture

Bought 1905. (AN G. 247)

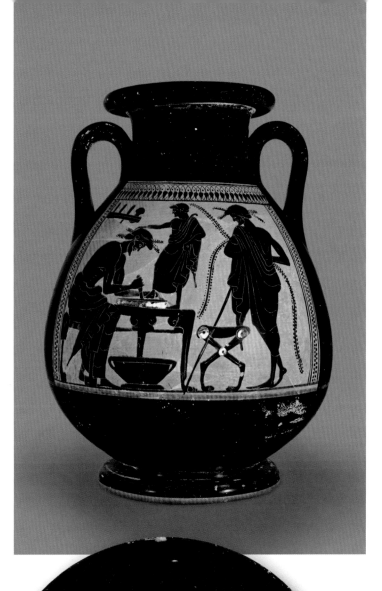

Painted pottery cup ↻
Clay, Greek, about 500-400 BC , 12.8 cm diameter

Attic red figure, found in an Etruscan tomb at Chiusi, Italy. Work and play are combined: a boy carries a plate of food covered with a napkin in one hand, and trundles a hoop along with the other. This is a masterpiece of composition, designed to harmonise with the circular frame. Greek painting was an important source for the development of Western European art, but the large murals that once adorned great monuments have vanished. Some slight indication of the style and subject matter that informed them is offered by the very extensive survival of Greek pottery, itself based on work in precious metal. Many scholars have been involved in building up the impressively representative collection in the Ashmolean, most famously Sir John Beazley (1885-1970), Lincoln Professor of Classical Archaeology and Art in Oxford – a great analyst of the development of Greek painting and the styles of the individual painters, and benefactor of the Ashmolean.

Presented by Sir Arthur Evans, 1886. (AN 1886.587)

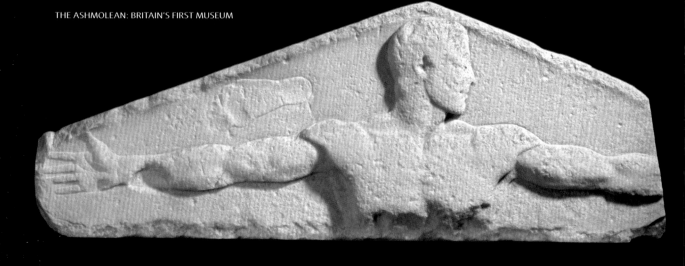

Metrological relief ↻
Marble, Greek, about 450 BC, 173 x 62 x 10 cm

The relief was acquired somewhere in the Aegean by William Petty, Lord Arundel's agent, in 1625. It shows the upper part of a man with his arms outstretched. The relief is clearly concerned with measurement, and the pedimental shape suggests that it once stood over the porch of a public weights and measures office. Various dimensions are described (a foot, an ell, fist, finger), and what were once dismissed as puzzling discrepancies can now be seen to belong to different classification values, or variants belonging to a logical, elegant and integrated system based on divisions of the Earth's surface at different points on the longitudinal meridian. Thus, for example, the foot in relief measures 29.42 cm, while the proportional foot of the 4-cubit measurement represented by the outstretched arms is 34.33 cm, a 7 to 6 ratio with the shorter foot.

Arundel Collection, presented by the Dowager Countess of Pomfret in 1755. (AN Michaelis 83)

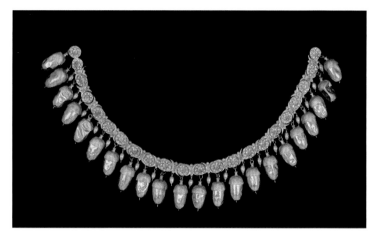

Necklace and bracelets ↺
Gold, about 400 BC, 31 cm long (necklace); gold on bronze, 8.5 cm diameter (bracelets)

Found at Nymphaeum in the Crimea, made in the fifth century BC. There are few more exquisite pieces of jewellery from the classical period than this necklace. Twenty-two rosettes with acorns suspended from them are alternated with stylised lotuses which support small beads. Each rosette and lotus has another, much smaller, rosette attached to it. All these elements are made of sheet gold edged with beaded gold wire. Originally they were decorated with coloured enamel. The acorns are very realistically made; where the striated cups are joined to the smooth glands the junction is cleverly disguised. The grave in which they were found exceptionally contained a silver cup, as well as a bronze wine-strainer.

Acquired in 1885, Presented by Sir William Siemens. (AN 1885.482) necklace; (AN 1885.479) bracelets

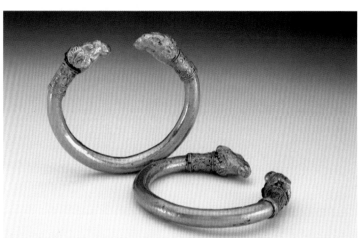

Mug and beaker ↻↺

Silver, Thracian, about 400 BC, 9 cm and 11.5 cm high

In the spring of 1879 a cemetery in the village of
Dalboki, some miles east of Stara Zagora in north-central
Bulgaria, was being cleared for military purpose and an
important Thracian burial of the late fifth century BC
came to light. Its rich contents included an electrum
pectoral, silver drinking vessels, imported Greek pottery
and bronze armour.

*Presented by the Seven Pillars of Wisdom Trust in memory of
T.E. Lawrence in 1948. (AN 1948.104) mug; (AN 1948.102) beaker*

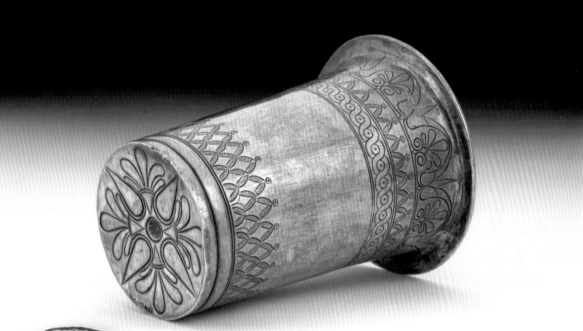

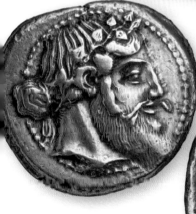

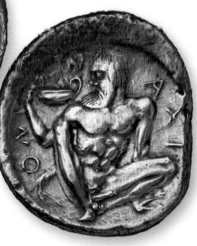

Head of Dionysus/Silenus ↺

Silver, Greek, about 460 BC, 2.9 cm diameter

Naxos in Sicily was a centre of viticulture; this silver
tetradrachm coin celebrates the fact with a finely
engraved head of the wine-god Dionysus wearing an
ivy-wreath, and a drunken figure of Silenus gazing at
his cup.

The treatment of the foreshortened leg has no parallel
in Greek die engraving. Hieron, the tyrant of Syracuse,
had destroyed Naxos and moved its people to Leontini.
This spectacular coin, for which only one set of dies was
cut, may commemorate the subsequent return of the
people of Naxos to their own city.

(HCR5264)

57

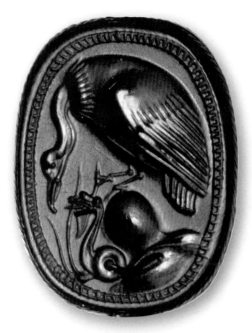

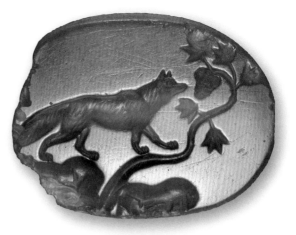

Sealstone: fox and grapes ↻

Chalcedony, Greek, about 500-400 BC, 1.6 x 2.1 cm

Late fifth century BC from Trikka in Thessaly, Greece.

Bequeathed by G.J. Chester. (AN 1892.1494)

Scarab: a vulture threatens a coiled snake ○

Cornelian, Etruscan, about 500-400 BC, 1.4 x 1 cm

There was a thriving school of gem-engraving in Etruria, where scarabs carved in the shape of beetles (on the Egyptian model) were favoured.

(AN 1965.347)

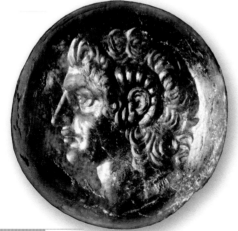

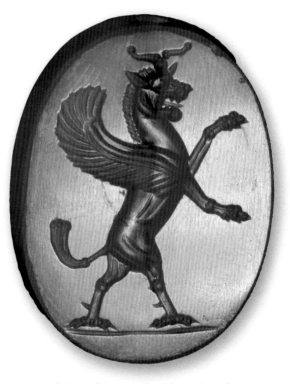

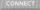
CONNECT

Sealstone: portrait of Alexander the Great ○

Tourmaline, Greek, 2.5 cm diameter

This late 4th-century sealstone is a very early and very fine portrait of Alexander wearing the horns of the god Zeus Ammon. The seal was perhaps made in an eastern area of his vast empire.

Bought in Beirut and bequeathed by G.J. Chester, 1892. (AN 1892.1499)

Sealstone decorated with a winged, horned lion ○

Chalcedony, Graeco-Persian, about 400 BC, 2.7 x 2 cm

From Grave V at Nymphaeum in the Crimea, fifth or fourth century BC. An Achaemenid (imperial Persian) mythological beast, typical of Greek craft products for Persian clients.

(AN 1885.491)

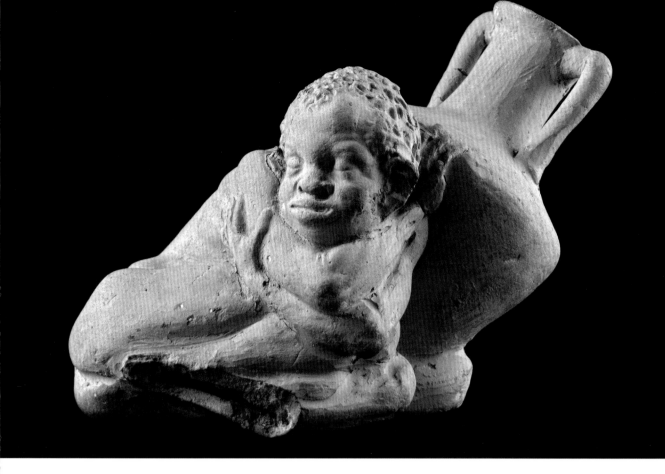

Figure of an African boy asleep ⟳
Terracotta, Greek, about 350-325 BC, 6.3 cm high

A miniature masterpiece of Hellenistic Greek craft skills in a naturalistic style typical of the region of Tarentum (modern Taranto, southern Italy). The boy, possibly a slave, is curled up asleep at the base of a wine jar, perhaps exhausted, perhaps happily drunk.

Presented by Sir Arthur Evans, 1884. (AN 1884.583)

Head of Alexander / Athena ⟲
Silver, Greek, 280 BC, 3 cm diameter

Among the portraits of Alexander the Great that survive from antiquity, those on Greek coins provide some of the earliest and most interesting examples. Portraits of Alexander were not used on coinage during his lifetime, but do appear on the coinage of a few of his successors, including this silver tetradrachm from the reign of Lysimachus. For them the invocation of the image of Alexander represented a powerful claim to legitimacy. Alexander is depicted wearing a diadem, the white headband that became a symbol of kingship from the time of Alexander, and the ram's horns of Zeus Ammon. Alexander had visited the oracle at Siwa in Egypt in 331 BC, and was there proclaimed to be the son of Zeus Ammon.

(HCR6279)

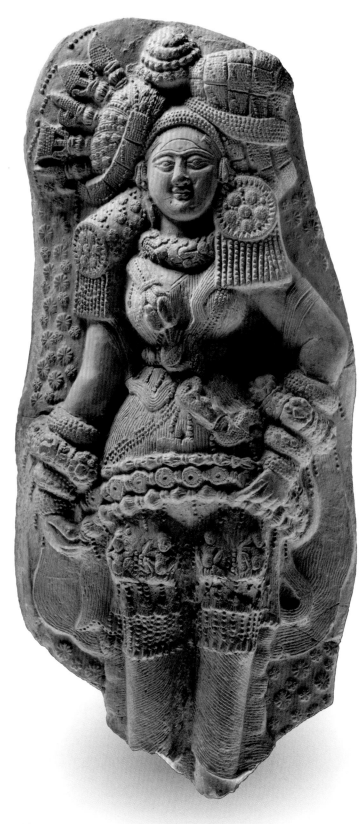

Standing goddess ⟲
Terracotta, Indian, about 200 BC, 21 cm high

Terracotta has been an important sculptural medium in the Indian subcontinent for five thousand years. Around 200 BC to AD 200, a remarkable flowering of terracotta art took place in several regions, including Bengal. One of the most common types is the moulded plaque with a relief figure of an elaborately adorned standing female – a goddess, a *yakshi* (nature spirit) or an *apsaras* (heavenly nymph) – wearing the accoutrements of a royal lady. Discovered in 1883 in a riverbank at Tamluk (the ancient port of Tamralipti), this famous plaque of a goddess with voluminous headdress, massive ear ornaments and heavy bracelets, belts and necklaces is the finest and best preserved example of its type to survive.

Acquired in the 1880s for the former Indian Institute Museum. (EAX.201)

Torso from a statue ⟳
Marble, Roman, about 100 BC, 104 cm high

A good Roman version of a Greek original of 500-400 BC. The elder Pliny, the Roman encyclopaedist, tells the story of a competition in ancient Greece for a statue of the Amazon for the Temple of Artemis at Ephesus. The artists involved (who included Phidias, Polyclitus and Cresilas) had to choose the winning statue. This proved to be the Amazon that 'each artist had placed second to his own', namely the one made by Polyclitus. The Ashmolean's Amazon may well relate to such a project. It is one of the dozens of pieces of antique sculpture and inscriptions from the Arundel Collection, formed in the early seventeenth century by Thomas Howard, 2nd Earl of Arundel, the pioneer collector in England of works of art from classical antiquity. They were kept at Arundel House, long since demolished, just south of the Strand in London. A first group came thence to Oxford at the instigation of John Evelyn (1620-1706, the diarist) in 1667; a further large group was given by Louisa, Dowager Countess of Pomfret, in 1757 (including this Amazon); a few other items followed at different times. Arundel's collection was assembled for him by agents active in Italy, Greece and the eastern Aegean. The nucleus preserved in Oxford, though very variable in quality, has great importance for the history of collecting in England and of taste.

(Michaelis 24)

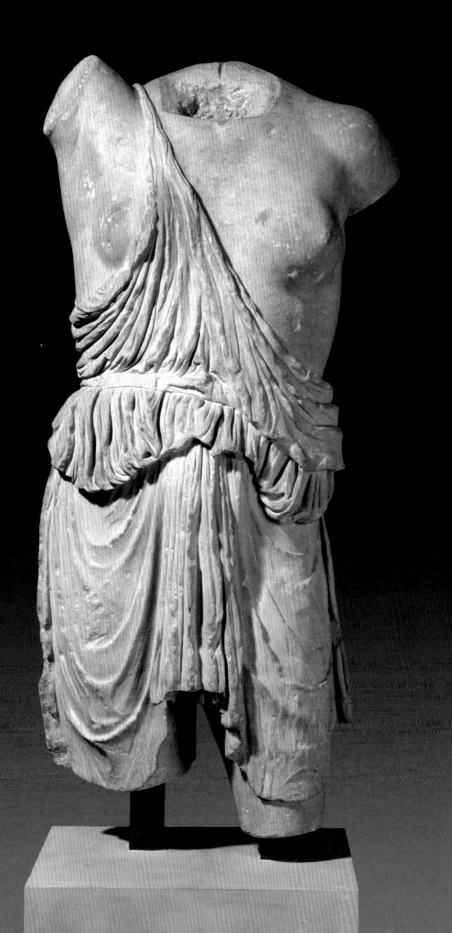

Augustus of Prima Porta ⟳

*Plaster cast, modern after Roman original,
about 15 BC, 219 cm high*

A portrait statue of Augustus, the first emperor of
Rome (31 BC -AD 14). The marble original in the
Vatican (inv. 2290) was found in the Villa of Livia at
Prima Porta near Rome. Augustus stands in a
classical pose and stretches out his right arm in a
gesture of address, as if talking to the crowds of
Rome or his legions. He wears a cuirass and
paludamentum – the outfit of a Roman general. The
statue support carved in the form of Eros riding a
dolphin brings to mind the goddess Aphrodite, from
whom Augustus's Julian family claimed to be
descended. In the centre of the relief the decorated
cuirass shows a historical scene from shortly after
20 BC of a Parthian returning the military standards,
lost by the Romans in 53 BC, to a Roman legionary.
Above is the personified sky Caelus embracing
Helios, the rising sun, as he pushes away Aurora and
Luna (the dawn and the moon). On either side of the
central group are personifications of conquered
peoples, below them on the right side of the cuirass
is Apollo on a griffin and on the left Diana riding a
stag. Below is Tellus, the personification of mother
Earth, with a horn of plenty. The Roman army, and
indirectly the emperor as its leader, is placed in the
centre of the composition and thereby in the centre
of the world. Remains of paint preserved on the
surface of the marble indicate that the statue was
once richly painted, specifically with blue for details
of the cuirass and leather straps, red for the mantle
and tunic, and brown for the hair.

*Purchased in 1910 from the workshop of M. Gherardi in
Rome. (Cast Gallery inv. B161)*

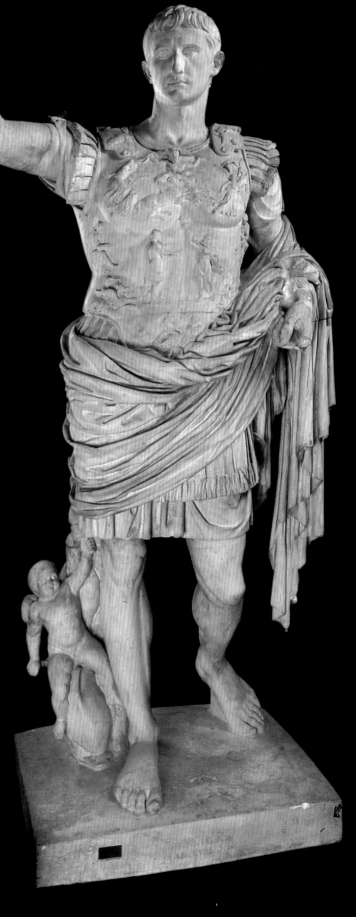

Tiberius / Temple of Concordia (AD 14-37) ⊃
Brass, Roman, about AD 35-36, 3.7 cm diameter

The practice of putting buildings on coins was essentially a Roman innovation. In a general sense this is a reflection of the Roman preoccupation with building. More particularly the representation of monuments on coins may have been suggested by the Roman view of their coins as monuments in their own right. This spectacular Roman brass sestertius depiction of the Temple of Concordia is particularly notable for its array of statuary, which gives a good impression of the web of imagery associated with Roman temples.

(HCR4832)

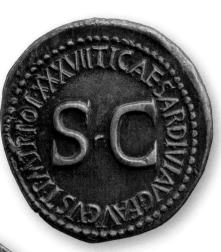

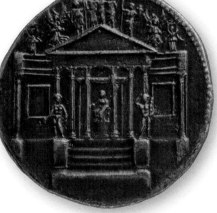

Head of Nero / Roma (AD 54-68) ⊃
Brass, Roman, about AD 65, 3.5 cm diameter

The head of the Roman emperor Nero on this brass sestertius coin is one of the finest numismatic portraits in the collection. The sophisticated treatment of the hair reflects the elegance of Nero's court. The high quality of the coinage of Nero suggests the artistic standards of the emperor himself. His famous last words were 'What an artist dies in me.' The coin was struck not long after the great fire at Rome, at a time when the city was being rebuilt in spectacular fashion. The personification of Roma on the reverse may be considered as symbolic of the new city.

(HCR4837)

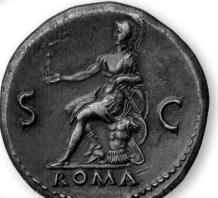

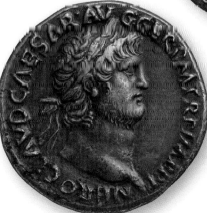

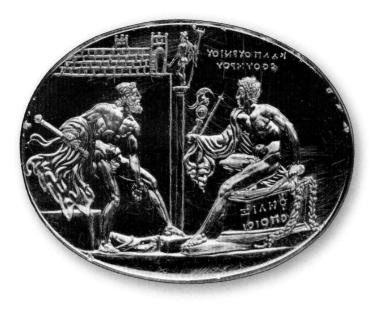

'The Felix Gem' ☞

Cornelian, Roman, about AD 1-50, 2.6 x 3.5 cm

Ulysses remonstrates with Diomedes for killing a temple guard before seizing the Palladium (an image of Troy's patron goddess, which the Greeks had to capture to be able to conquer Troy). The story of the Palladium is told by Virgil in the *Aeneid*, the epic tale of the foundation of Rome by the exiled Trojan prince Aeneas. The gem, signed in Greek by the gem-cutter Felix, was made for Cornelius Severus, otherwise unknown but perhaps a member of the Roman imperial court. Previous owners of this very famous piece include Pope Paul II, the Gonzaga family, the Earl of Arundel, Sir Arthur Evans and Captain E.G. Spencer-Churchill.

Acquired with the aid of the Victoria and Albert Museum Purchase Grant Fund. (AN1966.1808)

Statuette of a lar ☞

Bronze, Roman, about AD 70, 21.5 cm high

The god of the home and family is shown dancing forward, his tunic awhirl with the vigour of his movements. With one hand he holds up an ibex-headed drinking-horn (*rhyton*) from which he pours an offering into the dish (*patera*) held out in the other hand. On his head is a wreath of laurel or myrtle leaves. The eyes are enhanced with silver, as are the fastenings at the shoulders and the boot buttons, and strips of silver are let into the surface of his tunic. This is the right-hand example of a pair that would once have flanked a Roman household altar, the *lararium*. Many such altars, some complete with their figures, have been found at Pompeii. The image of the dancing lar became popular in the time of the first emperor, Augustus.

Given by the Friends of the Ashmolean, through the generosity of Mr James Bomford. (AN1970.1065)

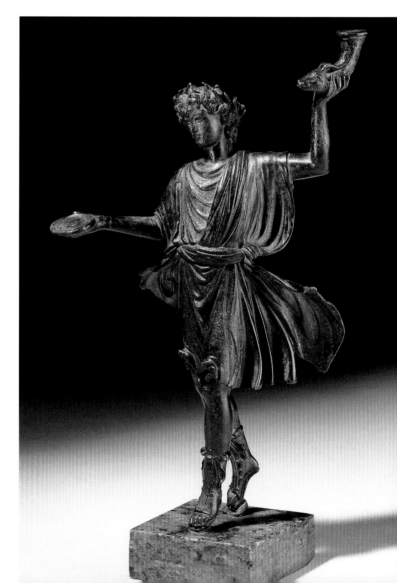

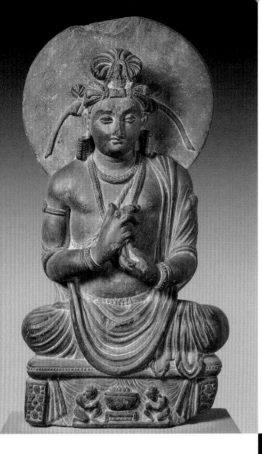

Seated bodhisattva ☾
Grey schist, Gandharan, about AD 150-250, 56 cm high

Found near Hoti Mardan, Gandhara (part of which is now in Pakistan, and part in Afghanistan), this image probably adorned a large stupa (the dome-shaped monument characteristic of early Buddhism). The dress is such as a prince of the region would have worn. Iconography and pose belong to the Indian tradition, the ritual pose of hands signifying preaching – in this case the Buddhist *dharma* or law. The style however bears the clear stamp of Graeco-Roman influence. The halo is of Middle Eastern origin, and the two narrow bands that extend from the turban have been interpreted as derivations from the knotted ends of the Greek diadem.

Presented by Mrs Gooding, before 1914. (EAOS.24)

The Buddha ↺
Grey schist, Gandharan, about AD 200, 95 cm high

The Buddha (d. 483 BC) was first depicted from around AD 0-100, when separate sculptural traditions developed at Mathura, south of Delhi, and in the region of Gandhara (north-west Pakistan). Though Indian in iconography, Gandhara images show a strong Graeco-Roman stylistic influence. In this commanding image of a standing Buddha, the rhythmical modelling of the folds of the robe, which follow the contours of the body, is in the Roman tradition, while the head distantly recalls the Grecian Apollo type. The refined carving of the Buddha's face – with its curving brow-line, subtle transitions of planes and almond-shaped eyes half-closed in meditation – conveys a conscious serenity that is wholly Indian.

Barlow Gift. (EAOS. 26)

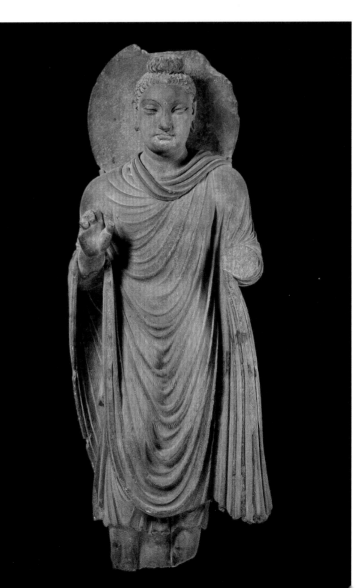

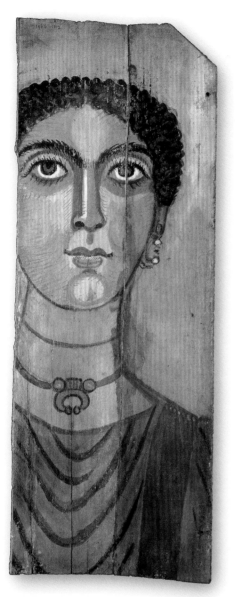
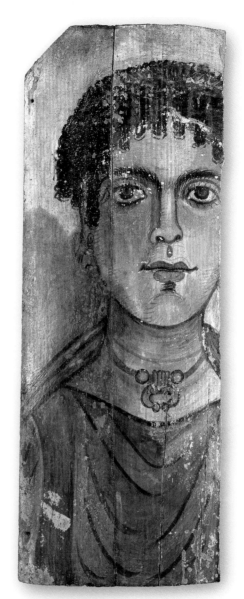

Double-sided mummy portrait ☙

Encaustic paint on wood, Egyptian, about AD 100-130, 38 x 14.8 cm

The use of a painted portrait of the deceased to replace the impersonal mummy-mask of Egyptian funerary tradition was an introduction of the Roman period. This example is unusual in being double sided; its former owner, Sir John Beazley, thought that the plain woman on the reverse side might be the elder sister of the pretty one on the front, but the similarity of facial features and jewellery suggests that they are the same woman, depicted in formal and informal dress.

Presented by Sir John Beazley. (AN 1966.1112)

Silver cup ☙

Sheet silver, partly gilded. Roman, about AD 50-150, 10.5 cm high

The cup is decorated with olive branches and was originally brightly polished. It has an inner liner and an outer casing with a junction skilfully made at the rim. The hollow foot is separately made. The gilding of the interior is unusual in silver vessels known in the West (whose survival pattern is patchy), and the gilder may have been influenced by central Asian or even Chinese work. Objects like this cup rarely survive, partly because they are so delicate, and partly because they were often melted down, the metal recycled for other purposes.

Acquired with the aid of The Art Fund, Resource / the Victoria and Albert Museum Purchase Grant Fund and the Friends of the Ashmolean. (AN 2003.1)

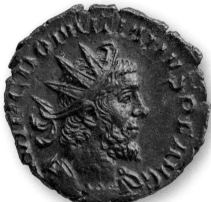

Domitianus / Concordia ↻
Base silver coin, Roman, about AD 271, 2 cm diameter

This remarkable coin provides definitive proof that a man named Domitianus claimed to be emperor in the early 270s. It was discovered in April 2003 by Brian Malin, a long-standing friend of the Ashmolean's Heberden Coin Room, on farmland near Chalgrove, less than ten miles from Oxford. The coin was fused in a mass of nearly five thousand superficially similar coins in a largely intact Roman jar. Domitianus's bid for power is unlikely to have lasted more than a few days, but he caught the popular imagination when news of the find was released in February 2004. The story was covered on 25 February on the front page of *The Times*, which gave it a nationalistic spin ('Is this Britain's lost emperor?'), and *Private Eye* had a delightful parody on Britain's lost leader, 'Duncansmithonius'.

Purchased in 2005 with the aid of generous grants from The Art Fund, the Headley Trust for Treasure, the V&A/MLA Purchase Grant Fund, the Carl and Eileen Subak Family Foundation and the Friends of the Ashmolean. (HCR6264)

CONNECT

The Wint Hill bowl ↻
Greenish glass, Roman, about AD 350, 19 cm diameter, 5 cm deep

The bowl is believed to have been made at Cologne about the middle of the fourth century AD, but was found in 1956 in excavations at a Roman site at Wint Hill, Somerset. This example is engraved and painted on the outer surface, but was intended to be viewed from the inside. A horseman and two hounds drive a hare into a net. Around the edge is inscribed *VIVASCVMTVISPIEZ* in Latin characters, meaning 'Long life to you; drink, and good health'. Presumably it was intended as a drinking vessel. The decoration links it to other examples with hunting, mythological and Christian scenes whose distribution is centred in the Rhineland.

Purchased with the aid of The Art Fund. (AN 1957.186)

Chandragupta II / goddess of prosperity ☾
Gold dinara, Indian, about AD 380-414, 2cm diameter

The Gupta kings showed themselves on their gold coins
in various roles. Here Chandragupta II is dramatically
recorded as slaying a lion. Hunting was a royal privilege
and its depiction connotes bravery and power
as well as the ideals of kingship. The inscriptions are in
chaste Sanskrit language in keeping with the 'classical'
paradigms of the Gupta period.

(HCR6769)

Head of a Roman Emperor ☽
Porphyry, Roman, c. AD 350-400, 21.5 cm

This fragmentary head of a diademed figure represents
a youthful emperor of the fourth century AD. The choke
of purple stone and the jeweled diadem clearly signal
imperial status. The face, which appears to have been
severely pockmarked, has been smoothed and polished
in post-antique times. At this period the empire was
divided into eastern and western sectors, with capitals
at Constantinople and Rome. The head is an
outstanding example of porphyry sculpture, of which
authentic examples are rare.

Acquired in 1994. (AN1994.58)

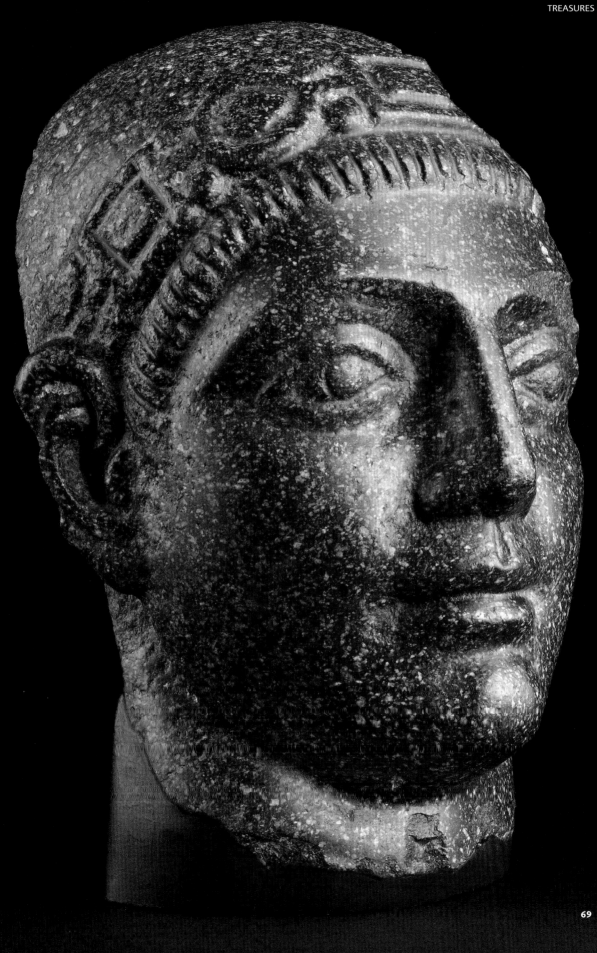

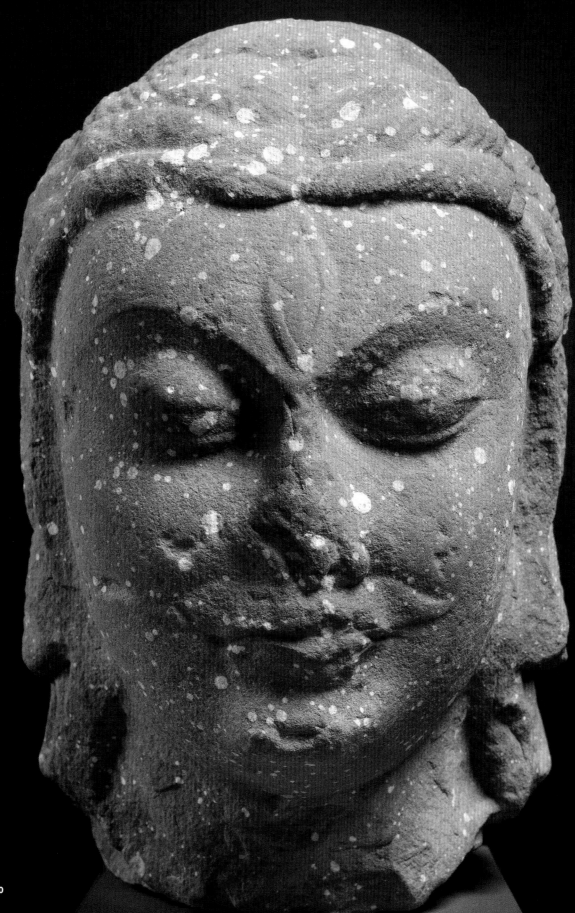

Head of Shiva ↺

Red sandstone, Indian, about AD 400, 30.5 cm high

This powerful head of Shiva is a superb example of the classical Gupta style of north Indian sculpture, probably from Mathura, Uttar Pradesh. One of the two most important Hindu deities (with Vishnu), Shiva is shown with the matted locks of the ascetic, his eyes half-closed in yogic meditation, the lips half-smiling in compassion and detachment. Set centrally in the forehead is his third eye of divine insight, also the seat of his wrathful fire of destruction. It is uncertain whether this head originally belonged to a full-length figure or formed part of a *mukha-linga*, the primordial phallic icon of the god.

Acquired in 1939 with the help of Mr and Mrs H.N. Spalding and The Art Fund. (EAOS.38)

Jar ↻

Ceramic, Chinese, about AD 550-599, 38.3cm high

This green ware jar is of a rare type, unusual for its massive proportions and the style of the ornament. For the first hundred years AD Western ornamental motifs were increasingly used in the decoration of Chinese architecture and artefacts; the half-palmettes applied to this vessel derive ultimately from the classical Mediterranean. Green glazes – the colour results from iron fired in a kiln without oxygen – were developed as early as 1400 BC and are particularly associated with east China.

Presented by Sir Herbert Ingram. (EA1956.964)

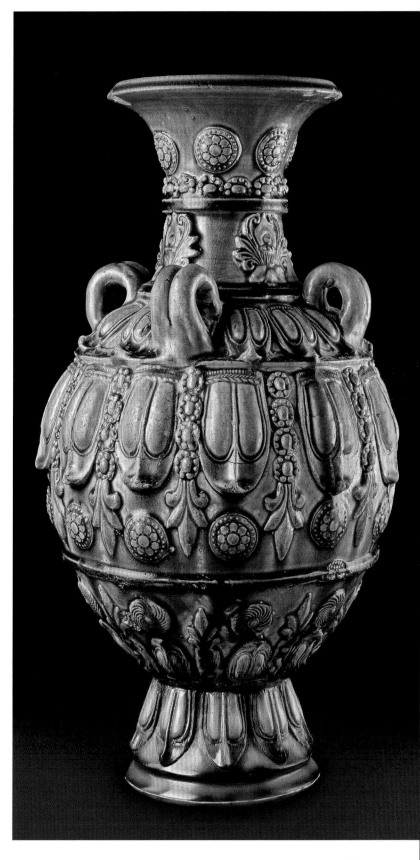

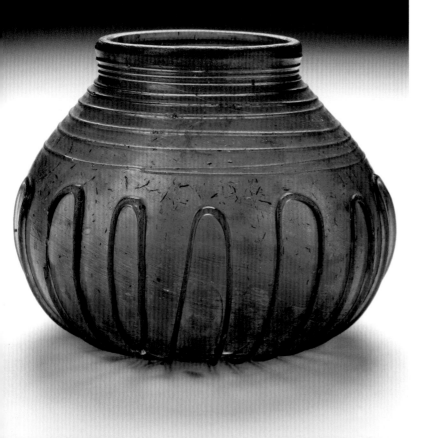

The Cuddesdon bowl ☉

Glass, Anglo-Saxon, about AD 600, 11.5 cm diameter

Of brilliant blue glass with fine trailed decoration, the bowl is probably Kentish. It was found in a grave at Cuddesdon, Oxfordshire, in 1847, with another (less complete) vessel, a bronze pail and jewelled bronze fittings from a lyre – all the sort of accoutrements buried with Anglo-Saxons of noble rank. The bowl came to light during the building of a palace for the bishop of Oxford, then Samuel Wilberforce (1805-1873); it passed into his possession and was eventually sold with the contents of his house and lost from view. It turned up again in 1971 holding primroses on a mantelpiece in Northamptonshire and was recognised by the keen eye of a passing archaeologist.

Purchased in 1977 with the aid of grants from The Art Fund, the Victoria and Albert Museum Purchase Grant Fund and the Friends of the Ashmolean. (AN 1980.269)

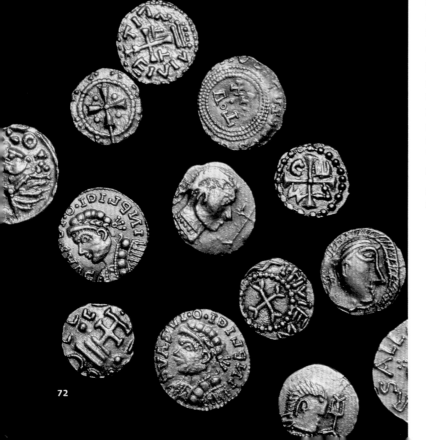

Selection from the Crondall hoard ☉

Gold thrymsas, Anglo-Saxon, about AD 640, 1.2 cm diameter

This hoard was discovered in 1828 in Crondall, Hampshire. It remains the most important body of evidence for early Anglo-Saxon coinage, marking the reintroduction of coinage into Britain two centuries after the abandonment of the province by the Romans. The new coinage was modelled on that of Merovingian Gaul, but also looked back to Rome for inspiration. These gold coins may have been the earliest English shillings.

Hoard purchased for the Ashmolean in 1944 as a memorial to Sir Arthur Evans. (HCR4915)

Horse ↻

Earthenware with traces of unfired pigments, Chinese, about AD 750, 35.7 cm high

This horse is a fine example of the many models of horses, camels, mythical beasts and human figures that were made for burial in the Tang dynasty. Their purpose was to protect or accompany the tomb occupant in the afterlife, and their forms provide an informative reflection of Tang life. For example models of camels or foreigners demonstrate the cosmopolitan nature of life in the capital and its debt to the Silk Road, while human figures document styles of dress. The figures were made in moulds, with the parts assembled together using dilute clay slip in a process known as luting. This type of horse, in life larger than the native Chinese pony and highly valued, was an import from Ferghana (present-day Uzbekistan).

Presented by Sir Herbert Ingram. (EA1956.1063)

'Standing caliph' ↻

Gold dinar, Syrian, AD 696-697, 2cm diameter

Minted at Damascus, the coin depicts the Caliph 'Abd al-malik ibn Marwan (AD 685-705). The designs evolved from the Byzantine gold coinage of the period. Note how the cross-on-steps common on Byzantine coins has been modified to transform the Christian symbol, which would have been inappropriate on an Islamic coin.

(HCR6573)

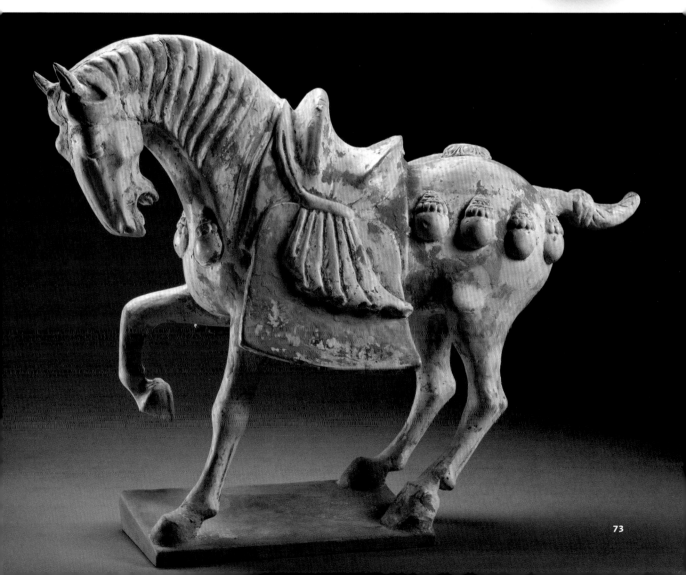

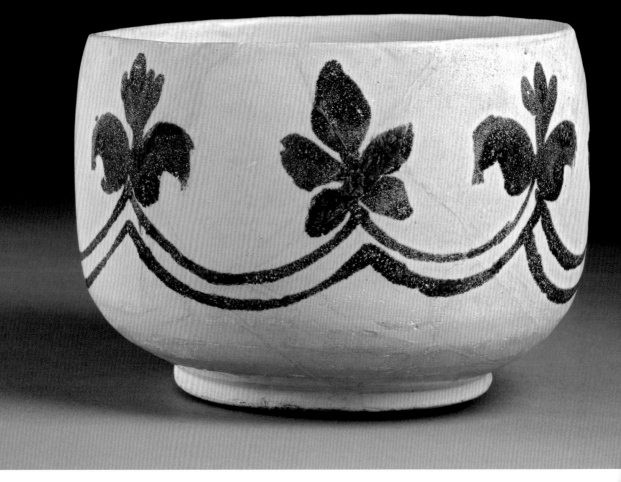

Bowl with vegetal decoration ⌒
Earthenware, with painting in blue on an opaque white glaze, Abbasid Iraq, AD 800s, 13 cm diameter

Islamic potters initially developed the opaque white tin glaze as a response to Chinese high-fired white ware, which had been imported in the Middle East since the late AD 700s. They soon understood the potential of the white surface and began to paint on it with colours – cobalt blue and manganese brown, with occasional splashes of copper green. This technology of painting with metallic oxides on a white glaze opacified with tin oxide quickly spread across the Islamic world and around the Mediterranean. In later centuries it was adopted in Spain and Italy, and spread north throughout Europe, where under the names Hispano-Moresque, maiolica, faience and delftware it provided Europe with colourful tablewares until the 1700s. As early as around 850AD cobalt blue was successfully used in the Middle East as a ceramic pigment painted on a white ground. Some five centuries later, at the beginning of the 1300s, it was with cobalt imported from the Middle East that China began its enormous production of blue-and-white porcelain whose massive export dominated world ceramics for centuries.

Gift of Gerald Reitlinger Gift. (EA1978.2137)

Circular ceiling slab with eight warrior figures ↻

Sandstone, Indian, about AD 750-850, 76 cm diameter

Slabs carved in high relief were commonly used as ceiling decoration in the temples of western India and the Deccan. This slab is probably from north-eastern Gujarat or southern Rajasthan. Here eight armed warriors, their feet intertwined, radiate from a centre like the spokes of a wheel; each brandishes a sword. These figures may represent *vidyadharas* ('bearers of knowledge'), magical beings of the air who wield the sword of knowledge that cuts through ignorance. There are no other identifying features except for low reliefs of flames on the ground.

Acquired in 1985, with a grant from the Victoria and Albert Museum Purchase Grant Fund. (EA1985.5)

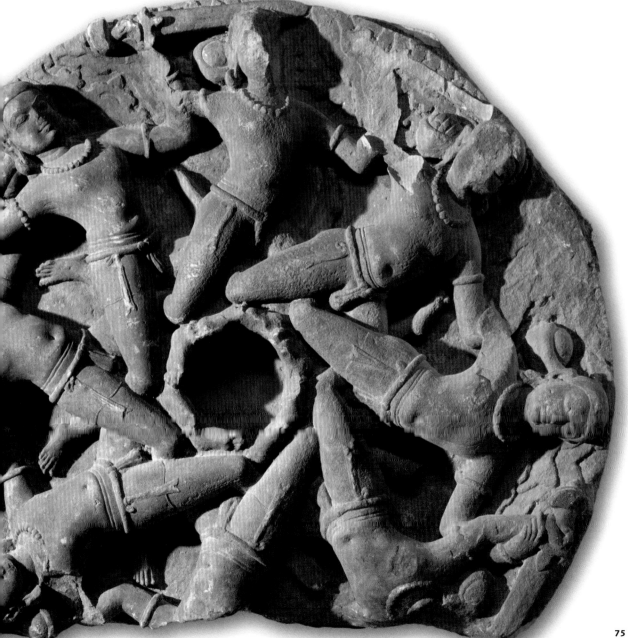

The Alfred Jewel ↩

Gold, rock-crystal and enamel, Anglo-Saxon,
about AD 871-899, 6.2 cm long

Found near Newton Park, North Petherton, near Athelney, Somerset, in 1693. Undoubtedly the single most evocative artefact from the Anglo-Saxon period, the Alfred Jewel embodies all the spiritual and cultural refinement that characterised the court of King Alfred the Great (d. AD 899). Within a gold frame is clasped a cloisonné enamel plaque representing a seated figure holding (apparently) two flowers; on the front the plaque is protected by a teardrop-shaped cover of rock-crystal, while the back is closed by a gold plate engraved with plant motifs. The jewel terminates in a dragonesque head covered with tiny granules of gold and holding in its jaws a tubular socket pierced by a transverse rivet.

The association of this piece with the greatest ruler of the Anglo-Saxon period has never been doubted, for around the frame is an openwork inscription reading ÆLFRED MEC HEHT GEWYRCAN – 'Alfred ordered me to be made'. As a supreme example of technique, everything about the piece speaks of a court workshop employing the most skilled workers: the modelling of the gold-work with its delicate granulation is unmatched, while the use of enamelling is a rarity in Anglo-Saxon England. Agreement on its function took longer to achieve.

The enamelled figure at the centre was initially interpreted as a representation of Saint Cuthbert (d. AD 687), one of the most revered figures in the early Christian community in England, but more recently comparison with contemporary figural art has led to a convincing conclusion that it should be interpreted as a personification of the sense of sight. This strong visual allusion, combined with the suggestion that the basal socket could have held a small pointer, perhaps of ivory or wood, strongly suggest that the jewel is to be equated with the pointers or aestels of precious metal that Alfred is recorded as having distributed to certain monasteries along with copies of influential texts that he had caused to be translated into English as part of a far-reaching campaign of cultural reform. The jewel may therefore be pictured in the hand of a monk who reverently follows with it a text that he reads aloud to his brother monks without sullying the manuscript with his finger. A number of (much more modest) objects with comparable socketed terminals are now known, but the Alfred Jewel remains unparalleled in its splendour.

Presented by Colonel Nathaniel Palmer, 1718.
(AN1836 p. 135.371)

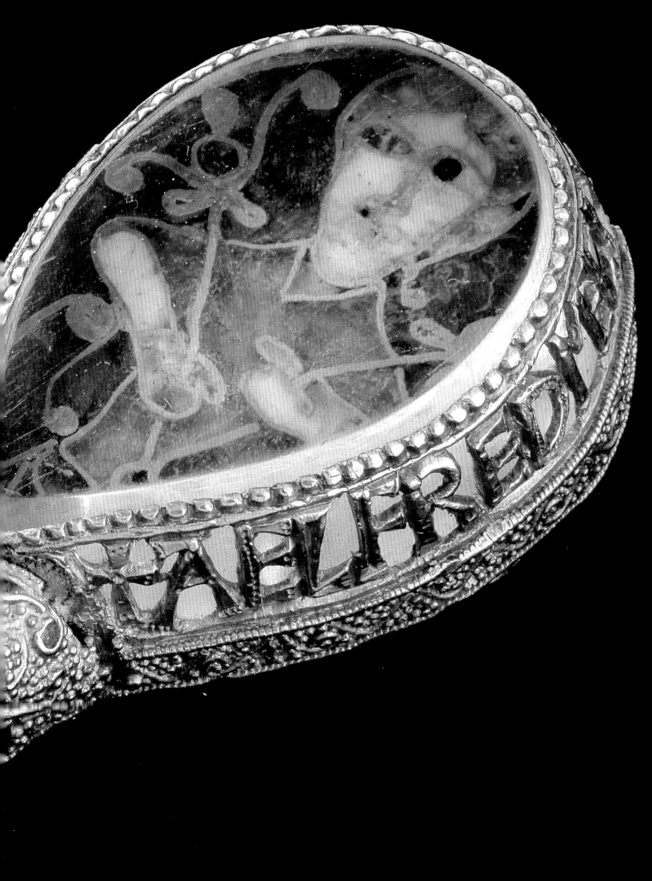

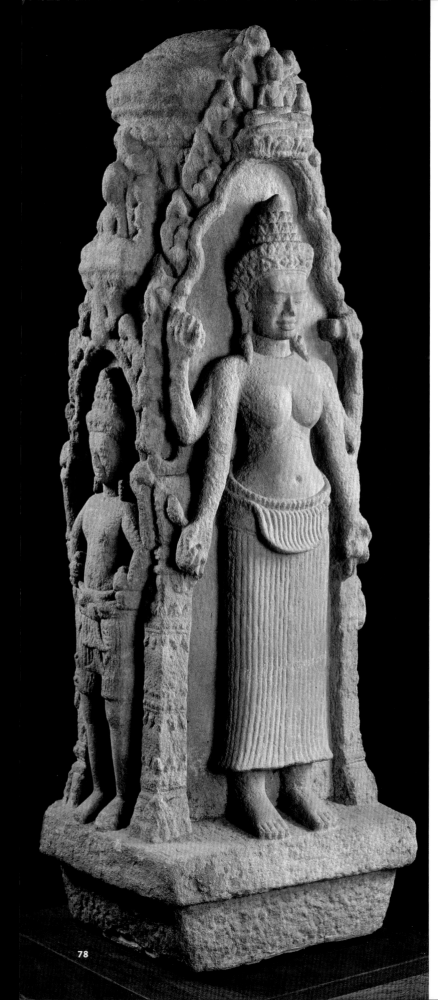

Chaitya shrine with images of Prajnaparamita and other deities G
Sandstone, Cambodian, about AD 950, 110 cm high

This imposing monolithic sculpture in the Khmer style is in the form of a *Chaitya*, a Buddhist votive shrine resembling a miniature temple or tower-shrine (*prasat*). It would originally have been set into a plinth and placed at a cardinal point in a temple complex to mark out the sacred area of the sanctuary. Standing figures of auspicious protective deities in niches are depicted on each of its four faces. The principal image represents the goddess Prajnaparamita, an object of great devotion in Cambodia at this period. She is the personification of Perfect Wisdom as embodied in the sacred text of the *Prajnaparamita Sutra*. Wearing a tiered headdress, she is four armed, her two upper hands holding a rosary and a book of scripture.

Purchased in 1999 with the help of the Art Fund, The MLA/V&A Purchase Grant Fund, an anonymous donor, and the Friends of the Ashmolean. (EA1999.102)

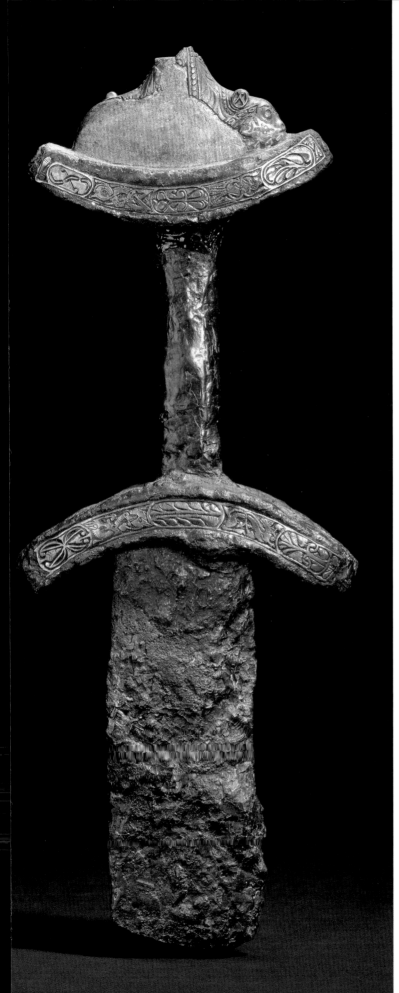

The Abingdon Sword ⊙

Iron with silver mounts, Anglo-Saxon, about AD 875, 31.5 cm long

Found about 1874 near Abingdon, Berkshire (now Oxfordshire). In this one powerful piece the harsh reality of an age when power was won and held by the sword is combined with evidence for a devotion to Christian doctrine expressed in terms of a sophisticated artistic sensibility. The sword itself, with trilobed pommel and curved guards typical of the late ninth or tenth century, clearly met with a violent end when much of its blade was broken off. The sheet-silver mounts decorating the hilt are engraved in so-called Trewhiddle-style ornament with motifs highlighted by typically nicked detailing, all infilled with niello, a black sulphide of silver that causes the engraving to stand out against its background. The fragmentary animal heads to either side of the pommel hark back to pagan Saxon imagery, while the use of Christian iconography on the upper guard – in the symbols of the Evangelists – and of interlacing animals on the lower guard, all combined with scrolling plant ornament, recalls strongly the courtly taste of the age of King Alfred. The suggestion has been made that it may have been a product of one of the court workshops, perhaps even at Winchester, Alfred's capital.

Presented by Sir John Evans, 1890. (AN 1890.14)

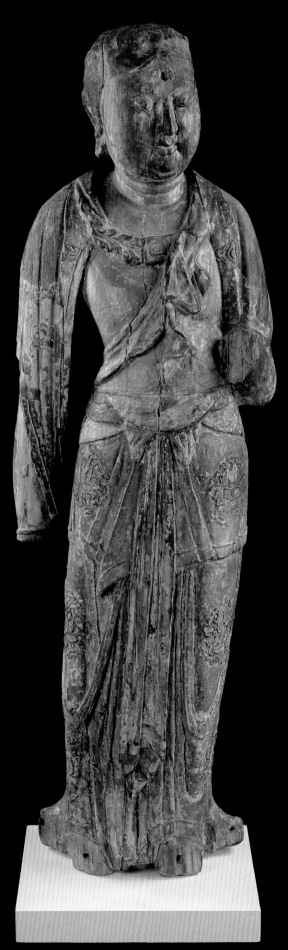

CONNECT

Bodhisattva Guanyin ☉

Wood, Chinese, about AD 960-1050, 93 cm high

From north China and dating from the early Northern Song dynasty, this polychrome and gilded figure of the goddess of compassion, carved from a single piece of wood, would originally have stood to the left of a central Buddha image in a temple. Sculptures such as this were an aspect of temple architecture rather than individually conceived works of art. The robes are in keeping with extant fabrics of the period.

Purchased with assistance from The Art Fund, S. Wheatland Fisher, the Friends of the Ashmolean, an anonymous benefactor and the Dr Mortimer and Theresa Sackler Foundation. (EA1999.96)

Box lid ☉

Carved ivory, Umayyad Spain (probably Cordoba), dated AD 998-999, 10.5 cm diameter

Carved from a section of elephant's tusk, this beautiful lid is decorated with the figures of four huntsmen and their prey. It was originally part of a cylindrical box (probably a container for perfumes and other precious substances), and it was likely made in Cordoba, one of the main centres of ivory carving in Muslim Spain. It is inscribed with the name and titles of Abu'l-Mutarrif, second son of the vizier of the Umayyad Caliph of Spain, which makes it a rare example of luxury object made for a member of an Islamic royal court. It is outstanding both for the representation of movement and for the quality of the detail.

Purchased with the assistance of the MLA/V&A Purchase Grant Fund, the Art Fund, and the Friends of the Ashmolean Museum. (EA1987.3)

Seated bodhisattva ⟳
Fig-tree wood, Chinese, about 1200, 173 cm high

This statue is in the Chinese Buddhist tradition, which still reflected Indian prototypes. Traces of painting (at two different periods) remain on a pink gesso ground. Originally it was probably in a cave temple in the Shanxi province in north China; it came to Europe in the 1930s. This bodhisattva is an image of Avalokiteśvara – the guide to souls with whose aid humans can be helped towards enlightenment. The pose shows the formal gesture of teaching: the right hand is raised, the left (now missing) would have lain palm upwards on his knee. The headdress crowning his blue hair contains the miniature figure of the Amitabha Buddha, the image of the historic Buddha who could be evoked even after his Nirvana. The third, all-seeing, 'eye' is central in his forehead.

Acquired in 1982 with help from The Art Fund, the Victoria and Albert Museum Purchase Grant Fund and the Friends of the Ashmolean Museum. (EA 1982.2)

Bowl ☾

Fritware, with overglaze lustre decoration, Seljuq/pre-Mongol Iran (probably Kashan), dated AD 1211-1212, 20.5 cm diameter

Notable not only because it is dated, this piece is an excellent example of Islamic potters' skill in matching the design to the shape of the circular, curving bowl. Women painted in lustre are shown sitting by a stream. Lustre painting is a complicated technique that demands very careful control of the materials and the firing, but when successful it results in a spectacular metallic finish. It was invented in the early Islamic period, and used at different times throughout the Middle East, before spreading via Spain into Italy. In medieval Kashan it certainly found one of its most elegant and most accomplished expressions.

Presented by Sir Alan Barlow. (EA1956.33)

Bowl ☾

Fritware, with painting in black under a turquoise glaze., Seljuq/pre-Mongol Iran, early 1200s, 22.2 cm diameter

From the 1100s, potters in Iran enjoyed a period of extraordinary creativity. They adopted a new ceramic body (similar to European soft-paste porcelain), which was high in quartz, pure white, and could be potted thinly, and applied to it a variety of decorative techniques. The bowl illustrated here shows a combination of the most significant innovations in ceramic art of the medieval period: the use of the new body, and its decoration in the newly developed technique of underglaze painting. The design of animals against a background of foliage and vegetal cartouches is depicted in a sharp black under a glaze stained blue with cobalt oxide, showing the fine control over the pigments achieved by potters in Iran by the turn of the century.

Presented by Sir Alan Barlow. (EA1956.29)

Mosque lamp ☾

Glass, with enamelled and gilt decoration, Mamluk Egypt, first half of the 1300s, 31 cm high

The techniques of enamelling and gilding on glass, developed in Syria in the 1100s, reached their apogee in Egypt in the 1200s and 1300s. The traditional form of hanging lamp was transformed from a plain transparent object into one of great splendour and beauty. Rows of similar lamps would be used to decorated mosques and tombs of the sultans and their senior officials. This lamp was made for a religious building of the Mamluk sultan Muhammad ibn Qala'un (ruled 1294-1340, with interruptions) and is inscribed with his name and a quotation from the Qur'an. Enamelling on glass seems to have died out in the Islamic world in the 1400s, possibly because of competition from the Venetian glass-makers of Italy who had developed a great export industry, supplying all Europe as well as the Middle East.

Purchased with the assistance of the Friends of the Ashmolean Museum. (EA1972.5)

Studio of Giotto di Bondone (1266/7?-1337)
The Virgin and Child ☾

Tempera and gilding on panel with integral frame, Italian (Florence), about 1310, 28.5 x 19.7 cm

Giotto was admired by contemporaries as a highly original artist and an important teacher; he worked in Florence, Padua, Assisi, Rimini and Naples. This intimate devotional image was probably painted in about 1310 by an assistant who worked closely with him. The traditional severe types of the Virgin and Christ Child as venerable figures have been endowed with a new naturalism as the Child affectionately reaches to touch his mother's face. The lettering in the border seems to be ornamental rather than meaningful.

Presented by Mrs James Reddie Anderson, 1913. (WA1913.1, A332)

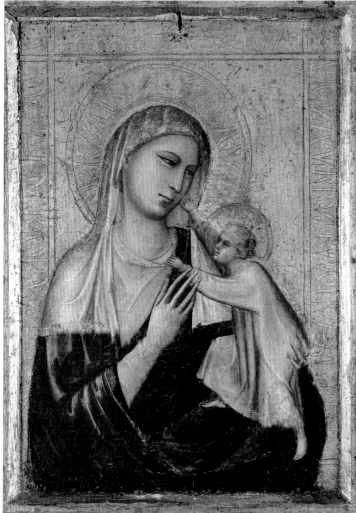

Stemmed bowl ᴄ◡

Porcelain with underglaze blue decoration, Chinese, about 1340, 16.8 cm high

This bowl was probably for ceremonial use. The technique of underglaze painting, which involved painting decoration onto the partially dried body before covering it with transparent glaze and then firing, was established at Jingdezhen in Jiangx, a province in south-east China, in the second quarter of the fourteenth century. Initially both copper red and cobalt blue pigments were used, but red was difficult to control and fell out of use by the beginning of the 1400s. Imperial kilns were set up at Jingdezhen in the early Ming dynasty and it has been the centre of the porcelain industry ever since.

A.H. Sayce Bequest. (EA X1386)

Tripod basin ⌂

Lacquered zelkova *wood, Negoro type, Japanese, about 1345-1405, 8.5 cm high*

This generic type of lacquer, based on the colours red and black, and sometimes with plain transparent lacquer (as here), derived its name from the Negoro Temple in the modern prefecture of Wakayama, where it was made from the late 1200s. The temple was burned down in 1585, so that any similar articles made after that period are not considered true Negoro. In the 1500s the temple had grown very large, with several hundred monks, and very disorderly. This was a time of civil wars and such was the threat of the monks' unruly behaviour that Toyotomi Hideyoshi, the military dictator, was forced to attack the monastery and burn it down. In spite of the stiff resistance put up by the monks, he spared their lives. The temple was later rebuilt. It had originally been built in a major valley and several side valleys, one of which was the Jissoin-tani.

A contemporary inscription on this bowl reads *Jissoin-tani Itokuin kinoto-tori no yoshi*, meaning 'The Itokuin subtemple in the Jissoin valley', and gives a cyclical date conforming to 1345 or 1405. Such inscriptions are exceedingly rare and provide secure evidence of provenance. The tripod bowl, raised on *neko ashi*, or 'cats' paw' feet, is called a *tarai* and would have been used by a monk for washing his hands in the repentance ceremony, *fusatsu*, held on the fifteenth day of each month. The construction is that of cooperage, the barrel-shaped body features uncoloured lacquer bound with black-lacquered bands and red borders.

Anonymous gift. (EA2002.32)

The Thame Ring ⌂

Gold, amethyst and enamel, French (probably Paris), about 1350-1450, 2.5 x 2.5 cm

This magnificent ring was dredged from the river at Thame together with a collection of silver groats and four more modest finger-rings in 1940. While the latter were undoubtedly secular in character, the splendid piece shown here is to be interpreted as an ecclesiastical ring.

The hollow bezel in the form of a box is dominated by an amethyst cut in the form of a cross of Lorraine and framed by a gold panel; this gem-set lid is held in place by T-shaped pins with heads in the form of flowers, placed at the top and bottom of the bezel; turning the flowers releases the lid. On the back is engraved a Crucifixion scene outlined by a background of red enamel, while an inscription in Lombardic letters running over and around the bezel reads MEMANTO MELDOMINE 'Remember me, O Lord'. The interior is engraved with a flowering plant motif. It currently contains a loose gold plate, similarly decorated. A further seven amethysts are set around the hoop. The whole is judged to be of French workmanship. The intricately contrived opening mechanism indicates that much significance was attached to the former content - almost certainly a relic. This precious item is likely to have been owned by an important and wealthy prelate towards the end of the fourteenth century.

Purchased with the aid of the National Art Collections Fund, 1940. (AN 1940.228)

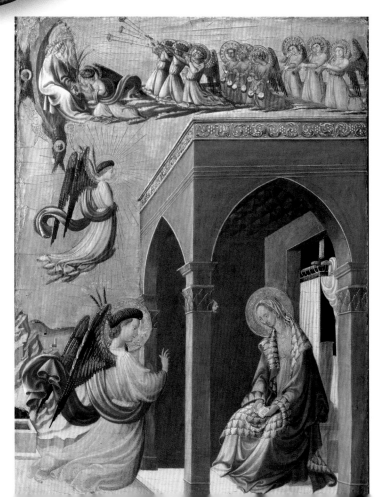

Lacquer dish ↻
*Carved lacquer on wood,
Chinese, about 1420, 54.3cm
diameter*

The technique for this kind of
dish was complicated and
expensive as dozens
of layers of lacquer had to be
applied to a support, usually
wood, in order to create a
material thick enough for carved
ornament. The wares were
therefore carved only by highly
skilled craft workers. The base of the
dish is covered with plain black lacquer
and bears the reign marks of two Ming
dynasty emperors: Yongle (1401-1425) and
Xuande (1426-1435). The design includes peony,
prunus and lotus flowers.

(EA 1981.9)

Probably by Paolo di Dono, called Uccello (1397-1475)
The Annunciation ↻
*Tempera and gilding on panel, Italian (Florence), about
1420, 65 x 48 cm*

The Angel Gabriel is sent by God the Father to announce
to the Virgin Mary that she will bear the son of God (Luke
1: 26-8). This vividly coloured devotional image may
have been painted by Uccello in the early 1420s. The
elegant figure types, the interest in perspective, the
refined, decorative approach and the unusual treatment
of the subject are all characteristic of Uccello's work.
Recent examination has revealed a lively underdrawing
with changes and revisions, including an alteration in the
position of the dove of the Holy Spirit. With its lavish use
of gold and ultramarine, this panel was an expensive
image to produce.

Fox-Strangways Gift, 1850. (WA1850.7, A80)

Master ES (active about 1450-1467)
**Consolation through Confidence
(from the Ars Moriendi)** ⊃
*Engraving, sole state, German, about 1460, 9.1 x 6.8cm
(sheet)*

The series of the *Ars Moriendi* by the fifteenth-century
Master ES is one of the greatest highlights of the
Old Master print collection. Although examples of all
the sheets in the set are known in other print rooms, the
Ashmolean's is the only collection that has the entire
series. The images refer to a late medieval instruction
manual for Christian behaviour in the face of death.
It illustrates the various stages of virtuous behaviour

that will support the dying person and assist them to get
to heaven; at the same time it indicates a series of
examples of the type of behaviour to avoid. If a person
does not follow these rules, they will be punished in
hell, with demons already taking possession of their
soul while they are still on Earth.

The series is one example from an internationally
outstanding collection of fifteenth-century prints from
northern countries assembled in the early 1800s by
Francis Douce.

*Bequeathed by Francis Douce in 1834 and transferred from the
Bodleian Library in 1863. (WA1863.1978)*

Bicci di Lorenzo (active late 1380s-1452)
Saint Nicholas of Bari banishing the Storm ↻
Tempera and gilding on panel, Italian (Florence), about 1433-1435, 29 x 59 cm

This lively and colourful scene comes from the predella or lower horizontal section of a large altarpiece of 1433-1435 for the Church of S. Niccolò in Cafaggio, Florence. The other parts are now scattered in various collections. A large image of The Virgin and Child with Four Angels in the centre was flanked by panels with pairs of saints (Saints Benedict and Nicholas of Bari and Saint John the Baptist and an Evangelist, probably Saint Matthew). The predella was made up of narrative panels with scenes from the life and miracles of Saint Nicholas. Five of these are known: the birth of the saint, pilgrims at the shrine of the saint, Saint Nicholas resuscitating three youths, the saint providing dowries for three sisters (three gold balls, his traditional attribute) and the saint banishing the storm. The panels probably originally had quatrefoil frames. Bicci based the design of this picture on a similar scene in Gentile da Fabriano's Quaratesi altarpiece of 1425 for S. Niccolò oltr'Arno.

Fox-Strangways Gift, 1850. (WA1850.26, A89)

Paolo di Dono, called Uccello (1397-1475)
The Hunt in the Forest ⟲
Tempera and oil, with traces of gold, on panel, Italian
(Florence), about 1465-1470, 73.3 x 177 cm

Celebrated in his lifetime as a painter of perspective and
of animals and landscape, Uccello was a versatile artist
who worked at times on mosaic and stained-glass

design. Based mainly in Florence, he travelled to Venice
and the north of Italy early in his career, and
late in life spent time at the court of Urbino. This lively
scene is a late work, probably of about 1470. It is a
highly original painting, both as a nocturnal landscape
and as a brilliantly structured composition. Uccello
mapped out a grid on the panel's surface as a guide for
his design, fixing a central vanishing point. The devices

of the huntsmen's spears, the cut branches and logs, and the area of water denote this coherent space, inhabited by the receding forms of men and animals. Uccello's approach is also very decorative, with bright, clear colours set off against a dark background. The foliage of the trees was once picked out with gold, accentuating the precious, mosaic-like effect. Hunting was an aristocratic pastime with its own rituals (and the crescent moon, symbol of Diana, the chaste goddess of the hunt, appears in the horses' trappings) and the idea here of a hunt by night may be playful or symbolic rather than realistic. Although the patron is unknown, the picture was painted for a luxurious domestic setting, perhaps in Urbino or in Florence.

Fox-Strangways Gift, 1850. (WA1850.31, A79)

Bertoldo di Giovanni (1420-1491) ⚙
*Bronze, Italian (Florence), about 1480,
9.3cm diameter*

Bust of Mehmed II / Personifications of
Greece, Trebizond and Asia held in a lasso in
the back of a victory chariot. This medal was
produced as a diplomatic message from
Bertoldo's patron, Lorenzo de' Medici, to the
Ottoman sultan Mehmed II.

The reverse commemorates Mehmed's victories over
the three kingdoms of Greece, Trebizond and Asia,
drawing its iconographic inspiration from a number
of Roman imperial coins. The medal thus crosses
cultures from West to East, and crosses time
from the Renaissance back to Rome.

(HCR6589)

Albrecht Dürer (1471-1528)
Landscape ↻
*Brush and watercolour and bodycolour on paper,
German, 1494, 21 x 31.2 cm*

This is now generally agreed to be a view of the Val de
Cembra, between Cembra and Segonzano, taken on
the artist's outward journey from Nuremberg to Venice,
his first Italian trip, in 1494. The rare surviving
watercolours by Dürer anticipate with startling
vividness the achievement of watercolourists working
direct from nature three centuries and more later.
Though brought to different degrees of finish in various
areas of the drawing, this one is among his most
remarkable masterpieces.

Presented by Chambers Hall, 1855. (WA1855.99)

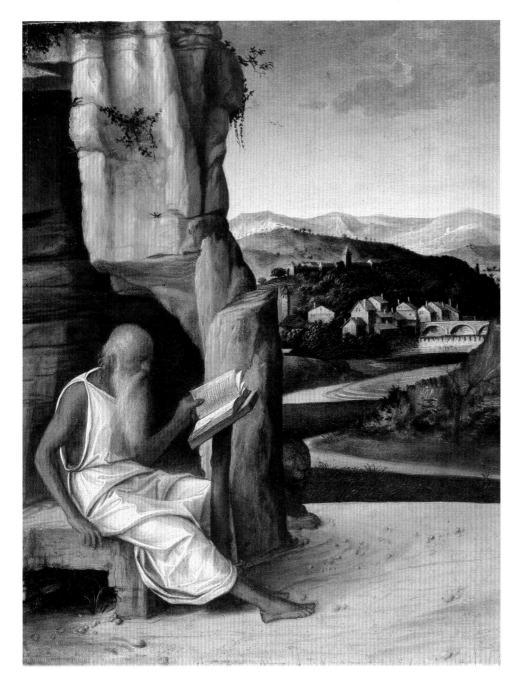

Circle of Giovanni Bellini (about 1431/6-1516)
Saint Jerome reading in a Landscape ☊
Tempera and oil on panel, Italian (Florence), about 1470-1510, 26.6 x 21.7 cm

The learned Saint Jerome retired to the desert around 374-376 to lead a life of prayer and contemplation; according to the legend he befriended a lion by removing a thorn from its paw. Here the landscape with its hills, towns and imposing bridge is typical of the Veneto. This beautiful devotional image has sometimes been attributed to Giovanni Bellini (about 1430-1516), who lived and worked in Venice. Other suggestions for its authorship have included artists in his circle such as Andrea Previtali and Vittore Carpaccio; the latter is the author of a related drawing in Berlin.
Bequeathed by C.D.E. Fortnum, 1899. (WA1899.CDEF.P1, A302)

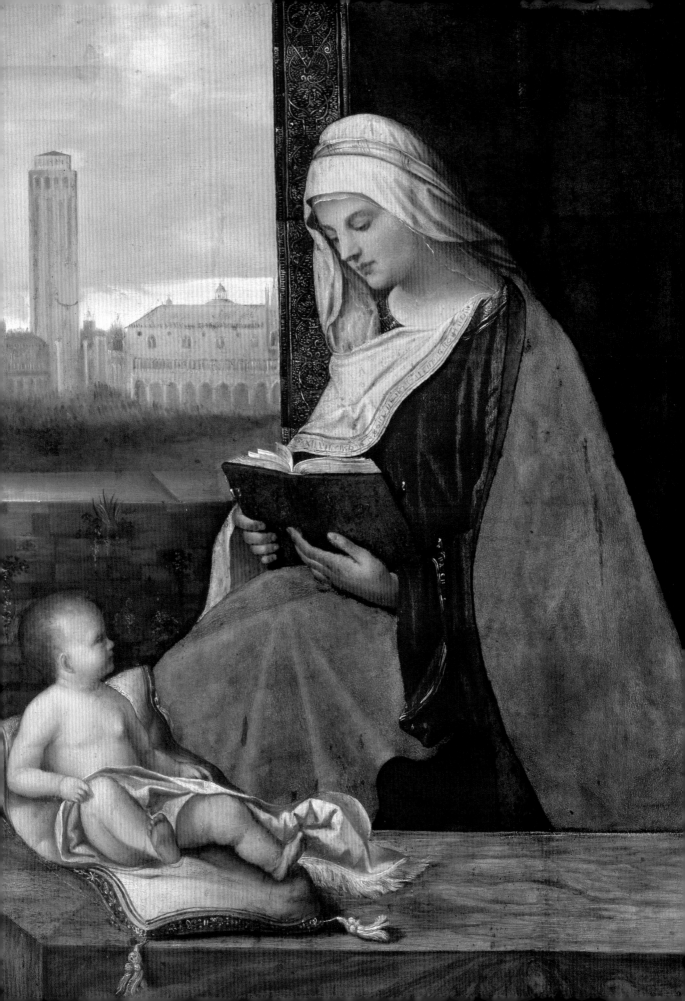

Circle of Giorgione (about 1477/8-1510)
The Virgin and Child with a View of Venice (The Tallard Madonna) ☉
Oil on panel, Italian (Venice), about 1489-1510, 76.7 x 60.2 cm

Although Giorgione was celebrated in his short lifetime, very few pictures can be securely attributed to him. This meditative devotional image is often known as the *Tallard Madonna* after its French owner, the duc de Tallard (1652-1728).

It was traditionally thought to be by Giorgione; however it is more likely to be by a pupil in Venice such as the young Sebastiano del Piombo (about 1485-1547), or by an artist close to Giorgione such as Giovanni Cariani (about 1490-1547). The hazy, atmospheric view of the Piazza San Marco from the water shows the ducal palace and the campanile of St Mark's with a temporary flat-roofed bell-chamber, which was in place from 1489 to 1511.

Purchased, 1949. (WA1949.222, A777)

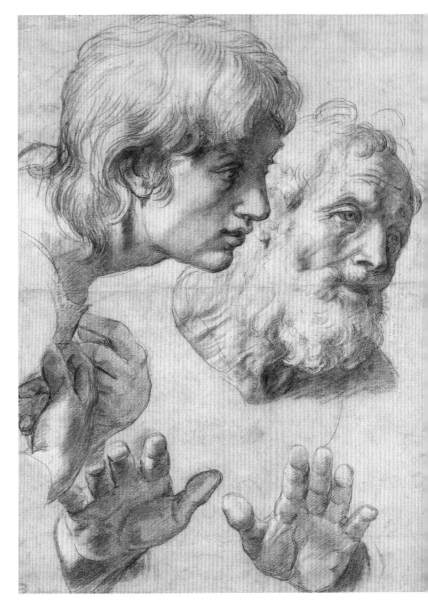

Raphael (Raffaello Santi, 1483-1520)
Studies of the Heads of two Apostles and their Hands ☉
Black chalk touched with white on greyish paper, Italian (Rome), about 1517, 49.9 x 36.4 cm

The Ashmolean's collection of drawings by Raphael and Michelangelo mostly came to Oxford in 1845/6, when part of Sir Thomas Lawrence's unrivalled collection of Old Master drawings was acquired by public subscription for the University. It is the largest and most representative collection of drawings by Raphael in any one institution, and the most spectacular of all is this magisterial drawing of two apostles for Raphael's last painting before his premature death: *The Transfiguration*, in the Vatican. This huge painting was commissioned by the pope's nephew, Cardinal Giulio de' Medici (1478-

1534), in 1517; he also ordered another altarpiece, *The Raising of Lazarus*, now in the National Gallery, from Raphael's rival Sebastiano del Piombo. This drawing relates very closely to the figures traditionally identified as the young Saint John the Evangelist and Saint Peter as realised in *The Transfiguration*; the two men are mesmerised by the miracle taking place before their eyes. In this sublime work of art, Raphael unites naturalistic observation and ideal representation, intense emotion and powerful expressiveness.
Presented by a Body of Subscribers, 1846. (WA1846.209)

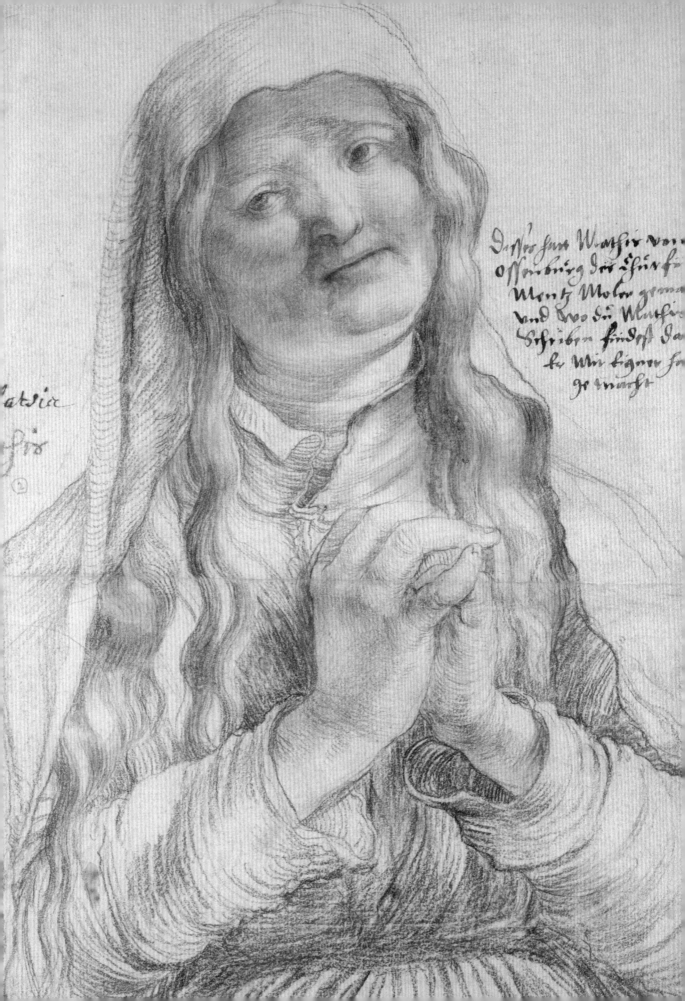

Matthias Grünewald (about 1475-1528)
An Elderly Woman with Clasped Hands ☾

Charcoal or black chalk on paper, German, about 1520, 37.7 x 23.6 cm

Very few drawings by Grünewald, one of the greatest geniuses of German art, have survived. This (from the Douce Collection) is one of the most striking, entirely characteristic of his sinewy style, and of about the same date as his *Tauberbischofsheim Crucifixion* at Karlsruhe. The ink inscription (early, though not in the artist's hand) identifies the drawing as by 'Mathis von Ossenberg' and is a crucial link in the evidence that established the artist's real name, Mathis Nithart, called Gothart, now universally known as Grünewald. His masterpiece is the famous Isenheim altarpiece at Colmar. The subject of our drawing is uncertain, and is perhaps a study for a figure attendant in a *pietà* rather than for the Virgin Mary at the cross or Mary Magdalen.

Bequeathed by Francis Douce, 1834. (WA1863.421)

Francesco Urbini (active 1530-1537) ☾
Maiolica plate painted
Italian (possibly Gubbio), 1536, 23.3 cm diameter

This shallow maiolica bowl stands on a low foot and is painted on dark blue ground with a head composed of penises. On the scroll are the words: *OGNI HOMO ME GUARDA COME FOSSE UNA TESTA DE CAZI* ('Every man looks at me as if I were a head of dicks'). On the reverse: *1536 El breve dentro voi legerite Come i giudei se intender el vorite* ('If you want to understand the meaning, you will be able to read the text like the Jews do'), referring to the fact that the inscription on the scroll is written right to left; also marked on the reverse with the painter's mark *FR*, a pair of scales and the date 1536. Francesco Urbini was active in Gubbio and Deruta in the 1530s. This unparalleled plate is a Renaissance joke reflecting contemporary ideas about sexual explicitness in the writings of Pietro Aretino (1492-1556) and others.

The composite head recalls compositions by Leonardo da Vinci (1452-1519) and prefigures the work of the painter Giuseppe Arcimboldo (about 1530-1593).

Purchased (France, Madan and Miller Funds) with the aid of The Art Fund, the Resource / Victoria and Albert Museum Purchase Grant Fund and numerous private donations, 2003. (WA2003.136.)

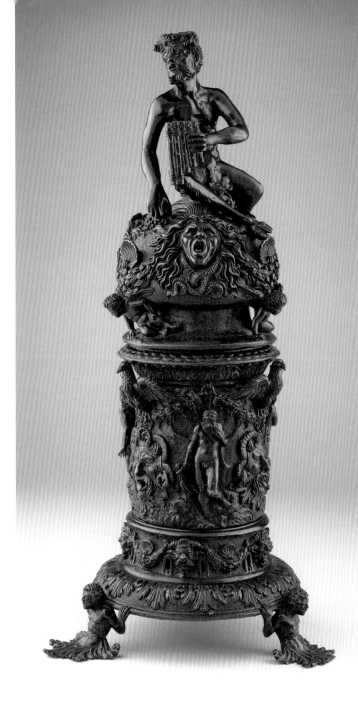

Attributed to Desiderio da Firenze (active 1530-1537)
Perfume burner ↻
Bronze, cast and chased, with traces of gilding, Italian (Padua), about 1530-1540, 51.2 cm

The perfume burner consists of three detachable sections, each richly decorated with *all'antica* ornament, including swags, tritons, grotesque masks, shells, eagles, freestanding deities, putti and Medusa masks. On the top is Pan, holding his pipes. This is one of the largest and most splendid Renaissance functional bronzes in existence. Perfume burners were used by wealthy Renaissance men and women to keep their living spaces smelling sweet. Charcoal was burned in the lower section and scented pastilles placed on a platform gave off perfumed smoke through the mouths of the satyr and Medusa masks. Lorenzo de' Medici (1449-1492) owned a large bronze perfume burner and the Mantuan *studiolo* of Isabella d'Este (1474-1539) contained in 1541 a silver example. This outstanding example of Paduan bronze casting has been attributed to Desiderio da Firenze, who is first recorded in Padua in 1532 and may have taken over Riccio's workshop.

The collection formed by Sir Julius Wernher (1889-1948) and later at Luton Hoo in Bedfordshire was among the climaxes of a tradition of broad-ranging Victorian art collecting.

Purchased (France, Madan, Bouch, Russell, and Miller Funds) with the aid of the National Heritage Memorial Fund, The Art Fund, the Friends of the Ashmolean, the Elias Ashmole Group and private donors. (WA2004.1)

Inkstand: Pan listening to Echo ↻
Bronze, Italian (Padua), about 1520-1540, 20.2 x 21.5cm

This famous and poetic bronze depicts the Greek god Pan pausing from playing his pipes to listen to the voice of the nymph Echo. It was made in Padua, a great centre of Renaissance bronze-casting, and was for many years attributed to the most celebrated artist of the Paduan school, Andrea Briosco (about 1430-1532), known as Riccio. More recent research has suggested the name of another Paduan bronze caster, Desiderio da Firenze (active 1530-1537). Like some of the most beautiful bronzes of the period, this is a functional object, an inkstand. The Museum has one of the finest collections of Renaissance bronzes in Europe.

Bequeathed by C.D.E. Fortnum. (WA1899.CDEF.B1077)

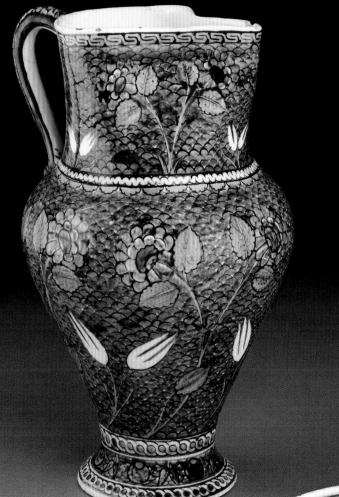

Jug and dish ↺ ↻

Fritware, with polychrome underglaze painting, Ottoman Turkey (probably Iznik), about 1530-1550, jug, 25 cm high; dish, 28.8cm diameter

In the early 1500s the potters of Iznik developed one of the most beautiful ceramics ever made. The soft-paste fritware body provided a glowing pure white ground against which resonated an unparalleled range of colours. The characteristic Iznik palette evolved over time from the blue-and-turquoise scheme of the earliest pieces, to the addition of sage green and purple, to the bold red and brilliant green introduced by the second half of the century. This jug, with its simple sprays of tulips and roses against a blue-scale ground, illustrates the rich and harmonious colour scheme of the middle phase. The dish, belonging to the same period, shows an elegant floral design masterfully fitted to the awkward circular shape.

Bequeathed by C.D.E. Fortnum, 1899. (EAx3272) jug and (EAx3277) dish

Titian (Tiziano Vecellio, about 1485/90-1576)
Giacomo Doria ⊙
Oil on canvas, Italian (Venice), about 1533-1535,
115.5 x 97.7 cm

Giacomo Doria, a Genoese merchant resident in Venice
from 1529 to 1541, commissioned this dignified,
restrained portrait around 1533-1535. Doria acted as
diplomat for the Genoese state and had connections with
the Habsburg court; two of his sons were to become
doges of Genoa. The portrait displays Titian's keen
psychological sensitivity and his painterly skills
in orchestrating a near-monochrome composition. He
used, possibly for the first time in his portraiture, the
device of a grand, polished marble column that functions
in several different ways. It suggests an expansive
space beyond that visible in the picture;

it is a symbolic device denoting strength and fortitude;
and as a piece of classical architecture it denotes the
sitter as a person of wealth, erudition and authority.
Titian's signature appears on the plinth in the form of a
chiselled inscription. The portrait remained with
Giacomo Doria's descendants until the late 1800s, when
it became part of the important art collection of Sir Julius
Wernher at Luton Hoo in Bedfordshire.

Purchased in memory of Professor Francis Haskell with the
assistance of the Heritage Lottery Fund, The Art Fund and other
donors, 2000. (WA2000.85, A1228)

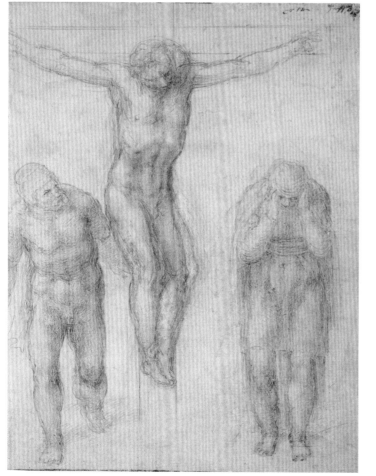

Michelangelo Buonarroti (1475-1564)
The Crucifixion ⊙
Black chalk with corrections in white chalk, Italian
(Florence), about 1540-1549, 27.8 x 23.4cm

Michelangelo's profound religious feelings lie behind
his treatment in drawings of subjects such as the
Crucifixion made from the 1540s onwards, which in
their obsessively worked black chalk technique seem to
function as lingering meditations. This sheet is one of a
highly pictorial group probably dating from the last few
years of his life, showing Christ on the cross with two
mourning figures, always frontally viewed. Traditionally
such figures represent Christ's mother, Mary, and Saint
John the Evangelist, and the right-hand agonised figure
here seems to be that of a woman – although the figure
has also been identified as Saint John or Longinus, or
another male saint; similarly the male figure on the left
has had various identifications and may even be
intended for the artist himself. The drawing is highly
worked, with subtle shadowing on the body of Christ
(another study of the crucified Christ alone is on the
verso of the sheet). The tremulous repetition of the
outlines and the brushing over of corrections with the
same white pigment that is used for highlights give the
drawing a tentative, nervous quality and
an almost visionary radiance.

Presented by a Body of Subscribers, 1846. (WA1846.89)

Alessandro Allori (1535-1607)
Portrait of a Young Man ⟳

Oil on panel, Italian (Florence), 1561, 133 x 140cm

The young collector holds a medal which he has just been polishing, showing a profile head of a woman in classical costume. His arm rests on an ornate chair with carved and inlaid decoration.

A replica of the antique statue of Apollo Citharoedos stands on the elaborate table; the original was in the Della Valle Collection in Rome when this portrait was painted in 1561. Different identifications have been proposed for the aristocratic sitter, including that of Paolo Capranica – who was related to the Della Valle family – and a member of the Palma di Cesnola family, because their motto *Oppraesa Resurgam* appears on a scroll across a palm tree in the table inlay. The view of an imaginary landscape with a muscular classical figure leaning on a Mannerist balcony gives the portrait an enigmatic air; perhaps the sophisticated young man imagines himself in ancient times as he handles the objects in his collection. Allori was a pupil of Bronzino (1503-1572) and shared his ideals of polished refinement and courtly elegance in portraiture. This striking picture was painted soon after Allori's return to Florence from Rome, where he had studied antique and modern art from 1554 to 1560 and had established himself as a portraitist.

Purchased with the assistance of the Victoria and Albert Museum Purchase Grant Fund and The Art Fund, 1982. (WA1982.38, A1123)

Henry VIII medal ⟳

Gold, English, 1545, 5.2 cm diameter

Minted at London, this medal shows a bust of Henry VIII with inscriptions in Hebrew and Greek on the reverse. As a consequence of Henry VIII's break with Rome, he claimed to be the 'Supreme Head of the Church of England'. This medal by Henry Basse records the king's full titles, in Latin on the obverse, surrounding his portrait, and in Greek and Hebrew on the reverse. This vivid and unusual portrait of the king may be compared with the image of him more generally broadcast by copies after Holbein.

(HCR6591)

Flask of imitation porcelain ⟳

Painted in underglaze blue, Italian (Florence), about 1575-1587, 18.5cm high

Marked beneath the base with the Dome of Florence Cathedral and *F*. This is one of about seventy known surviving examples a ground-breaking project to imitate Chinese porcelain. The porcelain-making workshops were sponsored by the Medici grand dukes of Tuscany between about 1575 and 1587. The firing temperatures were at the limit of contemporary Italian ceramic technology and the blue has run slightly in firing. The flask was bought in Naples in 1879 by Fortnum, whose gifts and bequest are still the basis of the Ashmolean's collections of sculpture and decorative arts of the Renaissance.

Bequeathed by C.D.E. Fortnum. (WA1899.CDEF.C298)

Amir Hamza defeats 'Umar-i Ma'di Karab ↻
Gouache on cloth, Indian, about 1562, 67 x 49.5 cm

Commissioned by Akbar (1556-1605), the *Hamzanama* was one of the earliest Mughal manuscripts and by far the most ambitious. It originally ran to 1,400 large paintings on cloth, illustrating the fantastic adventures of its hero Amir Hamza which the emperor liked to have recited to him. In this early episode the youthful Hamza

effortlessly overcomes a giant infidel warrior (later to be his staunch companion), by toppling him from the saddle with a single blow of his foot.

The painting shows a strong influence of the Safavid Persian style, already offset by more dynamic Indian elements such as spirited musicians playing in the background.
Presented by Gerald Reitlinger, 1978. (EA 1978.2596)

Ganesha ℭ

Gilded bronze, Indian, about 1500-1600, 10.8 cm high

One of the most popular Hindu deities, the benign, elephant-headed Ganesha is a god of wisdom, bestower of wealth and remover of obstacles, who is invoked at the beginning of any enterprise. A son of Shiva and Parvati, he is generally shown as chubby and pot-bellied. In this fine example of Orissan bronze casting, Ganesha sits with his feet pressed together on a lotus-petalled throne while the rat or mouse (his associated animal or vehicle) looks up at him from the rim of the base. He holds in his upper hands an *ankus* (elephant goad) and a serpent (associated with his father Shiva). The sacred thread around his body is likewise a snake. His lower hands hold the broken end of his tusk and a bowl of small sweet cakes, which he is sampling appreciatively with his trunk.

Barrett Gift. (EA1980.64)

Isaac Oliver (about 1560/5-1617)
Portrait of an Unknown Man ℭ
Body colours on vellum, French, 1588, 68 x 49cm

The identity of the old man so brilliantly characterised here is still elusive (an old inscription, 'Lord Bacon', on the back of the frame, probably of the 1700s, cannot be correct). It is inscribed by the artist in gold: *Anno Domini 1588 Ae Suae. 71.*

As a child Oliver came to London from Rouen with his parents, who were Huguenot refugees; his father was a goldsmith, and at some point Isaac worked with the great English-born miniaturist Nicholas Hilliard (about 1547-1619). By the late 1580s Oliver rivalled his master in quality, but was already developing his own style, more down-to-earth, using more shadow. Here the elegant calligraphy recalls Hilliard's practice, but Oliver was not yet patronised by the court and the sitter may be a member of the foreign community of merchants and craftsmen settled in London, a Dutchman (as in another miniature of Oliver's the same year) or a Frenchman.

Purchased with the aid of the Victoria and Albert Museum Purchase Grand Fund, The Art Fund and the Friends of the Ashmolean, 1979. (WA1979.72, MIN322)

Ewer and basin ⟲

Silver-gilt, English, 1592 basin, 41.2 cm diameter;
ewer 29.8 cm high

The basin is enamelled with the arms of Richard Proctor, Master of the Company of Merchant Taylors of London, and his wife, and the ewer and basin are mentioned in Proctor's will made in 1610. Ewers and basins, used for washing hands at table in days before forks were in regular use, were the most ambitious form of Elizabethan table plate, but few have escaped being melted down over the centuries. The ewer and basin are chased over the whole surface with a characteristically Elizabethan pattern of strapwork and flowers.

Formerly in the collection of early English silver made by the financier Sir Ernest Cassel (1852-1921) and purchased with the aid of the National Heritage Memorial Fund, The Art Fund and private donations, 2005. (WA2005.131.1-2)

Guy Fawkes's lantern ⟳

Sheet iron, English, early 1600s, 34.5 cm high

One of the best-known relics in the collection. Originally it had a horn window, and could also be closed completely to hide the light (a dark-lantern). Given to the University in 1641 by Robert Heywood, son of a justice of the peace who had been present at the arrest of Guy Fawkes in the cellars of Parliament House, when the 'Gunpowder Plot' was foiled on 5 November 1605. Transferred from the Bodleian Library to the Ashmolean in 1887.

(AN1887.2)

CONNECT

Powder flask ɕ

Lacquer on wood, Japanese, about 1600, 15.7 cm high

The Portuguese were the first Westerners
to arrive in Japan, in 1542, and their personal habits,
extraordinary European clothes, stature and colouring
caused great astonishment. They brought with them two
previously unknown imports: Christianity and guns. This
attractive little object is a flask to hold the black
gunpowder for muskets. The rich brown lacquer is
decorated with a Japanese view of the absurd exotic
foreigners to whom Japan owed the introduction of
firepower. On one side a man stoops to admire some
flowers, accompanied by an immensely tall figure draped
in an ankle-length cloak. The man on the other side wears
a tall red hat and an exaggerated version of the baggy
trousers in fashion in Europe at the time. The images
suggest that the Japanese, always delighting in caricature,
saw their visitors as such; present-day Europeans may be
reminded of the style of Aubrey Beardsley (1872-1898).
Examples of this type of lacquer are extremely rare.

*Acquired with the assistance of the Friends of the Ashmolean in
1983. (EA1983.243)*

Zodiac coin of Jahangir ↻↺

Gold mohur, Indian, 1611, 2.1 cm diameter

A superb example of the numismatic art of the Mughals – the coin displays on the obverse Sagittarius, the sun-sign of the month of the Persian calendar in which it was struck at Agra. The reverse inscription is engraved in the *Nastaliq* style of calligraphy and alludes to the poetic idea of gold being 'enlightened' with the name of the emperor inscribed on it.

(HCR6770)

Sir Anthony Van Dyck (1599-1641)
The Deposition ↺
Oil on canvas, Flemish, about 1619, 207 x 137 cm

Christ has been lowered from the cross and is supported by Mary and Saint John, with Mary Magdalen in prayer behind. The composition is based on an earlier work by Van Dyck, now in the Alte Pinakothek in Munich. This painting probably dates from around 1619, when Van Dyck worked as an assistant to Rubens in Antwerp. The figure of Christ may owe something to Rubens's great *Descent from the Cross* at Antwerp.

Van Dyck's unrelentingly intense treatment of the appalling physical destruction inflicted by crucifixion is, however, essentially his own, though it conveys a starkly tragic feeling that is rare in his work.

Presented by C.T. Maud, 1869. (WA1869.1, A232)

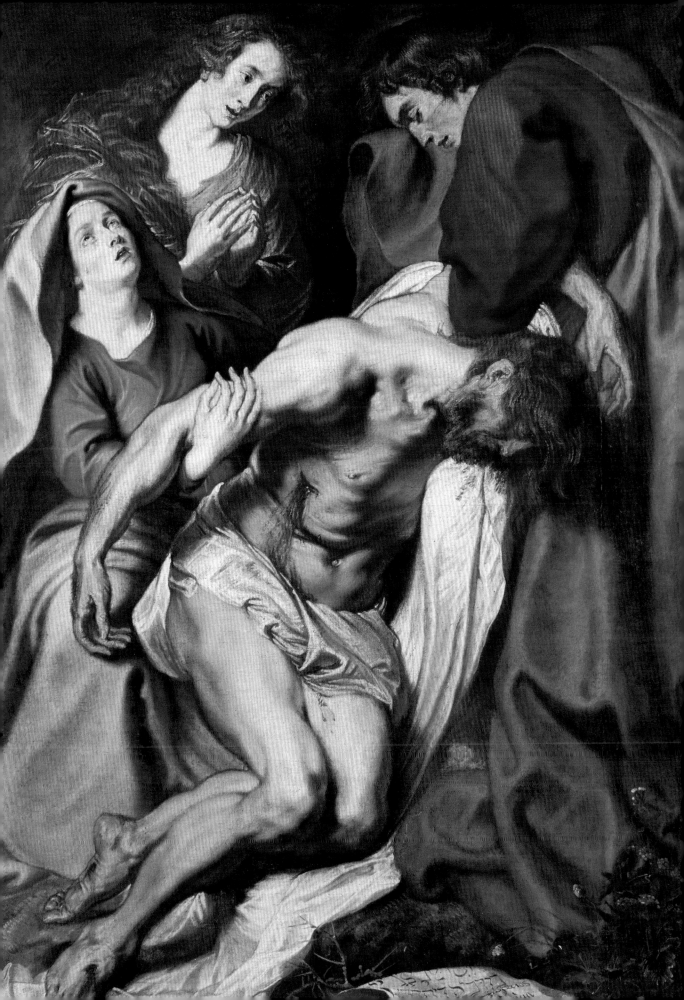

Ewer and basin ↻

*Silver, cast, embossed and chased, Italian, 1619, basin
50.5 cm diameter; ewer 46 cm high*

The basin is dated (in a shield held by one of the tritons)
1619; the arms are those of the Lomellini family of Genoa.
The cartouches on the rim of the basin feature loves of
Jupiter: Danaë, Olympias, Leda and Semele. In the bowl a
sea-battle between nude warriors on sea-horses, tritons
and nereids, against a background perhaps showing the
Ligurian coast, is depicted with great vivacity and subtlety.
On the central boss, behind the figure of Victory
crowning Neptune, rises the landmark of the lighthouse
of Genoa. The ewer has a handle with the young
Hercules astride its top, cartouches showing Venus and
Cupid, and Mars, on the shoulder, and on the body in
high relief, the triumph of Neptune and Amphitrite. They
formed part of a set now dispersed between the
Ashmolean Museum, Birmingham City Art Gallery and
the Victoria and Albert Museum. These superb examples
of the goldsmith's craft at its most exuberant and most
sophisticated were bought by the 5th Earl of Shaftesbury
(1761-1811) in Naples in 1807.

*Purchased with the aid of the Victoria and Albert Museum
Purchase Grant Fund, The Art Fund and the Friends of the
Ashmolean, 1974. (WA1974.234-5)*

'Powhatan's Mantle' ↺

*Deer-skin, with shell decoration, North American
(Virginian), early 1600s, 235 x 160 cm*

Not only the most famous exhibit from the
Ashmolean's founding collection, 'Powhatan's
Mantle' is also one of the earliest documented. In
1638 Georg Christoph Stirn recorded seeing 'the
robe of the King of Virginia' at the Ark in South
Lambeth. As leader of the confederation of tribes
with whom the settlers at Jamestown had to
negotiate at the time of its foundation in 1607,
Powhatan was already well known in London.
How his 'mantle' came to enter the Tradescant
collection is unknown, although Captain John
Smith (about 1580-1631, sometime president of
the Virginian colony) and John Tradescant the
Younger (1608-1662, who visited Virginia in
1638) have both been suggested; whatever
the case its exhibition at South Lambeth
must have caused a sensation.

While the Powhatan connection seems
likely enough, the rather traditional
identification of this piece as a cloak or
mantle cannot be supported. It seems
likely to have been a ritual hanging,
charged with symbolism. It is constructed
from four skins of white-tailed deer,
sewn together with sinews; the pictograms
composed of shells, similarly attached, include
a central figure in human form flanked on one
side by a cloven-hoofed animal (a deer?) and on
the other by a feline (a cougar?), both upright.
The remaining circular-spiral motifs may be
intended to represent settlements – perhaps
those bound together in the Powhatan
confederacy.

While the meaning of its symbolism is
lost, 'Powhatan's Mantle' remains the
single most important artefact surviving
from the period of first contact between
European settlers and the Native Americans
of Virginia.

(AN1685B.205)

Georg Petel (1601/2 - about 1634)
Venus and Cupid ↻↺
Ivory, German, about 1624, 40.5 cm high

Signed on the base *IÖRG.PETLE.F*. A superlative example of German small-scale sculpture of the early 1600s, once in the collection of Rubens and possibly based on a design by him. Petel worked in Rome and Flanders as well as in his home town of Augsburg, and this statuette may perhaps be dated about 1624, when he and Rubens were both in Antwerp. It was bought by George Villiers, 1st Duke of Buckingham (1592-1628), from Rubens's collection; and ultimately was one of the most prized acquisitions (1932) made for the Museum by Lord Clark when he was Keeper of Fine Art at the Ashmolean.

Purchased in 1932. (WA1932.194)

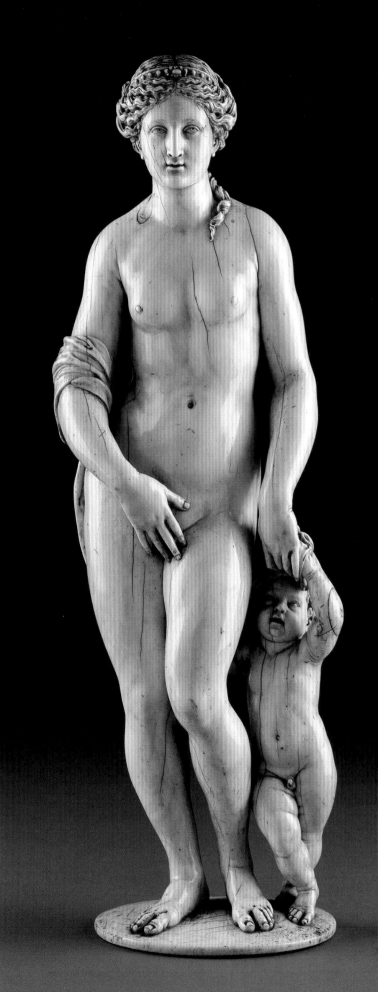

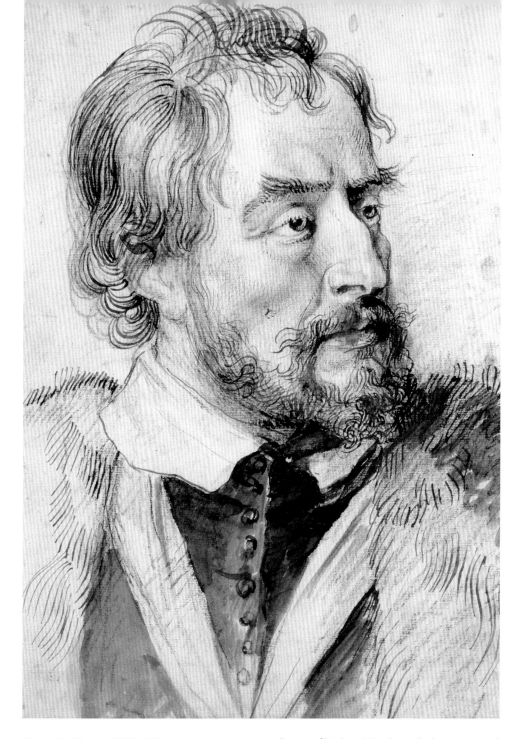

Sir Peter Paul Rubens (1577-1640)
**Thomas Howard, 2nd Earl of Arundel
(1585 -1646)** ⚲
*Pen and brush in brown ink over black and red chalk on
paper, Flemish, about 1629-30, 28 x 19 cm*

Probably made from the life by Rubens when he was in
England in 1629/30, the drawing was almost certainly
taken back to Antwerp to serve as a record of the earl's
likeness, although it does not correspond exactly with any
of three known paintings of him. In superb condition and
in an unusual combination of media, it is one of the finest
portrait drawings in existence by the artist. Arundel, who
patronised Rubens, formed one of the most important art
collections of his day. His Greek inscribed monuments and
many of his Greek and Roman sculptures are now in the
Ashmolean along with a number of single items, including
in particular the ancient Felix Gem, one of the undoubted
treasures of the Museum (see p. xx). Arundel was
somewhat less successful in his diplomatic and military
career and died a lonely bankrupt in exile in Italy in 1646.

*Purchased, with grants from the National Heritage Memorial
Fund, The Art Fund, the Museum and Galleries Commission,
Victoria and Albert Museum Purchase Grant Fund, the Michael
Marks Charitable Trust and the Friends of the Ashmolean,
1994. (WA1994.27)*

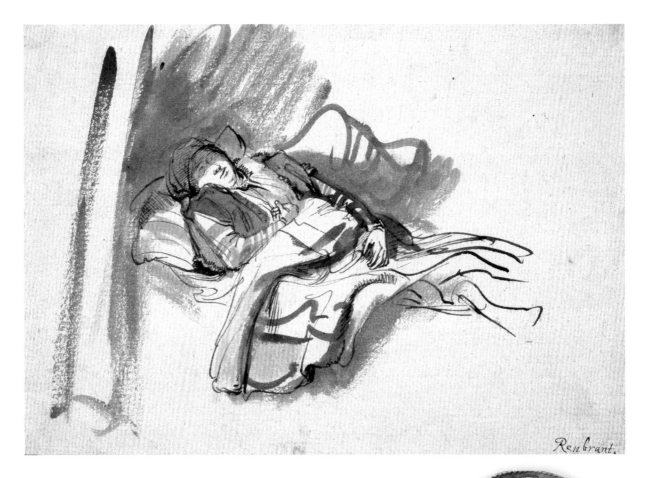

Rembrandt van Rijn (1606-1669)
Saskia asleep in Bed ↻

Pen and brown ink on paper, Dutch, about 1635,
14.4 x 20.8 cm

The inscription *Rembrant* is later, but this is undoubtedly
one of the masterpieces of Rembrandt's own hand. It was
drawn in perhaps a few minutes, with breathtaking speed
and virtuosity and with superb control of the contrast of
different tones of the bistre wash, of the broad brush and
the sharp quill pen, and of light and shade. It records the
artist's young wife Saskia, asleep – perhaps during one of
her frequent pregnancies.

Purchased, 1954. (WA1954.141)

'Oxford crown' ↻
Coin, English, 1644, 4.4 cm diameter

Depicting Charles I on horse (on
obverse) and plumes and inscription
on the reverse. This crown was
struck at the mint in Oxford, which
was situated in New Inn Hall Street,
near the current site of the
Ashmolean. Much college treasure
was struck into coin to support the
royalist cause during the English Civil
War. The obverse shows the city of Oxford
depicted beneath the king's horse.
The inscription on the reverse summarises
Charles I's war aims as support for the
Protestant religion, the laws of England
and a free Parliament.

(HCR6571)

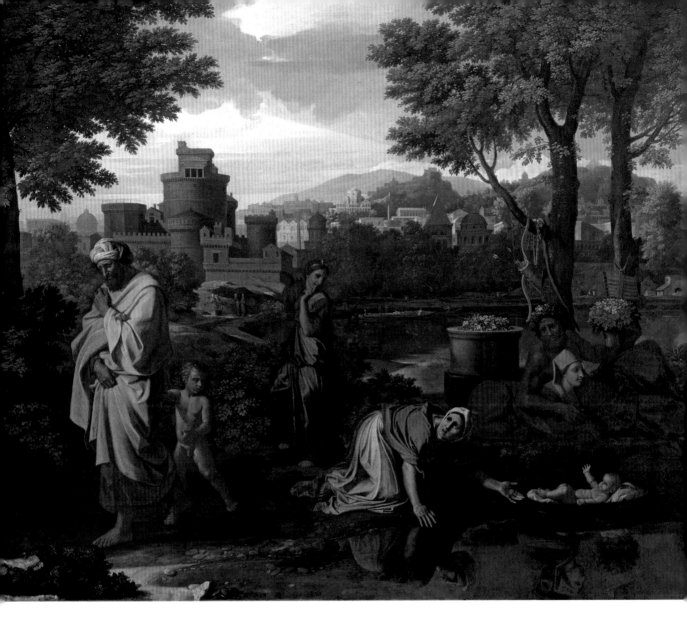

Nicolas Poussin (1594-1665)
The Exposition of Moses ↻
Oil on canvas, French, 1654, 149 x 204 cm

When Pharaoh ordered all new-born Hebrew sons to be killed, Moses's mother put him in an ark of bulrushes in the Nile. His sister stayed to watch while Pharaoh's daughter came to the river with her maidens and found the child (Exodus 2: 2-4). Dating from 1654, late in Poussin's career, the painting is striking for its emotional intensity, with the focus on Moses' grief-stricken parents, although hope dawns in the background. The joyful scene of the finding of Moses was a popular one, whereas this painful subject is far less common. Poussin painted it for his friend Jacques Stella (1596-1657); the picture was greatly admired by contemporaries for the artist's learned treatment of the subject, his skill in painting reflections and the beauty of the landscape. Pharaoh's city is based on the Renaissance artist and architect Pirro Ligorio's

reconstruction a hundred or so years before of some of the most famous buildings of ancient Rome. A sphinx accompanied by a river-god and cornucopia identifies the Nile. Different explanations based on Poussin's antiquarian interests and wide-ranging visual references have been proposed for the significance of the pipes of Pan that hang from a tree behind this group. Two painted copies are recorded in the late 1600s; other copies and variations are known (including a tapestry version of the right side) and three engraved versions were made, the first by Stella's niece Claudine Bouzonnet Stella in 1672.

Purchased through the generosity of the daughters of the Rt Hon. Sir Edward Fry, GCB, with the assistance of The Art Fund, 1950. (WA1950.169, A791)

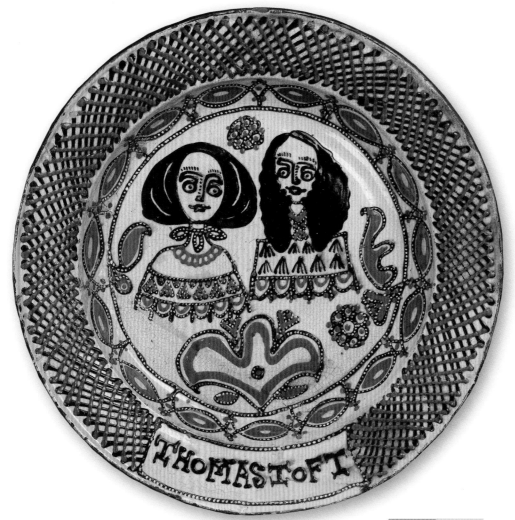

Thomas Toft
Charger ⟳
Slipware, English (Staffordshire), about 1660-1670,
45 cm diameter

The slipware technique – in which decorative motifs were painted onto earthenware vessels (in this case a large dish or charger) with thin mixtures of coloured clay (slip) before being fired in the kiln – reached a fine flowering in Staffordshire during the second half of the seventeenth century. Amongst the principal exponents were a father and son from Stoke-on-Trent, both named Thomas Toft, whose name is borne by this impressive piece. (The form of the lettering has been taken to indicate that it is a work of the son rather than the father.) The buff earthenware body has been coated in yellow slip to form a field on which are represented in typical naïve style the busts of an aristocratic man and woman of the Restoration period, thought perhaps to represent the then Prince of Wales, James Stuart (later James II and VII), and his first wife Anne Hyde, daughter of the Earl of Clarendon.

(AN 1940.343)

CONNECT

Willem Kalf (1619-1693)
Still Life with an Oriental Rug ↻
Oil on canvas, Dutch, about 1660-1665, 65 x 54 cm

After painting a number of barn interiors in the early 1640s, Kalf began to specialise in painting still-life compositions of luxury objects in which he displayed his talent for rendering effects of light and texture. The silver dish in the foreground, the knife with a cornelian handle, the watch, the tall cup and cover, the oriental rug and translucent blue-and-white Chinese bowl are beautifully illuminated by a shaft of light that picks them out against a dark background. As several of the items included in this painting reappear in a number of words dating from the early 1660s, this painting probably dates from the same period. It is part of a large collection of Dutch and Flemish still-life and flower paintings assembled by the artist Daisy Linda Ward (1883-1937) and her husband Theodore Ward.

Daisy Linda Ward Bequest, 1939. (WA1940.2.39, A563)

Mughal carpet ↻

Pashmina wool pile, silk warps and wefts, Indian, about 1660, 211 x 147 cm

This superb, finely knotted carpet, possibly from Kashmir or Lahore, is one of the most important objects in the Museum's collection of Mughal Indian art. Carpet weaving developed among the nomadic peoples of central Asia and Iran and was introduced into India under the Mughal emperors, especially Akbar (1556-1605), who brought carpet-weavers from centres such as Herat in modern Afghanistan. This carpet is a refined example of the late seventeenth-century millefleur style, which developed from European influences on the abundant Mughal repertoire of floral patterns. In the main field diverse floral sprays, blossoms, leaves and palmettes are connected by scrolling vines in repeating pattern units. The border pattern employs the traditional motif of lotus buds and flowers, found in Indian art since ancient times.

Purchased with the help of the beneficiaries of Sir David Ross and the Friends of the Ashmolean. (EA1975.17)

Porcelain jar ↻

Underglaze blue and overglaze enamel, Japanese, about 1670, 42 cm high

This is an exceptionally large jar for its date, the early period of the export porcelain trade from the Arita kilns in Kyushu through the Dutch and Chinese merchants to the West. Although it has sagged slightly in the kiln, it was considered worth saving by the kiln-master, who had it decorated in the characteristic colours of the early Kakiemon masters; the painter has even emphasised the bulge instead of trying to conceal it. The trade in porcelain from Japan began in the mid-1600s and developed into a considerable undertaking for the Arita potters, with only half a century's experience of making porcelain, for they had to compete with the thousand-year-old industry of Jingdezhen in China. By the 1720s

Arita had succumbed to economic pressures from China and only the domestic market survived. It has become the custom in the West to call the blue-and-white products Arita, and the coloured wares Imari after the port of that name. A group of the coloured wares (and, in fact, of the blue-and-white wares also) have been singled out as products first of the Kakiemon painters and enamellers and then of the Kakiemon kiln. These are usually the finest products of Arita, but not necessarily the most sumptuous. Extremely fashionable in Europe in the 1600s, Japanese porcelain was often a major component of royal porcelain collections; for instance, Mary II at the time of her death in 1694 had over seven hundred pieces of porcelain at Kensington Palace, about half of which were Japanese and half Chinese.

Anonymous gift. (EA2000.19)

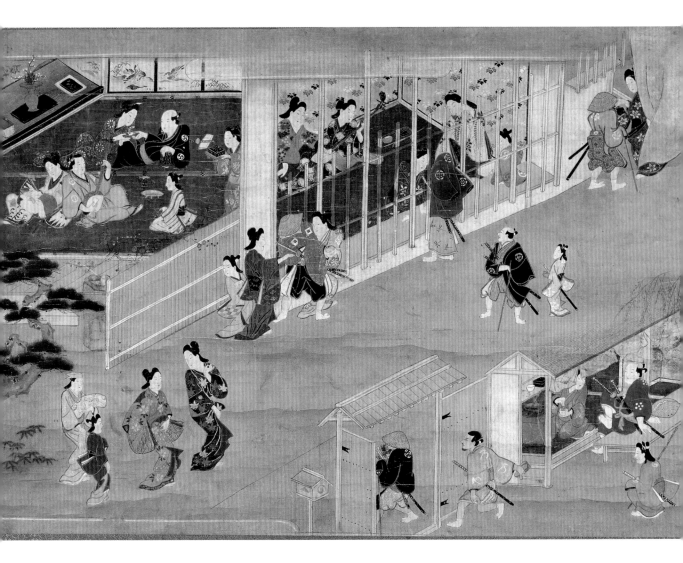

Anonymous
Scene in the pleasure quarters ⌕
Hanging scroll, ink and colours on paper, Japanese,
about 1670-1685, 52.7 x 77.7 cm

The licensed pleasure quarter of Edo (modern Tokyo) was the Yoshiwara, a restricted area where the rules of society were different. Here passed the ephemeral life of the courtesan and her rich clients, of the Kabuki actors, the wrestlers and other popular heroes of the day. The paintings and woodblock prints that celebrated this life were called 'paintings of the floating world', *Ukiyo-e*, and they differed sharply from the products of the classical schools of Japanese painting. The emphasis was on people and their occupations, their surroundings and their way of life. The perspective is vertical – that is, the higher up the figure is, the further away – giving the whole scene a tilted-up aspect, but it allows great attention to detail.

Here a future customer drinks tea outside the gate at a tea-stall, while two others enter through the gate; one conceals his identity in a basket-hat. The courtesans, such as the two with their servants to the lower left, are very richly dressed, proclaiming their status in this world within a world. Further clients look through the windows of the 'Green Houses' to see the carousing within. This painting, unsigned, may be a fragment of a larger composition, though it seems self-contained; it follows some of the characteristics of the pioneer painter of this genre, Hishikawa Moronobu (about 1618-1694) but cannot be certainly attributed to him.

Presented by C.W. Christie-Miller. (EA1959.87)

Model of a book ⮎
Tin-glazed earthenware ('delftware'), English, 1672, 12.7 cm high

This amusing model book, of a type sometimes thought to have been used as a hand-warmer, is inscribed with memento mori inscriptions: *TOE POTERS CLAY THOU TAKEST ME TO BE REMEMBER THEN THY ONE MORTALYTY 1672 and EARTH I AM IT IS MOST TREW DISDAIN ME NOT FOR SOE ARE YOU.* Tin-glazed pottery was introduced to England from the Low Countries in the Elizabethan period; it was widely made in England in the 1600s and 1700s, and this type of ware is named after the great Dutch production centre at Delft.

Presented by Mrs J.D. Warren. (WA1963.136.45)

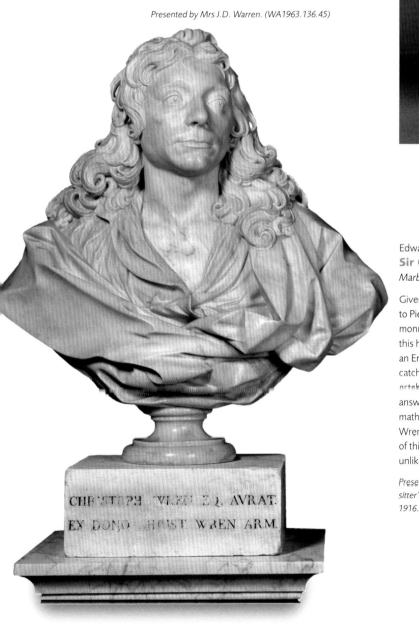

Edward Pierce (about 1635-1695)
Sir Christopher Wren (1632-1723) ⮌
Marble bust, English, 1673, 66.1 cm high

Given by the sitter's son in 1737, and attributed by him to Pierce. Portrait busts, other than for funerary monuments, were still extremely rare in this period, and this has been called the best piece of sculpture made by an Englishman in the 1600s. No other portrait of Wren catches him in anything but the settled dignity of the establishment; this one, in its quick and eager vitality, answers the versatile genius of the young sitter, brilliant mathematician and great architect. Pierce worked for Wren as a sculptor, notably in St Paul's; the exuberance of this bust and the sophistication of the treatment are unlike anything else in Pierce's work.

Presented to the University of Oxford by Christopher Wren, the sitter's son, 1737. Transferred to the Ashmolean Museum, 1916. (WA1916.74, NBP559)

Lovers at Dawn: Raga Vibhasa ↻
*Gouache with silver and gold on paper, Indian, about
1675, 19.7 x 15 cm*

While a lady sleeps languorously in a palace bed-
chamber, her lover prepares to depart at daybreak; he
holds a floral bow and arrow like that of the Hindu love-
god Kama. A wine flask and cups stand in a niche behind
them, and a peacock promenades on the roof above.
This amorous scene belongs to a series of *ragamala*
('Garland of Ragas') paintings, a popular artistic and
poetical genre in India from about 1500-1800. The
essential character of each of the musical modes (*ragas*)
was evocatively depicted in a range of compositions
filled with ladies, lovers, warriors, gods and ascetics, as
well as birds and animals. The subtle richness of colour
and the decorative detail suggest that it was painted at a
court in the northern Deccan. The Museum has four
more paintings from the same series.
Purchased in 1991. (EA1991.154)

Claude Gellée (Le Lorrain, 1604/5-1682)
Landscape with Ascanius shooting the Stag of Silvia ○
Oil on canvas, French, 1682, 120 x 150 cm

Signed and dated: *Clavdio .I.V.F.A Romae 1682;* and inscribed by the artist: *come. Ascanio. saetta il. Ceruo di Silvia figliuola di Tirro lib. 7. Vig.* Signed again below: *Clavdio Rom.* An inscription recorded on the back of the original canvas was probably written by the artist: *Quadro per l'Ill.mo et excell.mo Sig. Contestablile Colonna questo di 5 Ottobre 1681.*

Painted for Lorenzo Onofrio Colonna (1637-1689) in 1681-1682 as a pendant to the *Dido and Aeneas before Carthage* of 1675-1676 (now in the Kunsthalle, Hamburg), this haunting scene was Claude's last painting. The subject is from Virgil's *Aeneid* (VII, 483-99): Ascanius, hunting in Latium with his companions, becomes the instrument of the Fury Alecto who is sent by Juno to provoke war. Alecto, here evoked by the wind bending the trees in an impending storm, directs Ascanius's uncertain aim to wound mortally the tame stag of Silvia, the daughter of Tyrrheus, ranger to the king of the Latins; war ensues. The silvery tones and hazy atmosphere of the beautifully composed landscape, which is based on Claude's studies of the countryside around Rome, suggest the tranquillity and calm that is about to be lost once the arrow of Ascanius cuts across the river valley. The earlier pendant takes as its starting point Virgil's description of Dido and Aeneas leaving for the hunt (IV, 136-42) but the composition encapsulates other moments in the narrative, including Dido showing Carthage to Aeneas, and Dido accusing Aeneas of betrayal. Both pictures explore moments of peacefulness and uncertainty before violence and sorrow, and both are concerned with Aeneas's heir, Ascanius, for whose future Aeneas abandoned Dido. Each includes prominent reference to the Colonna family emblems of columns. The pendants remained together until 1801. Mrs Weldon also presented to the Ashmolean one of Claude's compositional drawings for the painting.

Presented by Mrs W.F.R. Weldon, 1926. (WA1926.1, A376)

Dish ↻

Fritware with underglaze painting in blue, Safavid Iran, about 1600-1720, 44.5 cm diameter

A charming example of Safavid blue-and-white ware, with seven quails decoratively dispersed within a meander border. In the 1600s and 1700s much of the pottery production in Iran concentrated on the copying of imported Chinese blue-and-white porcelains. Occasionally pieces of such quality were produced that they were mixed with the Chinese by unscrupulous traders for sale to unsuspecting Europeans. Like numerous Islamic ceramics now at the Ashmolean, this piece originally belonged to the writer and art collector Gerald Reiltinger, and came to the Museum as part of his generous gift in 1978. Reiltinger passionately collected Islamic as well as Chinese, Japanese, and Korean ceramics, and he had a keen interest in the cultural and artistic relationships between the Middle and Far East, as well as between Asia and Europe.

Gift of Gerald Reiltinger. (EA1978.1783)

Large storage jar ↺

Porcelain with underglaze decoration in iron and cobalt blue, Korean, about 1690, 39.7 cm high

Korean ceramics are at many periods closely related to Chinese wares but the irregular, rounded shape of this jar is distinctively Korean. It is an outstanding piece of potting and the underglaze painting in iron and cobalt blue is unusual for both its quality and motif; the grape vine was favoured on court wares but usually appears in iron-brown only. The jar is a rare example from the late seventeenth century (Choson dynasty) and no comparable piece is known.

Given by Mr and Mrs K.R. Malcolm in memory of their son John Malcolm, Scholar of Worcester College, died 1974. (EA1974.016)

Jean-Antoine Watteau
(1684-1721) ⓖ
Le Repos Gracieux
*Oil on panel, French,
about 1713,
19.5 x 11.3 cm*

This small, intimate scene
is typical of Watteau's
charming and often
enigmatic paintings
inspired by theatrical and
musical themes; it may
date from around 1713.
The figures are dressed
as Columbine and
Crispin, from the
Commedia dell'Arte and
French popular drama
respectively; they may be
actors or lovers in fancy
dress. Watteau
developed the *fête
galante*, a subject
involving elegant
gatherings in a parkland
setting, with music and
fancy dress, to which
he brought a new
psychological sensitivity
and refinement of touch.
The figures reappear in
an engraving by Gabriel
Huquier.

*Presented by Mrs W.F.R.
Weldon, 1927.
(WA1927.2, A387)*

Goblet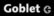

Of baluster form, with Adam and Eve in diamond engraving, English, about 1710-1720, 27 cm high

The Ashmolean's holdings of glass from the late 1600s and early 1700s are large, comprising over 750 pieces. They come principally from two collections that were acquired between 1948 and 1957. The first was a bequest of 122 glasses from Sir Bernard Eckstein (1894-1948), a wealthy businessman who had attended Trinity College, Oxford. The second, more eclectic collection came from Mrs Monica Marshall. It comprises nearly five hundred pieces that range from simple tavern glasses to more elaborate pieces like this goblet. The decoration shows Adam and Eve with the tree of knowledge and the serpent, among the beasts of the field and the birds of the air.

Presented by Mrs Monica Marshall, through The Art Fund, 1956. (WA1957.24.2.21)

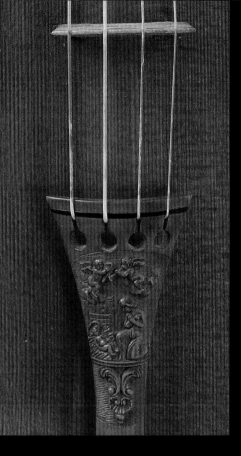

Antonio Stradivari (1644?-1737)
Violin ⊙ ⊙
Spruce, maple and ebony woods, Italian (Cremona),
1716, 59.3 cm long

This violin bears the original label: Antonius
Stradivarius Cremoensis / Faciebat Anno 1716.
Known as the 'Messiah', this is one of the most famous
violins in the world. In the 1800s one of its owners,
Tarisio (about 1790-1852), often boasted about it but
hardly ever produced it until someone said: 'It's like
the Messiah, always promised and never appearing.'
The body has survived in excellent condition although
the neck has been lengthened and the fingerboard,
tail-piece and pegs are modern. The varnish is
particularly well preserved. Joseph Joachim (1831-
1907) praised the tone when playing the instrument in
the late 1800s. It came to the Museum with the
remarkable gift of the Arthur and Alfred Hill Collection
of musical instruments, 1939.

Presented by Arthur and Alfred Hill in 1940. (00A1940.112)

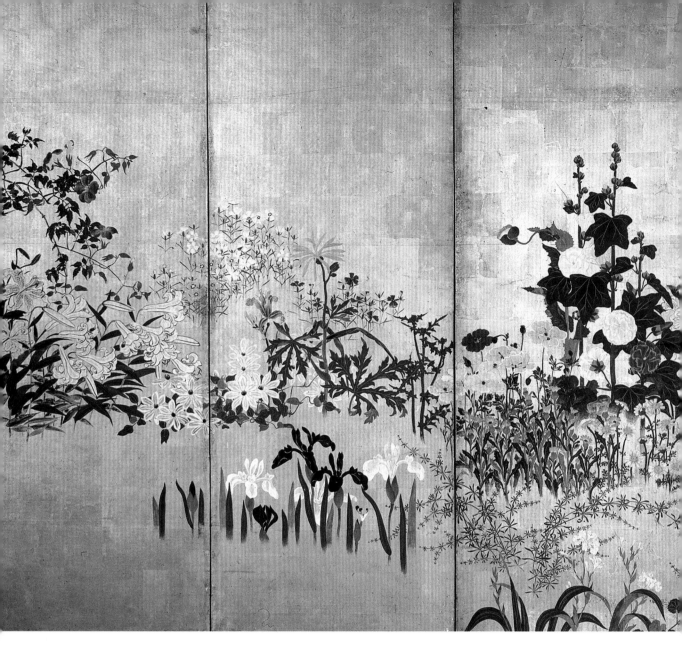

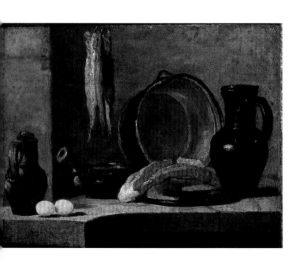

Jean-Siméon Chardin (1699-1779)
Still Life of Kitchen Utensils G
Oil on canvas, French, about 1733-1734, 32.5 x 40.3 cm

On a curved stone shelf in front of a concave recess are two earthenware jugs, a pipkin, a brass cauldron and a pewter dish. A flat loaf and a chunk of salmon lie on the dish; two eggs are on the left, and three herrings are suspended from a hook. Despite the modesty of the individual elements, Chardin has endowed this small still-life painting with a sense of monumentality, accentuated by the sweeping curve of the shelf and the strong play of light and shade. Chardin's studies of kitchen utensils fall roughly into the years 1728-1734; before that he concentrated on still life with game. He may have turned to kitchen subjects on his admission to the Academy in 1728 to distinguish himself from artists such as François Desportes (1661-1743) and Jean-Baptiste Oudry (1686-1755), who specialised in game and hunting pieces. This striking scene was probably painted about 1733-1734; two other versions are known.

Presented by Mrs W.F.R. Weldon, 1927. (WA1927.3, A388)

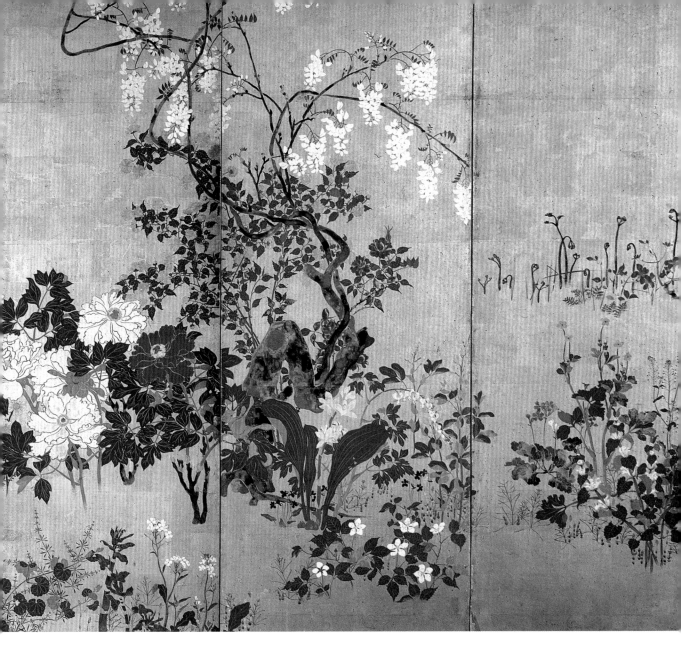

Attributed to Watanabe Shikō (1683-1755)
Flowers of the four seasons ☺
*Ink and colours on paper, Japanese, about 1740, pair of
six fold screens (one pictured), 154.7 x 333.4 cm*

Although unsigned, these screens may be confidently
attributed to Shikō on the basis of signed works. A
follower of the great Ogata Kōrin (1658-1716), Shikō
used the decorative styles of the so-called Rimpa school
but drew his inspiration from a close study of nature. He
was ahead of his time in the realistic depiction of
animals, flowers and birds from specimens, often
with considerable anatomical detail. Japanese screens
'read' from right to left; in these screens spring is on the
right, leading through to winter on the left. In Japan the
wild narcissus flowers in December. Although treated as

furniture, screens were of a shape habitually used by
the foremost painters, who saw no difference in status
between painted screens and hanging paintings.
Screens usually, but not always, occur in pairs; they are
most commonly of six folds but frequently of two and
occasionally of eight. They may be of head height or less
than a metre tall and are painted to be viewed from a
sitting position; thus in the West they often have to be
raised from the floor level. They are eminently moveable
and do not conform to the rigid module of the classical
Japanese room. Japanese rules of perspective decree
that viewers are always at right angles to any place in a
screen, so that they do not cast their eye across the
painting but, as it were, walk past it.

(EA1970.174-5)

Plate with view of the Church of SS Giovanni e Paolo, Venice ↻

Glass, Italian (Venice), about 1741, 22.7 cm diameter

Part of a set of white glass known as *lattimo*, made in imitation of porcelain, painted with Venetian scenes. This scene is derived from an engraving by Antonio Visentini (1688-1782) after Canaletto. It is from a set made for an influential English 'grand-tourist' in Italy, Henry Fiennes Clinton, 1st Earl of Lincoln (about 1544-1616).

Presented by The Art Fund in memory of Robert Charleston. (WA1997.25)

Francis Perigal I (active 1741-1756)
Watch ↺
Gold and agate, English, about 1745, 4.83 cm diameter

The outer case, shown here, is carved from a single piece of reddish, brownish-veined agate, mounted in gold cagework (mark of Stephen Goujon, registered 1720). Part of Eric Bullivant's bequest (1974), which strengthened the rich collection of watch cases bequeathed by J.F. Mallett (1947).

Bequeathed by Eric Bullivant, 1974. (WA1974.157)

Thomas Gainsborough (1727-1788)
Margaret Gainsborough gleaning ↻
Oil on canvas, English, about 1755, 73 x 63 cm

Gainsborough's two daughters were the subjects of several of his most enchanting paintings of the 1750s. This is the surviving half of a double portrait which was described in the *Somerset House Gazette* in 1824 as showing 'his two daughters in the garb of peasant girls on the confines of a cornfield dividing their gleanings'.

Purchased with the aid of a gift in memory of Helen, Henry and Marius Winslow and the assistance of the Victoria and Albert Museum Purchase Grant Fund, 1975. (WA1975.72, A1076)

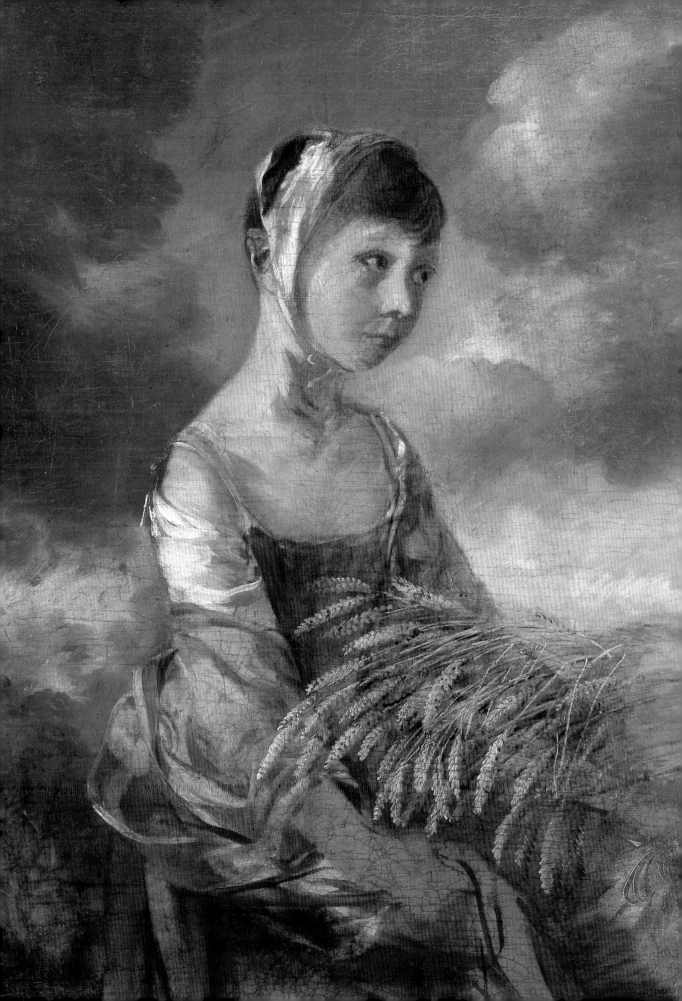

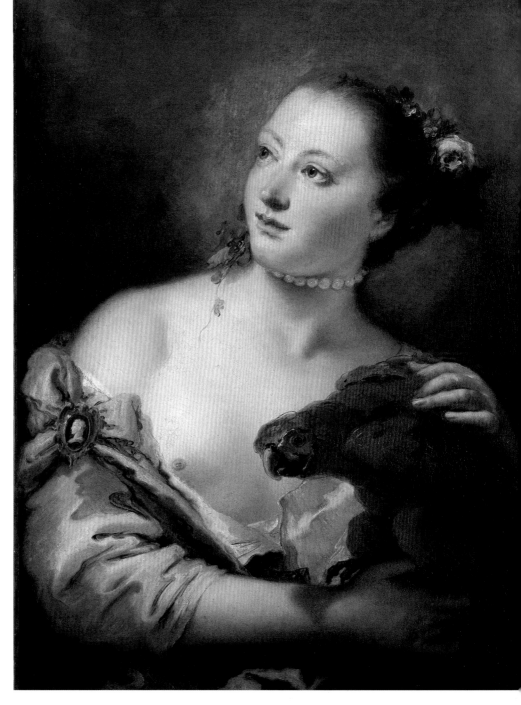

Giovanni Battista Tiepolo (1696-1770)
A Young Woman with a Macaw ♫
Oil on canvas, Italian, about 1760, 71 x 53.4 cm

A brilliantly painted and seductive image, this probably belongs to a series of half-length *capriccio* portraits of women made for Elisabeth Petrovna, Empress of Russia (1741 - 1761), on which Tiepolo was working in late 1760. This distinctive Venetian genre of poetic or fantasy portraits derives from Giorgione (about 1477/8-1510), and Tiepolo – who was celebrated as a latter-day Veronese (1528-1588) – often looked to sixteenth-century Venetian art for inspiration. Such images of beautiful women are often categorised as courtesans. Exotic birds are common in Tiepolo's work (as in that of

Veronese) and here the macaw provides a colourful and witty motif. The cameo portrait shows one of the Caesars, possibly Augustus. Tiepolo's son Lorenzo made a pastel copy of the painting (National Gallery of Art, Washington DC), together with a companion piece showing a woman in a fur wrap that may record a lost oil painting by his father. A red chalk drawing after the painting, with some variations, probably by Lorenzo, is in the Ashmolean (PII 1082).
Presented by The Art Fund from the collection of
Ernest E. Cook, 1955. (WA1955.67, A876)

Louis-François Roubiliac (1702-1762)
George Frideric Handel (1685-1759) ⤷
Terracotta, about 1762, 98 cm

This is one of Roubiliac's models for the full-scale
marble monument set up opposite Poets' Corner in
Westminster Abbey in 1762. Roubiliac, a native of Lyon
in France, brought to England the virtuosity and
movement and also, in portrait characterisation, the
naturalism of the finest European rococo sculpture. This
monument is far distant from the traditionally pompous
mode of funerary sculpture and shows the great
composer in everyday dress involved with the
composition of his score, humanly credible in posture
yet also nobly elegant. Handel points to an angel
playing a harp, as if claiming inspiration.

Presented by James Wyatt, 1848. (WA1848.1, NBP565)

Pompeo Batoni (1708-1787)
David Garrick ↻
Oil on canvas, Italian, about 1763-1765, 76 x 63 cm

David Garrick (1717-1779), the celebrated actor and playwright, travelled in Italy in 1763-1765 with his wife, the ballerina Eva Maria Veigel. This graceful portrait by Batoni, then the most successful portraitist in Rome, was made as a gift for Richard Kaye in exchange for an antique gem that Kaye had found at the Baths of

Caracalla. Garrick holds an illustrated edition (1736) of Terence's *Comedies*, with a page showing the masks for the *Andria* copied from a manuscript in the Vatican Library. This refers to Garrick's profession, classical learning and appreciation for antique works of art such as the carved gem that Kaye was to give him. Various copies of the portrait are known, some commissioned by Garrick himself.

Acquired by 1827. (WA1845.61, A61)

Circular dish ↻

Worcester porcelain, English, about 1770, 29.1 cm diameter

The Ashmolean contains the most comprehensive representation anywhere of coloured Worcester porcelain of the 'First (Dr Wall) Period' (1751-1783). This particular piece features decoration by J.H. O'Neale of a mule attacking a seated cavalier and his small dog, based on Aesop's fable 'The Ass and the Little Dog'. The dish is one of the items in this magnificent collection of over a thousand pieces.

Presented through the Art Fund by Mr and Mrs H.R. Marshall in memory of their only son William Somerville Marshall, of Trinity College, Oxford, 1957. (WA1957.24.105)

James Cox (active from 1749, d. 1791/2)
Striking clock ↻
English, about 1780, 65 cm high

James Cox, who signed the movement of this clock, was an entrepreneur in the second half of the eighteenth century in London. In 1769 he bought the Chelsea porcelain works but is chiefly remembered for his elaborate automata, which he exhibited in a museum at Spring Gardens. The case of this clock was almost certainly not designed by him but supplied to him by an unidentified designer. The ormolu case is topped with the arms of Henry Benedict. Cardinal of York (1725-1807), the last of the Stuarts, but as these have been clearly added to the original clock it is probable that the clock was not made for him. The allegorical figures, now gazing upwards at the arms, may originally have been looking at a figure of Father Time. The clock came to the Museum with the bequest of the art dealer J.F. Mallett in 1947. This was one of the richest and most varied bequests ever received by the Ashmolean.

Bequeathed by J. Francis Mallett, 1947. (WA1947.191.184)

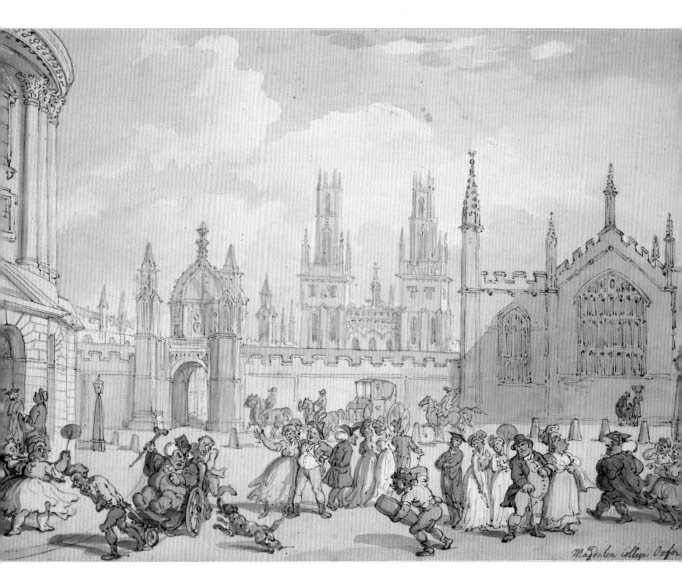

Thomas Rowlandson (?1756-1827)
Radcliffe Square, Oxford ☊
Pen and reddish-brown ink and watercolour on paper,
English, about 1790, 22 x 31.1 cm

Oxford was regarded in the late eighteenth century as one of the most beautiful cities in Europe, and many artists depicted its charms. Rowlandson's view of All Souls College, with the Radcliffe Camera on the left, is based on the engraving by Isaac Taylor (1759-1829) for the *Oxford Almanack* (the University calendar) of 1790. As the outstanding caricaturist of his age, Rowlandson has enlivened the scene with characteristically irreverent humour, such as the notably portly dons, one in a bath chair being harried by a dog.

Presented by Mr A.E. Anderson, 1910. (WA1910.3, DBB1605)

Sir Francis Chantrey (1781-1841)
William Wordsworth (1770-1850) ↺
Plaster, English, about 1820, 57.5 cm high

The model for a marble bust (now at the
University of Indiana) of the great Romantic poet
commissioned in 1820 by Sir George Beaumont
(1753-1827), leading patron and arbiter of taste in
Regency times, and a generous benefactor of
Wordsworth. Somewhat idealised ('the soul of the
poetry, but not the countenance of the man', said
Coleridge), this is nevertheless in many ways the
most satisfactory portrait of Wordsworth. Chantrey
kept the models for most of his commissions; these
were all given to the University by his widow in 1842
and constitute one of the founding gifts to Cockerell's
University Galleries.

*Presented to the University by Lady Chantrey,
1842. (WA1842.121, NBP784)*

Samuel Palmer (1805-1881)
The Valley Thick with Corn ☉
*Pen and dark brown ink on paper, English, 1825,
18.2 x 27.5 cm*

From the mid-1820s to the mid-1830s Samuel Palmer
produced a range of visionary landscapes in a technique
peculiar to him, creating from the Kentish countryside
around the little village of Shoreham an idyll of pastoral
luxuriance and abundance. This landscape is far from a
literal description, and is transposed into what Palmer
called 'the ponderous globosity of art'; in mood it is
reminiscent of the little woodcut illustrations by William

Blake (1757-1827) for Thornton's *Virgil*, conveying an
intense mystical apprehension of divinity informing
nature. The title comes from Psalm 65; the reclining
figure has been connected with John Bunyan's Christian,
resting half-way up the Hill Difficulty, in *The Pilgrim's
Progress* (first published 1678). This work is one of six of
the same date and technique which, together with the
haunting *Self-Portrait*, are the greatest glories of the
Ashmolean's outstanding and uniquely representative
collection of paintings, drawings and etchings by
Samuel Palmer.

Purchased, 1941. (WA1941.103)

William Blake (1757-1827)
**Dante and Statius sleeping;
Virgil watching** ↻
*Watercolour with some pen and black ink on paper,
English, about 1826, 52 x 36.8 cm*

The painter John Linnell (1792-1882), friend and patron of
Blake, from whose collection this came, commissioned a
set of illustrations for Dante's *Divine Comedy* from Blake
in 1824. Blake died before completing the series, which
numbered 102 watercolours and numerous related
studies. This one illustrates Canto 27, ll. 70-108, of
Purgatory: the poets rest after passing through the flames
guarding the Seventh Circle, Statius below, Dante in the
middle and Virgil leaning on his elbow above. Within the

enormous moon appears Dante's vision of Rachel and
Leah, the Old Testament types of the active and the
contemplative life. A characteristic and beautiful example
of Blake's visionary style, it reports what his 'inner eye'
saw but also depends on what his more orthodox eyes
had registered – in Michelangelo and in Gothic ogee
curves. Blake's Dante drawings remained in the
possession of Linnell's descendants until they were sold at
Christie's in 1918. The National Art-Collection Fund (now
The Art Fund) bought the drawings and distributed them
to museums and galleries in the UK and the
Commonwealth; the Ashmolean received three.

Presented by The Art Fund, 1918, WA1918.3, DBB387.]

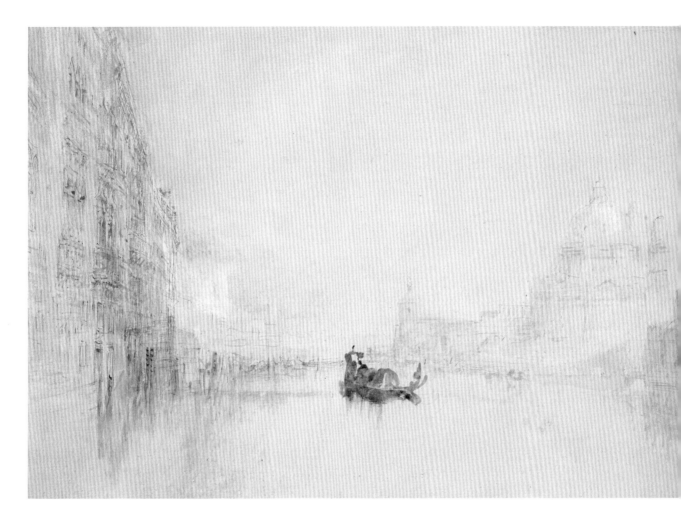

John Constable (1776-1837)
Water Meadows near Salisbury ☉
Oil on canvas, English, 1829, 32 x 38 cm

Archdeacon John Fisher (d. 1832) became Constable's closest friend, and Constable made long visits to him in the Close at Salisbury in the summer of 1820 and in July 1829. Constable painted several sketches looking from Fisher's house towards the ridge running westwards from Harnham Hill. This sketch corresponds to the left half of another sketch, dated 12 July 1829 (Victoria and Albert Museum, London), which is similarly painted with thick impasto and characteristic tiny dabs of red.

Presented by Chambers Hall, 1855. (WA1855.585, A202)

Joseph Mallord William Turner (1775-1851)
Venice, the Grand Canal ☉
*Watercolour on paper, English, 1840,
21.5 x 31.5 cm*

Santa Maria della Salute is seen on the right of this picture. Drawn in 1840 during Turner's last visit to Venice, this is among the finest of his later watercolours. Realised in swiftly fluid, delicate washes of diaphanous yet brilliant colour, it is stabilised by very economic pen-work and anchored in the dark tones of the gondola. This is one of the magnificent group of drawings by Turner, including two other watercolours of Venice, given to the University in 1861 by John Ruskin (1819-1900), patron and passionate apologist for the artist's work.

Presented by John Ruskin, 1861. (WA1861.8)

John Ruskin (1819-1900)

St Mark's, Venice. Sketch after Rain ↻

Watercolour on paper, English, 1846, 43 x 29.2 cm

Ruskin's talent as a draughtsman tends to be overshadowed by his greater fame as a writer and a social reformer. An undergraduate at Christ Church, he was later the first Slade Professor at Oxford (1870-1879, 1883-1884), and founded the Drawing School that bears his name in 1871. His lessons in drawing were based on a series of several hundred examples, including many by Ruskin himself, which are now housed in the Ashmolean. This work was included as an illustration of 'the connection between decorative and realistic design'.

Presented by John Ruskin to the Ruskin Drawing School (University of Oxford), 1875; transferred to the Ashmolean Museum about 1949. (WA.RS.ED.209)

Sir John Everett Millais (1829-1896)

The Return of the Dove to the Ark ↻

Oil on canvas, English, 1851, 88.2 x 54.9 cm

In 1850 Millais began work on an ambitious painting of *The Deluge*, known from descriptions in letters to Thomas Combe and from a drawing in the British Museum. His eventual painting, which is not the sermon he had at first envisaged, is much less rhetorical. The subject is from Genesis 8:11: in order to ascertain whether the Flood had abated, Noah sent out a dove which returned with a sprig of olive. Here the daughters of Noah hold the dove and the olive sprig. Although the background is untypically dark, the details are painted with astonishing fidelity. Ruskin so admired the work that he tried to buy it when it was exhibited at the Royal Academy in 1851, but it had already been sold to Thomas Combe in March. Its new owner hung it on one side of Holman Hunt's *The Converted British Family*, with Charles Collins's *Convent Thoughts* on the other. The frame is original and includes elements appropriate to the painting: olive leaves and fruit.

Combe Bequest, 1893. (WA1894.8, A271)

Dante Gabriel Rossetti (1828-1882)
Elizabeth Siddal (1829-1862) ⏏
Pen and brown and black ink on paper, English, 1855,
13 x 11.2 cm

One of many drawings Rossetti made of Elizabeth during their protracted engagement, and perhaps his most beautiful, conveying with entranced simplicity that melancholy, dreamy, feminine beauty that was the Pre-Raphaelite ideal. The drawing belonged to the artist's brother, W.M. Rossetti.

Bequeathed by F.F. Madan, 1962. (WA1962.17.77)

Philip Webb (1831-1915) and Sir Edward Burne-Jones (1833-1898)
The Prioress's Tale cabinet ⊕
Wood, English, about 1857, 222 cm high

Designed by Webb in 1857 and decorated by Burne-Jones with scenes from the tale told by the Prioress in Chaucer's *The Canterbury Tales*. Chaucer's portrait (following that in Thomas Occleve's manuscript) is shown at the bottom on the right. This was Burne-Jones's first major foray into oil painting, and formed his wedding present to William Morris (1834-1896) at Morris's marriage to Jane Burden in 1858. The principal scene shows the Virgin placing 'grain' on the tongue of a Christian boy to allow him to sing the hymn *Alma Redemptoris* even in death.

Bequeathed by May Morris, 1939. (WA1939.2)

Arthur Hughes (1832-1915)
Home from Sea ∩
Oil on panel, English, about 1856, 50 x 65 cm

This painting was first exhibited in 1857 as *The Mother's Grave*. The original composition, known from a drawing in the Ashmolean, showed the boy desolate over the grave of his mother. The landscape was begun in the summer of 1856 in the old churchyard at Chingford, Essex. Around 1862 Hughes altered the background and added the figure of the sister, for which the artist's daughter Tryphena posed. The painting was shown with its present title at the Royal Academy in 1863. The detail is used to reinforce the pathos of the subject; the ephemeral nature of spiders' webs, dew drops, dog roses and dandelion seeds all emphasise the theme of transience. The boy's loss is retold in the lamb separated from its mother by the barrier of the tomb.

Presented by Vernon Watney, 1907. (WA1907.3, A316)

Edgar Degas (1834-1917)
Study of a jockey ◠
Black chalk on buff paper, French, about 1880-1882,
48 x 31 cm

This bold incisive study was probably drawn in the early 1880s when Degas was working on a number of compositions based on the racecourse. Similar figures appear in several pastels and oil paintings of this period although none corresponds exactly. The model may have been a professional jockey, possibly posing briefly for Degas as the artist rapidly outlined the figure, revising it in the heat of the moment as the jockey changed position.

Bequeathed by John Bryson, 1977. (WA1977.27)

Vincent Van Gogh (1853-1890)
Restaurant de la Sirène, Asnières ⊙
Oil on canvas, Dutch, 1887, 52 x 64.4 cm

During his years in Holland, Van Gogh's paintings were generally dark and limited in colour. In February 1886 he moved to Paris where his meeting with Camille Pissarro (1830-1903) and the painters in his circle brought about a remarkable change. This painting, dating from the summer of 1887, is executed with stabs and strokes of bright colour inspired by the brushwork and colour of Pissarro, Claude Monet (1840-1926) and the Impressionists. Asnières, a district on the river Seine near Paris, was a popular site with the Impressionists. The restaurant featured here was situated at 7 boulevard de la Seine, seen from close to the riverbank and looking up from the river towards the restaurant steps. Van Gogh painted a number of works here, during his first period in Paris. In February 1888 he moved to Arles in the south of France, where the somewhat tentative approach to Impressionist colour evident in this painting developed into the extravagant bravura associated with his later work.

Bequeathed by Dr Erich Alport, 1972. (WA1972.18, A1066)

Camille Pissarro (1830-1903)
The Tuileries Gardens, Rainy Weather ○
Oil on canvas, French, 1889, 65 x 92 cm

The Ashmolean's collection of works by Camille Pissarro is the largest in the world and includes the largest single collection of drawings by any Impressionist artist. This is one of sixteen canvases painted from the windows of the apartment Pissarro rented at 204 rue de Rivoli, Paris, from January 1899. The view looks over the Tuileries towards the Seine, with the spires of the Church of Ste-Clothilde on the right. The weather was wet and cold, but appropriate for the pearly light and subdued effects Pissarro wished to convey.

Bequeathed by Mrs W.F.R. Weldon, 1937. (WA1937.73, A492)

Pablo Picasso (1881-1974)
Blue Roofs, Paris ↻
Oil on millboard, Spanish, 1901, 39 x 57.7 cm

Picasso, whose precocious talent and maturity were remarked upon by contemporaries, was the giant of the modernist movement, a chameleon continually reinventing himself and his art. In 1901, during his second visit to Paris, Picasso made 64 paintings and a number of drawings for an exhibition at Vollard's gallery. His palette at that time was restricted to blue, yellow and white, using mainly bright and clear tones. *Blue Roofs, Paris* is a precursor of what became known as Picasso's 'Blue Period', where more sombre tones were achieved by the addition of black to the palette. This work was painted in May-June 1901, looking out of his lodgings at 130 boulevard de Clichy.

Hindley Smith Bequest, 1939. (WA1940.1.16, A634)

Namikawa Yasuyuki (1845-1927)
Waterfall vase ↻
*Cloisonné enamel with silver wire, on copper, Japanese,
about 1910-1915, 14.9 cm high*

Cloisonné is not a traditional Japanese craft, and the first
three-dimensional pieces were probably those made by
Kaji Tsunekichi (1803-1883) in the 1830s. The craft
developed slowly until the 1870s, when an astonishing
transformation began which converted the clumsy,
muddy-coloured *cloisonné* wares of the early Meiji period
(1868-1912) into the virtuoso works of the period after
about 1890, reaching its apogee in the late Meiji and early
Taisho (1912-1927) periods. Namikawa Yasuyuki of
Kyoto, one of the most celebrated enamellers of his day,
was at the forefront of this development; he did not use
all the new techniques invented during this exciting
period, such as 'wire-less' *cloisonné* or raised *cloisonné*,
but concentrated on the perfection of colours and surface
of the increasingly prominent backgrounds and on the
use of the wire cloisons. Yasuyuki began by sculpting the
wire, treating it as here as part of the design and as equal
in importance to the colours. The conformation of subject
matter to shape is a triumph of design.

Anonymous gift. (EA2002.177)

Aleksandr Nikolaevich Benois (1870-1960)
Design for the décor of the emperor's bedroom, in 'Le Rossignol' ↻
Bodycolours on paper, Russian, about 1914-1917,
63 x 97 cm

One of the eight designs in the Museum by Benois for the Diaghilev (1872-1929) production of the opera *Le Rossignol* by Stravinsky (1882-1971) at the Paris Opera in 1914. Benois considered his *Rossignol* designs to be among his masterpieces, and never forgave Diaghilev when he replaced them with new ones by Matisse (1869-1954) for a ballet production of Stravinsky's music in 1920. This design was given to the Museum by Mikhail Vasil'evich Braikevitch, a dedicated patron of the ballet and a collector. He left his first collection in Russia (now in the Museum of Russian Art, Odessa) when he emigrated after the Revolution. His second collection was built up in Paris and London; he knew most of the émigré artists, most notably Benois and Bakst, and his bequest of some 68 items to the Ashmolean laid the foundation of its remarkable collection of Russian stage and costume designs. A replica of this drawing is in the Russian Museum, Leningrad.
Bequeathed by Mikhail Vasil'evich Braikevitch, 1949.
(WA1949.322)

Walter Richard Sickert (1860-1942)
The Brighton Pierrots ↻
Oil on canvas, English, 1915, 64 x 76.8 cm

Sickert stayed with his friend Walter Taylor (1860-1943) at Brighton in August and September 1915. He told his friend and pupil Ethel Sands (1873-1962) that he went every night for five weeks to the Pierrot Theatre. He painted this picture on his return to London and sold it to Ethel's brother, Morton Sands. The car-maker Sir William Jowett and his wife immediately commissioned a replica (Tate Britain). *The Brighton Pierrots* is one of Sickert's most impressive compositions, the gaudy colours contrasting with the empty seats in the front row.
Presented by the Christopher Sands Trust, 2001.
(WA2001.29, A1231)

John Piper (1903-1992)
Interior of Coventry Cathedral ⌒
Indian ink, wash and gouache on paper, English, 1940, 14.7 x 18.5 cm

Within the tradition of English landscape painting, John Piper is rated as one of the most prominent artists. Although he started his artistic career in the 1930s mainly in a more abstract manner, following Ben Nicholson (1894-1982) with his primary colours, he later turned his interest back to English architecture and landscape. With the commission of the Pilgrim Trust to record damaged buildings during the Second Word War, he had the opportunity to combine his pictorial skills and his interest in medieval architecture. In this particular case, he recorded Coventry Cathedral after it was destroyed during one of the largest raids on Britain, on the night of 14-15 November 1940. He made the study while the ruins were still burning. Later he used this watercolour for a much larger painting. Here he was mostly interested in the overall visual appearance and not so much in the detail. With his various versions of the destroyed Coventry Cathedral Piper built a reputation in Britain as a remarkable war painter; he later embarked on a further career as a painter and designer of stained glass. The Ashmolean holds a large group of watercolours and two abstract paintings presenting most aspects of Piper's artistic life. The majority were a gift of the art dealers Robert and Rena Lewin in 1992.

Presented by Mr and Mrs Robert Lewin, 1992. (WA1992.159)

Stanley Spencer (1891-1959)
Cows at Cookham ⌐
Oil on canvas, English, 1936, 76.3 x 50.8 cm

Spencer identified himself throughout his life with the area around Cookham in Berkshire. He attempted to recover his sense of inner equilibrium lost during the First World War by creating a chapel – finally unrealised – that would encapsulate the tranquillity of Cookham. In a semi-realistic manner he here recreates an ideal, rural harmony in a sun-filled landscape.

Bequeathed by Thomas Balston through The Art Fund, 1968. (WA1968.27, A1044)

Fu Baoshi (1904-1965)
Landscape ɔ
Ink and colour on paper, Chinese, 1943, 110 x 61 cm

Fu Baoshi is renowned as one of the foremost traditional painters of the twentieth century in China. He used classical formats and materials but developed his own distinctive style of brushwork combining wet and dry ink, as well as techniques of mixing ink with pigments. For much of his career he was Professor of Art at Nanjing University; during the Sino-Japanese War (1937-1945) the University, along with many other national institutions, moved to Chongqing in Sichuan province, where Fu painted this landscape. After the founding of the People's Republic of China in 1949 he held numerous public appointments in addition to working as an artist, and painted landscapes for several major new buildings, including the Great Hall of the People. This landscape was painted in 1943, when Fu Baoshi was living in Chongqing. Traditionally landscape paintings in China were executed in ink with only slight colour added, typically a pale grey-blue or buff pigment. In this work Fu Baoshi has used those pigments as washes, and in some areas they are mixed with ink as well. This use of colour is a distinctive feature of Fu's style. The composition is quite dense, and the slightly conical forms of the mountains evoke the style of the early Qing dynasty painter Shi Tao. Shi Tao (about 1640-1720) was a painter and theorist known for his individualism; Fu Baoshi was profoundly influenced by him and wrote extensively on his life and work.

(EA1962.222)

Hans Coper (1920-1981)
Ceramic vase on cylindrical foot ⌒
Pottery, British, about 1975, 18.3 cm high

Hans Coper, a refugee from Germany who came to work in England for many years alongside Dame Lucie Rie (1905-1995), is the most sculptural of all twentieth-century exponents of the studio pottery movement in England. This elegant and characteristic example of his work is a recent gift to the Museum's rapidly growing collection of British studio ceramics.

Presented by Henry Rothschild, 2005. (WA2005.90)

Chen Yuping (b. 1947)

My Hometown is by the Songhua River ↺

*Multi-block woodcut printed with oil-based ink, 1982,
36.5 x 65.2 cm*

Chen Yuping grew up in a rural village, trained as a
hydraulic engineer in the late 1960s and completed a
course in printmaking at the Central Academy of Fine
Arts in Beijing in 1983. His woodcuts largely build on
the tradition of the Great Northern Wilderness School,
with its non-key block technique and depictions of the
vast natural and reclaimed land. His work uses stronger
and more vivid colours than other printmakers in this
area and shows his boundless love for the land where
he was brought up. He is regarded as a passionate
devotee of the north-eastern landscape.
(EA 2007.13)

Georg Baselitz (b. 1938)

A Fascist flew past – Japanese ↺

*Drypoint, etching and aquatint, printed in black
and brown/red, German, about 1998-1999,
85 x 64 cm (sheet)*

In 1998 and 1999 Baselitz created a series of prints and a
number of paintings on the motif of a dead shepherd
lying in the grass, shot by a German aircraft during the
Second World War. The motif itself referred to a Russian
propaganda painting by Arkadi A. Plastov (1893-1972).
In the original painting the central motif of the boy was
meant to be a pathetic paradigm of Stalinist patriotism.
In the prints he has been isolated, analysed and altered.
Baselitz made eight different variations on this theme
(this is the eighth sheet) using different techniques and
developing the imagery to change the meaning and
expression of each sheet. As often in his prints, he not
only quotes a direct source but also makes allusions and
connections to others. Here the dead boy is no longer a
specific illustration of a particular shepherd shot by the
enemy, but an evocation of humanity.

*Purchased with the aid of Resource / Victoria and Albert
Purchase Grant Fund and the Christopher Vaughan Bequest
Fund, 2002. (WA2002.148.7)*

Learning more

To discover more about the Ashmolean and its collections you should first go to our website *www.ashmolean.org* It offers in-depth online searchable databases in key areas such as the collection European and Japanese paintings, Rembrandt prints, French drawings, drawings by John Ruskin, provincial coinage of the Roman Empire, and almost the museum's entire holdings of Oriental Art. The online collections are constantly evolving, and it is our intention to put the complete collection of the Ashmolean on-line in the near future. At present, all online collections can be found by going to the following URL: *www.ashmolean.org/collections/?type=resources* The website also features current news, events, exhibitions, and acquisitions.

The Ashmolean has an active book publishing programme with over 75 titles currently in print. It plays a vital part in the Ashmolean's mission to increase knowledge and enjoyment of its collections for both visitors to the museum and a wider audience throughout the world. Titles and subjects vary from general guidebooks, small handbooks dedicated to specific areas of the collection, and exhibition catalogues, up to large format scholarly works. The range is designed to suit all tastes and pockets. Full details of Ashmolean publications can be found in the Museum shop or online at *www.ashmolean.org/shop* and a selected list of titles is given below.

Here is a selection from our catalogue:

My Asmolean Discovery Book (with stickers)
Alison Honey

This book is designed to start children thinking about objects by introducing them to some of the Ashmolean's key exhibits and the fascinating stories behind them. How did a mummy get to Oxford from Egypt? What connects an octopus jar to the Minotaur? And what is Powhatan's mantle?

There are a range of activities to complete, ranging from imaginative drawing tasks to designing coins, and piecing together Samurai armour to mending a jar using stickers. All can be completed whether you are in the Museum or not. *Suitable for ages 8 to 11.*

ISBN: 978-1-85444-242-0
(paperback only)

Building the New Ashmolean
Weimin He

Weimin He was artist in residence at the Ashmolean in 2008 during the Museum's major redevelopment. Inspired by this historic project, he produced over 300 ink portraits of Ashmolean staff and BAM construction workers and managers. He also made many sketches of the building work in progress and a powerful group of woodblock prints based on these scenes. His work vividly portrays the building of the new Ashmolean and the people who helped to create it.

ISBN: 978-1-85444-245-1
(paperback only)

HANDBOOKS
The Handbook Series aims to bring to a wider audience the chief glories of the rich and varied collections of the Ashmolean, drawn from a diversity of cultures. Each title focuses on important groups of paintings, drawings or objects in which the Museum's holdings are internationally renowned and provides a stimulating introduction for the general reader and a compact, authorative guide for the expert. Priced at £8.95 for paperback and £12.95 for hardback. Titles include:

HANDBOOKS

The Alfred Jewel
David Hinton

The Alfred Jewel is probably the most famous archaeological object in England. The Ashmolean also houses many of the objects that belong to the same late Anglo-Saxon period, and they help to set the jewel in context. But the distinctive nature of the Jewel with its inscription that may refer to King Alfred (871-99), has a fascination that nothing else can rival.

ISBN: 978-1-85444-230-7 (pb); 978-1-85444-229-1 (hb)

Stringed Instruments
Jon Whiteley

The Ashmolean's collection of European stringed instruments is very famous. Several of the instruments in the Ashmolean are among the rarest and most beautiful of their kind. The collection was founded on a group of instruments which was given to the museum by the firm of W E Hill & Sons in 1939.

ISBN: 978-1-85444-200-0 (pb); 978-1-85444-199-7 (hb)

The Arundel and Pomfret Marbles
Michael Vickers

The largest surviving portion of the first major collection of Classical antiquities in Britain – collected in the early 17th century by Thomas Howard, Earl of Arundel – are held in the Ashmolean Museum. This handbook tracks their eventful history before they came to rest in Oxford.

ISBN: 978-1-85444-207-9 (pb); 978-1-85444-208-6 (hb)

Watches
David Thompson

The collection of watches in the Ashmolean Museum exists largely as a result of three major bequests, including the Bentinck Hawkins collection in 1894, the bequest of J Francis Mallett in 1947 and the collection of Eric Bullivant in 1974, comprising of 120 watches. Together these make the Ashmolean collection one of the most important outside London.

ISBN: 978-1-85444-218-5 (pb); 978-1-85444-219-2 (hb)

Japanese Decorative Arts of the Meiji Period
Oliver Impey

'Meiji' means 'enlightened government' and in 1868, the new Japanese government's primary aim was to bring Japan into a new group of modern western industrial powers, demonstrating to the world the brilliance of Japanese crafts-manship.

ISBN: 978-1-85444-198-0 (paperback only)

Oxford and the Pre-Raphaelites
Jon Whiteley

Oxford is exceptionally rich in Pre-Raphaelite associations. The Ashmolean has one of the finest collections of paintings, drawings and sculpture from this movement.

ISBN: 978-0-90784-994-0 (paperback only)

Drawings by Michelangelo & Raphael
Catherine Whistler

Michaelangelo and Raphael each brought technical mastery to new heights. The Ashmolean has one of the finest groups of Raphael drawings in the world and an important collection by Michaelangelo.

ISBN: 978-1-85444-002-0 (paperback only)

Ruskin's Drawings
Nicholas Penny

A selection of architectural drawings, largely of Venice and Verona; landscapes; studies of trees, flowers and birds, all types of strands of inspiration for Ruskin's art and ideas indicative of the breadth of his interests.

ISBN: 978-0-90784-974-2 (pb); 978-1-85444-104-1 (hb)

HANDBOOKS

Indian paintings
from Oxford collections
Andrew Topsfield

Indian Paintings from Oxford Collections
Andrew Topsfield

A selection of the Mughal period (c. 1500-1850) paintings from the Ashmolean Museum and the Bodleian Library. The illustrations include examples from the Rajput, Deccani and Mughal schools.

ISBN: 978-1-85444-150-1 (pb);
978-1-85444-051-8 (hb)

Maiolica
Timothy Wilson

Maiolica REVISED ED.
Timothy Wilson

Intended as a general introduction to Italian Renaissance ceramics – each piece illustrated is chosen from amongst the finest and characteristic of the major centres of production including Florence, Siena and Urbino.

ISBN: 978-1-85444-176-8 (pb);
978-1-85444-177-5 (hb)

Poussin to Cézanne
French drawings and watercolours
Jon Whiteley

French Drawings
Poussin to Cézanne
Jon Whiteley

Fifty-two works are illustrated from a collection of over 2000, from early seventeenth-century chalk drawings by Callot, Stella and Claude Lorrain, through to late nineteenth-century drawings and watercolours by the likes of Manet, Berthe Morisot and Tissot.

ISBN: 978-1-85444-168-3 (pb);
978-1-85444-169-0 (hb)

Camille Pissarro
and his family
Anne Thorold and Kristen Erickson

Camille Pissarro and his Family
Anne Thorold and Kristen Erickson

The Ashmolean's collection of drawings and watercolours by Camille Pissarro is the largest in the world. This book illustrates the full range of his work together with the work of his son Lucien and granddaughter Orovida.

ISBN: 978-1-85444-131-0 (pb);
978-1-85444-132-7 (hb)

Frames and framings
Timothy Newbery

Frames and Framings
Timothy Newbery

This book looks at frame history and design in the context of the Ashmolean's collection of frames and aims to provide a sense of importance of the picture frame in the history of art as a whole.

ISBN: 978-1-85444-174-4 (pb);
978-1-85444-175-1 (hb)

Worcester porcelain
Dinah Reynolds

Worcester Porcelain
Dinah Reynolds

The most representative collection known of 'First (Dr Wall) period' coloured Worcester porcelain, 1751-83, contains over 1000 pieces given to the Ashmolean in 1975 by Mr and Mrs H R Marshall.

ISBN: 978-0-907849-75-9 (pb);
978-1-85444-127-0 (hb)

The Ashmolean Museum
A brief history of the Institution and its collections
Arthur MacGregor

The Ashmolean Museum
A History of the Museum and its Collections

Three centuries and more of unbroken history render the Ashmolean one of the most venerable museums of its kind in the world. This book traces the eventful history of the institution.

ISBN: 978-1-85444-148-5 (pb);
978-1-85444-149-2 (hb)

Twentieth century paintings
Katharine Eustace

20th-Century Paintings in the Ashmolean Museum
Katharine Eustace

Includes early or transitional works by Bonnard, Picasso, Braque and Matisse, important British painters from the Camden Town and Euston Road schools, together with post-war works by Ben Nicholson, John Piper and Lucien Freud.

ISBN: 978-1-85444-116-4 (pb);
978-1-85444-117-1 (hb)

ARCHAEOLOGY

ORIENTAL ART

Ancient Egypt & Nubia
Helen Whitehouse

From vases to weapons, and 'serpent game' boards to decorated ostrich eggs, this book showcases the richness and diversity of the Museum's Egyptian collection in beautiful full-colour images with informative captions.

ISBN: 978-1-85444-202-4
(paperback only)

Medieval England
Arthur MacGregor and Moira Hook

The social, economic and political development of medieval England is discussed in the context of the Ashmolean's archaeological collection illustrating the evolution of trade, industry and agriculture.

ISBN: 978-1-85444-061-7
(paperback only)

Early Himalayan Art
Amy Heller

This book presents the Ashmolean Museum's collection of some sixty important early sculptures and other objects from Tibet and Nepal dating from c.500-1400 AD. They include a number of secular objects as well as images of deities in the Hindu and Buddhist pantheons.

ISBN: 978-1-85444-209-3
(paperback only)

Modern Chinese Art
The Michael Sullivan Collection

Many of the works presented in this complete catalogue were given to the Sullivans by the artists themselves, so that this is at once a work of scholarship and a record of many friendships. This revised edition has been extended to incorporate new works collected since this book was first published in 2001.

ISBN: 978-1-85444-233-3
(paperback only)

EUROPEAN ART

Chinese Paintings in the Ashmolean Museum
Shelagh Vainker

This catalogue publishes the collection of Chinese paintings in the Ashmolean Museum, with the exception of the 130 works in the Reyes collection already published as Modern Chinese Paintings.

ISBN: 978-0-90784-132-4 (pb);
978-1-85444-145-4 (hb)

A New Flowering
1000 Years of Botanical Art
Shirley Sherwood

Featuring 1000 years of botanical art, this catalogue represented the Ashmolean's leading exhibition of 2005, providing the unique opportunity to compare illustrations by contemporary artists alongside remarkable botanical art of the past.

ISBN: 978-1-85444-206-2
(paperback only)

Complete Illustrated Catalogue Of Paintings

For the first time ever, all paintings in the Department of Western Art in the Ashmolean Museum have been brought together in one volume. Every picture is illustrated and almost all are represented in colour.

ISBN: 978-0-90784-188-1 (pb);
978-1-85444-187-4 (hb)

Dutch and Flemish Still-life Paintings
Fred G Meijer

The Daisy Linda Ward collection consists of ninety-four 17th-century Dutch and Flemish still life paintings presented to the Ashmolean in 1940. This catalogue serves as an important up-to-date work of reference.

ISBN: 978-90-400-8802-5
(hardback only)

The Ashmolean Picture Library

The Picture Library at the Ashmolean has a growing archive containing tens of thousands of images. It includes early glass negatives through to large format transparencies and new digital images. New photography can also be requested of any available object from the collections. As part of the Ashmolean's transformation, we now offer an entirely digital service, providing high-resolution digital images and photographic quality inkjet prints.

For more information about photographic services and reproduction rights visit the Picture Library webpage on the Ashmolean's website *www.ashmolean.org/services/picture library*

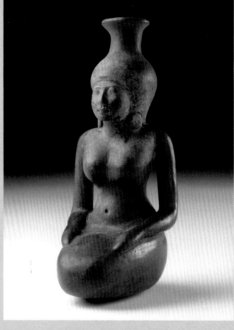

Egyptian
Pottery vase in the shape of a woman
(AN1896-1908 E.2432)

Central Asia
Ikat Coat
(EAX.3985)

Robert Bevan
Showing at Tattersalls
(WA1957.14.3)

Raphael
Portrait of an Unknown Youth
(WA1846.158)

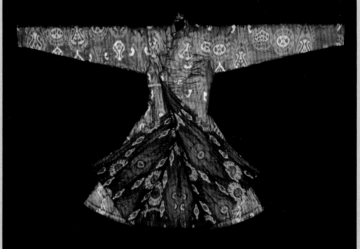

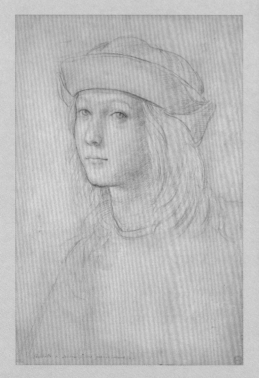